Contested

Terrain

Myth and

Meanings in

Southwest

Art

CONTESTED TERRAIN

SHARYN R. UDALL

University of New Mexico Press
Albuquerque

Library of Congress Cataloging-
in-Publication Data
Udall, Sharyn Rohlfsen.
Contested terrain: myth and meanings in Southwest art /
Sharyn R. Udall. — 1st ed.
p. cm.
Includes bibliographical references and index.

ISBN 0-8263-1669-7 (paper)
1. Art, American — Southwest, New — Themes, motives. 2. Art,
Modern — 20th century — Southwest, New — Themes, motives. I. Title.
N6527.U3 1996
709'.78 — dc20 95-4386
 CIP

This book is for my parents,
Irene and Ralph Rohlfsen.

CONTENTS

FIGURES

PLATES

ACKNOWLEDGMENTS

My greatest debt is to the artists, living and dead, whose work has moved me to write. Those who helped with the writing number in the dozens: colleagues who read and offered advice, staff members at institutions who provided materials, photographs, and permissions, and the editors of journals and periodicals named in the notes. My thanks also go to my editor, Dana Asbury, for her guidance. Finally, I thank my family, whose support means more than they know.

Contested

Terrain

INTRODUCTION

The Southwest steadfastly refuses to be fixed in a stable identity. More than in most places, past and present coexist in the Southwest, blurring sequences and cycles. While it is a region with a rich history, we cannot seize its definition whole from historical traces. It has been and remains a place of confluences—historical, mythical, social, and artistic. The essays in this volume look at the eddies where art pools with the broader flow of southwestern culture.

When I wrote the first of these essays, "Into the Neon Sunset," some twelve years ago, I never envisioned it as the germ for something larger. Yet without intent or awareness, the insights gained through its writing—particularly those pointing to the multiple mythic bases of Southwest painting—led to others. Now, seen in retrospect, the recurring themes and preoccupations in these essays add up to something approaching an autobiography of the mind.

Sometimes the writing has been aimed at a general audience; at other times it has been intended for more specialized academic readers. Those differences in style and documentation have been preserved here; the reader will easily be able to distinguish them, using or ignoring the endnotes as she/he wishes.

Writing, for me, has always been the process that clarifies my own thinking. It is also the arena where I've wrestled with and tried out new critical per-

spectives, though usually without direct reference to theory in the essays themselves. Ranging freely among new approaches born of widespread dissatisfaction with inherited categories, I've felt a persistent itch to participate in a small way in the groundswell effort to open, enlarge, and ultimately transform art history. That collective, ongoing process has given all of us permission to practice art history in a new way.

What has been the basis for such sweeping change? My training, like that of most art historians in the 1970s, centered on a discipline shaped by Enlightenment precepts of rationality. That view saw art as a discrete category, believed good scholarship to be objective and neutral, and stressed the importance of period labels, style developments, influence, and context. Organized around conceptual frameworks of art and artists, the discipline perpetuated old hierarchies and protected a relatively monolithic canon, tracing "progress" in a linear fashion from "ism" to "ism."

In the modern Euro-American tradition, that history developed from twin sources: Renaissance notions of perspective in the visual arts and Descartes's conception of subjective rationality in philosophy. For a long time Cartesian perspectivalism reigned as the prevailing model, marrying the "natural" human experience of seeing to an emerging scientific world view. A neat, circumscribed way of seeing—Alberti's window on the visual world—it presupposed a detached, ahistorical, universal observer, for whom the artist created some kind of significant, unified visual narrative.

Midway through the nineteenth century, that model began to crumble, dynamited by the likes of Manet's *Olympia*, whose brazen look-back challenged the viewer's controlling gaze. Close on her heels were the antiperspectival heresies of impressionist painting and the impudent new art of photography, with its arbitrary framing, immediacy, and fragmenting of wholes. We could argue about the degree of self-conscious opposition freighted in these vehicles of change, but this much is clear: they heralded the breakdown of old, monolithic hierarchies of seeing and anticipated the plurality of visual modes that confront us now.

The 1980s and 1990s have seen a burgeoning critique of old ways of seeing and of writing art history. From both inside and outside the discipline, a fresh wind brought with it new critical standpoints and tools of analysis, loosely grouped under the banner of postmodernism. Skepticism about absolute values and universal explanations found voice as early as the 1960s in the writings of French poststructuralists (especially Foucault and Derrida) and in semiotics (Saussure) and psychoanalytic theory (Lacan). Feminist theory, de-

veloping in distinct ways in France, Britain, and North America, helped further the study of the sociopolitical conditions under which art objects are made and experienced.

My own continuing dialogue with visual theory has benefited from contact with the work of many such theorists. Reading through this collection of essays, I encounter again my own behind-the-scenes struggles with their ideas. Roland Barthes and Claude Levi-Strauss, for example—both pioneer structuralists—have transcended disciplinary labels and demonstrated to me the centrality of myth in matters literary, anthropological, and visual.

Besides acknowledging my debt to theory, several of my own assumptions must be mentioned here. Within a social context, I believe that the human mind must operate with some kind of mythic and ideological structure. Out of that structure the artist draws memory, association, and feeling in measures beyond conscious intent. In other words, an artist's creativity is not limited to the efforts of the waking self, but often incorporates (in an admittedly Freudian-Jungian manner) levels of unconscious meaning. Not that psychoanalysis can explain creativity; even Freud admitted that impossibility.

Another of my assumptions is that such meanings can converge on one another in significant, unexpected, and discoverable ways. The work of art, then, is not a discrete object with its own internal or essential meanings. On the other hand, although I recognize that art is produced within cultural systems, it never becomes merely a social document transparently mirroring life. While knowing that what we see and how we see are closely tied to the ways we are encouraged, allowed, and taught to see, I insist as well on the artist's power of personal expression. As such, the artist's individual identity and voice remain important, and some of the essays in this book place the artist squarely in the center of discussion. Woody Gwyn and Page Allen find themselves there.

Let me add one other note on theory—particularly as I've found it useful in analyzing the art of the Southwest. Recent theorists, especially Jacques Derrida and Hélène Cixous, have called for the dismantling of longstanding binary oppositions—those paired extremes that frame and reframe cultural reality. They include the polarizing concepts of male-female, mind-body, nature-culture, self-other. Such discussions have led me to consider certain problematic polarities I see at the heart of art making in the Southwest. Especially crucial is the presumed opposition between nature and culture. Clearly a longstanding social construction, the historical split between nature and culture has entered my writing at several points, especially in chapter 1,

"Spiritual Icons in Southwest Art: The Sacred Mountain, Pueblo Cosmogony, and Euro-American Landscape Painting."

For better or worse, the perceived closeness of the Native American to nature has been a powerful mythic force in the Southwest. Encounters with Native Americans have been seen by some Euro-Americans as symbolic confrontations with inchoate nature. To an artist like Marsden Hartley, on the other hand, the Indian's oneness with the land produced a "principle of conscious unity in all things. . . . The redman proves to us what native soil will do."[1] In chapter 4, "Southwest Phoenix," I have recounted Hartley's search, via poetry and painting, for the redemptive roots of mythic power in the Southwest.

The Native American has also been a powerful example of the binary opposition between Self and Other. As Simone de Beauvoir argued, humanity inevitably seeks union with that which is Other than itself; we desire to possess that which we are not. Thus, with complex and sometimes troubling results, the mythic and artistic resources of Native people have been appropriated by generations of Euro-American artists and writers. In terms related to Michel Foucault's description of bourgeois social formations in the nineteenth century, the Native American has been brought to visibility in Southwest art within relations of power/knowledge that shaped that visibility. In a lopsided power relationship, Euro-Americans have assumed the "subject" position of looking, while the Native American has become the passive, powerless "object" of the artist or photographer's controlling gaze. I have taken a look at such relations in chapter 3, "The Irresistible Other: Hopi Ritual Drama and Euro-American Audiences."

In these essays I have tried to suggest that rejecting unnatural binary oppositions might help to remove the artificial wedges between connected entities. Approached through the visual arts but extending much more widely into Western culture, a major theme in this book involves identifying and enhancing those connections.

Sometimes spirituality has been a bridge. In several of these essays, notably "Spiritual Icons in Southwest Art" and "Beholding the Epiphanies: Mysticism and the Art of Georgia O'Keeffe (chapter 5), I have looked at the ways in which southwestern artists have reformulated art's traditional aspirations toward the sacred. With the waning power of religious faith as an impetus for artistic vision in the twentieth century, artists like Georgia O'Keeffe have sought aspects of the spiritual in the topography of the Southwest and in its storied light. Her vision, even when grounded in the material, yearned for the

redemptive unity of mind and matter, of West and East, of male and female, of Self and Other, of the conscious and the unconscious.

Beyond the ways suggested here, readers will undoubtedly find ways of connecting and comparing the essays that follow. They will surely find contradictions as well, but I have chosen to leave those stand largely as originally written. They expose, I trust, both human inconsistency and growth.

The Southwest, land of swaggering exploitation, genteel environmentalism, and self-conscious myth making has long beckoned to the artist. But art made by Euro-Americans in this region has too often basked in the sunny celebration of the picturesque, the exotic, and the sentimental. Purged of the shadows of poverty, human struggle, and racism, the Southwest has been portrayed as an innocent American Eden. Eden it is not, paradise it has never been. But that admission need not strip the place of its power to incite questions, to encourage looking, to search out and examine old and new representations. As Antaeus drew strength from the ground, artists and writers continue to find stimulus in the ideas, people, and mythic convergences of the Southwest. It is a place that challenges art's skill at reinventing nature and America's power of mythic assimilation.

SPIRITUAL ICONS IN SOUTHWEST ART

The Sacred Mountain, Pueblo Cosmogony,
and Euro-American Landscape Painting

Ever since Petrarch's fourteenth-century ascent of Mt. Ventoux, Western culture has had a written record of the powerful effect of mountains on the human psyche.[1] In Petrarch's case the pleasure of the view wilted abruptly when he dipped into his pocket volume of Augustine's Confessions, where he was stung by the lingering medieval admonition against finding pleasure in worldly things at the risk of one's immortal soul. A chastened Petrarch scurried quickly down the mountain. But countless generations of wanderers since have not retreated from the mountain; unlike Petrarch, they have embraced it as an emblem of the spiritual potency of nature.

That spiritual perception of nature has been a sustaining inspiration for artists and writers in America. One of our great treasures, an abundance of wilderness, has for two centuries encouraged American painters to range widely in pursuit of its spectacles and its secrets. For some landscape painters a straightforward search for new visual material, for stunning vistas, was sufficient to lure them into the wilderness. But for others, the search had an inward component as well: they wanted to connect spiritually and emotionally with the land. At various times and places this latter impulse has been particularly strong and has encouraged some art historians and critics to posit it as an alternative to the more widespread mode of materialist, pragmatic and descriptive American painting.[2]

Our focus here is on a specific region of the country, the American South-

west, where the promise of transcendent wilderness lingered long after settlements east of the Mississippi changed the character of the land. In certain parts of that region, especially those where the spiritual flavor of the land has long nourished its native inhabitants, Euro-American artists have sought their own intense nature-derived experiences.

Such a place is northern New Mexico, well known for its early-twentieth-century artist colonies at Taos and Santa Fe. Less well known are its attractions as a locus of spirituality—a metaphysics born of twin sources in its rugged topography and in the longstanding nature-based spirituality of its native peoples. For artists—whether celebrated or obscure—who have sought an emotive, intuitive connection with the American landscape, New Mexico has been a powerful magnet.

To begin to understand these artistic encounters, we must first know something of the ancient spiritual heritage of the Native Americans in the Southwest—a heritage like that described by Mircea Eliade as "the mystic experience of autochthony, of being indigenous, the profound sense of having emerged from the local ground, the sense that the earth had given birth to us."[3] More specifically, we must understand something of the sacred places where the corporeal reality of the Pueblo Indian is linked with the body of the earth itself.

On the eastern slope of New Mexico's highest mountain peak, not far from Taos, lies a shimmering body of water sacred to the Pueblo people. Photographs of Blue Lake show a placid, mirrorlike surface reflecting a dense surround of trees and white clouds scudding overhead. Most existing photographs and paintings of the site were made before 1970, the year the lake and forty-eight thousand acres of surrounding land were returned to the Taos Pueblo people. Removed from the public domain and the threat of logging, the lake is now off limits to wandering photographers and painters. No longer a subject for artists, the sacred lake instead collects its own visual images.

Lying silently like a great eye or mirror wedged into the body of the earth, Blue Lake gathers the reflections of nature—clouds, trees, an occasional animal pausing silently for a drink at water's edge. In other words, we might say that Blue Lake and its surroundings function something like a totemic mirror. Totemism, in fact, is an apt invocation here, for it helps to remind us of how art functions. Both art and totemism shift our minds from empirical levels of comprehension (namely, the visualized object) to the mythic (or conceptual). Art doesn't always make this metaphysical leap, but it can. Objects with a transcendent meaning (conferred through art or religious significance)

are distinguished from countless ordinary objects by this same mythic process. As Jack Burnham writes, "Belief in the physical authenticity of the work of art is absolutely essential to myth, since the object is the transubstantiated energy and psyche of the artist it survives. Hence totemism in art not only moves laterally in terms of linking contemporary art forms, but also vertically with relation to past and future events."[4]

It is appropriate that outside artists no longer have access to the totemic power of Blue Lake—appropriate in the sense that material representations cannot capture the significance of Blue Lake, for that reality lies in its spiritual importance for the Taos Indians. It is a sacred precinct within a sacred mountain. Upon their return, each year, to perform summer rituals beside the waters of Blue Lake, the Taos Indians renew contact with their spiritual origins. But even when they depart, the potency of Blue Lake and Taos Mountain remains, abstractly, in the mind of the Taos Indian. This sacred place is part of a complex symbolic, geometric, and material interplay that imposes order and meaning on the Pueblo world.

How, specifically, does the Pueblo sacred mountain function within this construct? To begin with, it is one of many physical features of New Mexico—along with its hills, lakes, rivers, and man-made shrines—that have linked the Pueblo people with their ancient origin myths, those stories that join their daily lives with an existence that preceded time.

Pueblo origin myths are multiple and have been recorded by anthropologists for decades.[5] Common to these stories, however diverse, is the belief that spiritual existence preceded the physical. The sacred came before the profane, which only developed after the first humans emerged from places within the earth where people, supernatural beings, and animals lived together. After emergence the humans divided into Summer and Winter people, saw the sacred mountains, made the sacred hills, and then migrated down both sides of the Rio Grande.

Sacred mountains define the boundaries of the Pueblo world—the most prominent features of a topographical concept that parallels multiple cosmic levels: the below, the middle, and the above. Each sacred mountain represents a cardinal direction, a totemic figure, and has a directional color associated with it. Earth navels (roughly analogous to the Greek omphalos) on each of the sacred mountains serve as entrances to the below and are at the same time "points at which the above, the middle and the below come closest to intersecting in each direction."[6] It is said among the Tewa that there is a shaft or tunnel within the navel that leads straight down into the earth. At

the autumnal equinox, notes Alfonso Ortiz, *axis mundi* symbolism is brought to life by the Pueblos. "At Taos," he explains, "it is the cosmic pole erected by the clowns in the dance plaza during the San Geronimo's Day celebrations" (fig. 1).[7]

We can rely for interpretive insights on the writings of Pueblo-born anthropologists such as Ortiz. But these public ceremonies, like the San Geronimo's Day dances, have also been observed and recorded by generations of respectful Euro-American visitors who have tried to capture in their visual images something of the religiosity of the Pueblo world view.

British-born artist Dorothy Brett (1883–1977), who painted for more than fifty years at Taos, made her intuitive spiritual affinity for Pueblo life a major theme in her art. Deaf since her teens, Brett could hear little of the aural rhythms of the Indian dances, but she filled her canvases with visual patterning and swirling color that recreate the dance rhythms for the eye. Her rich

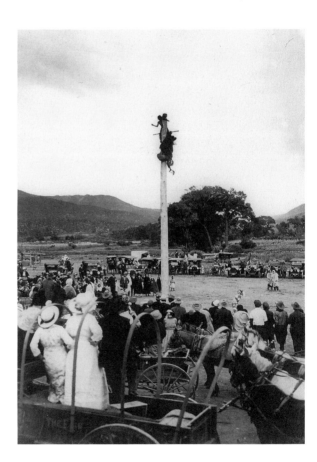

FIG. 1.
George L. Beam, *Pole Climb, San Geronimo Day, Taos Pueblo* (c. 1910–15). (Photograph courtesy Museum of New Mexico, Santa Fe; negative no. 86266).

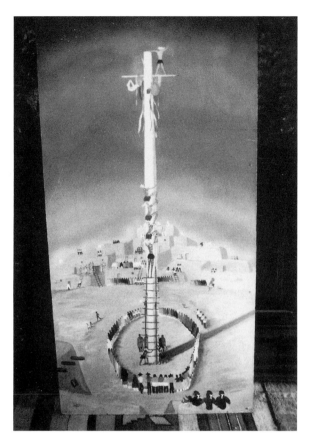

FIG. 2.
Dorothy Brett, Untitled
(Pole Climber, San
Geronimo Day, Taos)
(1945), oil on masonite.
(Courtesy Wurlitzer
Foundation, Taos, N.M.)

inner life fed the symbols Brett painted—symbols often related to the sacred in nature. As her friend, novelist Frank Waters, wrote, "It is this other-world which Brett has devotedly painted. The naturalistic yet mystical domain of intuitive awareness which coincides here with the Indian world dominated by the sacred mountain and Blue Lake high in the Sangre de Cristos."[8]

Her untitled painting of the San Geronimo Day pole climb (fig. 2), gives visual form to the *axis mundi* symbolism at Taos. Brett's exaggerated verticality and brilliant light transform the dance plaza at the base of the sacred mountain into a vast otherworldly realm. She knows that the pole is a symbolic bridge between cosmic levels, a physical and metaphorical axis for a vertical continuum in time. Time and space thus intersect in the Pueblo world to provide what Ortiz calls their "primary level of orientation to reality."[9] And this kind of organization echoes Burnham's totemic universals, noted above.

These are only the rudiments of a complex system of Pueblo classification

that relies on numbers and sacred geometric forms functioning simultaneously with certain conspicuous dichotomies. Social dualism and symbolic dualities—sacred/profane, summer/winter, male/female, vertical/horizontal, sun/moon, priest/witch—are a fundamental part (though only part) of the Pueblo culture. Beyond simple dualities, the Tewa classify human and spiritual existence into six levels (which can be further reduced to two triads—one representing the plane of being, the other the plane of becoming), and they construct their villages in quarters. Numerological symbols function on multiple levels among the Pueblo people; as Ortiz writes, "The tendency is to combine and balance opposites such as in color and number classifications."[10]

Even those of us who are not participants in the Pueblo belief system can still partake—through imagination, through words, or through artistic images—in the *idea* of the sacred. For we too are symbol-users, engaged in that basic human activity of inventing abstract models that bear some coherent relation to the external world. Such models (or visual images in the case of art) must be understood as themselves a kind of language. Paintings, for example, used to be considered as transparent windows through which reality could be presented to the understanding. Now we know that paintings are much more complex and powerful than that. They are *signs*, which—as W. J. T. Mitchell writes—"present a deceptive appearance of naturalness and transparence concealing an opaque, distorting, arbitrary mechanism of representation, a process of ideological mystification."[11]

In other words, paintings—like symbols themselves—can change according to their maker/user and can masquerade as *nature* while actually codifying *cultural* constructs. But this is not a new insight. Questions of nature-culture interplay belong to a venerable, if battered, tradition of theoretical and historical reflection on images reaching back at least as far as Plato. As we approach the twenty-first century, the questions are no nearer resolution; if anything, in fact, they have grown increasingly complex.

Whatever approach one takes, the complex relationships between form and meaning in literature or in the visual arts ultimately converge. The physical form, writes Vincent Scully, "must become the meaning in any work of art, since it must in varying degrees embody and symbolize the meaning, which otherwise is literally not there."[12] This idea is wholly congruent with Pueblo belief, and is well represented in the architecture of the Pueblo. The constructed visible world of the Pueblo people is mostly horizontal, ground-hugging architecture.

Yet at Taos particularly, where that pueblo's own sacred mountain looms

beautifully and terribly over all, the stepped-back adobe masses of the pueblo are built up in an articulated pyramidal mass against the mountain backdrop. Scully has called attention to the pueblo's stepped profile, apparently intended to invoke mountain and sky together. Even the church at Taos Pueblo, as elsewhere along the Rio Grande, varies from the twin-towered facades of Western European church architecture. The towers have been gentled into outlines reminiscent of the mountain's shape beyond. "In this way, as in others," writes Scully, "the intrusive European attitude, like the imperial European religion it housed, was deflated by Pueblo culture and drawn by it into a more naturally inclusive web of divinity."[13]

This loose Pueblo "web of divinity" was ancient and vast, yet more unified in its origins than the protean complex of European thought. With respect to the sacred mountain, for example, it is useful to recall here that European and Asian conflations of that image and idea had been accruing for thousands of years. Excavations of prehistoric and early historic people in the ancient Near East have uncovered nearly forgotten religions in which people revered their supreme creator (usually a goddess) on sacred mountains, hills, and knolls. As urban societies developed in Mesopotamia, stepped pyramids or ziggurats (really constructed mountains) raised temples for such worship high above the surrounding plain. Familiar too is the Greek mountain Olympus, dwelling place of the Hellenic pantheon.

It is not surprising that Judeo-Christian tradition shared such themes, with biblical admonishments to the Hebrews to "utterly destroy all the places, wherein the [pagan] nations which ye shall possess served their gods, upon the high mountains, and upon the hills."[14] Though they destroyed the pagan places of worship, the Hebrews and Christians continued to focus on the spiritual aspects of mountains: the Abraham-Isaac story, Moses receiving the law, and Christ's transfiguration and sermon on the mount are just a few of many biblical examples. The history of the mountain as a sacred place embedded itself as firmly in Western consciousness as it did in Pueblo thought.

Particularly in the eighteenth and nineteenth centuries, European tradition records heightened interest in sublime and romantic images seen in nature: oceans, deserts, space, and mountains were all thought to be God's vehicles for conveying sublimity. Theologians, who had once preferred the small and the beautiful in nature, gradually came to consider mountains as part of God's infinite variety, emblematic of the grandeur of their creator Himself.[15]

Heirs to this tradition were the landscape painters of the nineteenth century, a few of whom visited the American Southwest. Topographical artists vis-

iting what is now New Mexico borrowed adjectives like "mysterious," "infinite," and "lonely" from romantic tradition, applying them to the stark landscape they found there. Martha Doty Freeman has recorded the reactions of topographer James H. Simpson, who saw New Mexico in 1849. Simpson noted

> the generally geometric quality of the land which manifested itself in the particular form of the *triangle*. He noted "conical mounds" and regularly symmetrical cones composed of horizontal lime and sandstone strata. United States Boundary Commissioner J. R. Bartlett would have liked to build a large *pyramidal monument* on one of the conical hills, perhaps in recognition of the omnipresent and representative shape [emphasis added].[16]

Thus we see that early travelers created and used symbols suggested directly by the geometric forms in the southwestern landscape. Of these, the most striking and frequently mentioned was that of the triangle, representing the three-dimensional forms of volcano or mountain and resembling their human-constructed analogue, the pyramid.

Superimposed on these romantic interpretations of nature's forms were the momentary effects of nature's moods. Weather, especially cloud formations and storms, were prized in the romantic tradition, and have been featured since in dozens of New Mexico landscape paintings. Victor Higgins's *Winter Funeral* (c. 1931; fig. 3), for example, shows half-hidden Taos Mountain, like a symbol of veiled consciousness, looming over the puny human drama enacted below. Even earlier, Carlos Vierra's *Northern New Mexico in Winter* (c. 1922) also shrouds the mountains in clouds, like a mysterious, sentient cloak of silence. There are questions here of self-sufficiency, of hermeticism in nature, like those Susan Sontag has addressed: "A landscape doesn't demand from the spectator his 'understanding,' his imputations of significance, his anxieties and sympathies; it demands, rather, his absence, it asks that he not add anything to it."[17] The ahistorical silence of the mountain is itself a metaphor, better understood by the Pueblo than the Anglo artist in New Mexico. And the silent massing of clouds over mountain peaks, as Alfonso Ortiz has noted, "wordlessly proclaimed an enhanced sacredness to the Tewa people."[18]

As artists and writers explored the land of the Pueblo, they sensed his ability to draw the power of the earth into human art and ritual. To this they related a cherished belief that the outward form of things somehow expresses

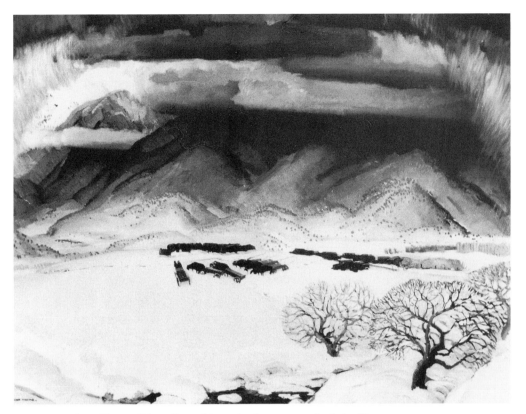

FIG. 3. Victor Higgins, *Winter Funeral* (c. 1931), oil on canvas, 46 x 60 in. (Courtesy Harwood Foundation Museum of Taos Art, Taos, N.M.)

their inner meaning. Not a new concept, this idea has held sway at various moments in history: in the rhetoric of twelfth-century and Renaissance Neo-platonism, for example, image and idea were joined by "aptly suggestive re-semblance."

The idea was also widely believed among advanced artists and writers earlier in this century. America's prophet of modernist art, Alfred Stieglitz, and his circle of artists in New York (including Georgia O'Keeffe, Arthur Dove, John Marin, and Marsden Hartley) were all exponents of such thinking.[19] So was the Russian theorist-painter Wassily Kandinsky, whose notion of the dis-coverable inner essences of visible forms found great currency among the artistic avant-garde and through them appeared in paintings produced in New Mexico during the first half of the twentieth century.

Kandinsky's search for spirituality in art led him to explore meaning in nat-ural forms. "The life of the spirit," he wrote, "may be fairly represented in di-

agram as a large acute-angled triangle divided horizontally into unequal parts with the narrowest segment uppermost." In other words, it was the shape of a great mountain—a "spiritual triangle" or "spiritual pyramid" from which, according to Kandinsky, "the invisible Moses descends and . . . brings with him fresh stores of wisdom to man." Artists, he declared, were spiritual seekers who could benefit from the nonmaterial wisdom of "primitives" and at the same time further their own self-enlightenment. "Every man who steeps himself in the spiritual possibilities of his art," he wrote, "is a valuable helper in the building of the spiritual pyramid which will someday reach to heaven."[20]

If Kandinsky believed that "form is the outward expression of . . . inner meaning," he also knew that its spiritual conduit to the viewer was color. Blue held the power of profound meaning, enhancing the spiritual dimension of any form it entered. Nowhere is Kandinsky's belief in the synergy of form and color seen to better advantage than in his *Blue Mountain* (1908; plate 1). Using direct, simple primary colors, he undertakes to set up a spiritual vibration in the viewer. Without veering into complete abstraction, Kandinsky has appropriated the spiritual resources of the mountain/triangle/pyramid construct and augmented it with the power of blue. Such paintings would serve as examples to many like-minded artists.

Much of Kandinsky's spiritual inquiry evolved from his study of Theosophy, a branch of metaphysics founded in 1875 by Helena P. Blavatsky.[21] Blavatsky was an encyclopedist of world religions with a special interest in synthesizing numerological and geometric symbol systems. In her *Isis Unveiled* (1877) and *The Secret Doctrine* (1888), Blavatsky explored the similarities of Eastern and Western myths and symbols. Through such writings Kandinsky (along with Frantisek Kupka, Piet Mondrian, Kazimir Malevich, and Marsden Hartley, among others) began to explore the purification of natural into abstract forms. From that step, they posited that geometric configurations function as paradigms of spiritual enlightenment. For example, the triangle—most rudimentary of true geometric shapes—was seen to refer simultaneously to a universal triune godhead, to the sides of pyramids (as Kandinsky noted), and to a tripartite matter-mind-spirit concept. Esoteric meanings of such sacred geometry are discussed at length in Blavatsky's *Secret Doctrine*. Also available to Blavatsky (and through her to Kandinsky and Hartley) was a considerable body of literature evidencing universal dualistic principles among ancient religious mythologies. Heaven-earth, male-female, sun-moon, and horizontal-vertical dualities were basic components of mystical iconography.

Such dualities, along with the tripartite levels of being, do not correspond exactly to the Pueblos' beliefs, but they are of such striking similarity that they made a powerful impact on minds initiated to Theosophy. Marsden Hartley, who had integrated numerological, geometric, and American Indian symbols into his painting in pre-World War I Berlin, could not miss the point.[22]

Moreover, Hartley had long made paintings of mountains with symbolic meanings, meanings that shifted with his own state of mind. From Maine to New Mexico to Mexico to France and back to Maine, he painted mountains as living, pulsating entities. In his poignant essay "On the Subject of the Mountain," Hartley explored the relationship of the mountain to its beholder:

> A mountain is not a space, it is a thing, it is a body surrounded by illimitable ethers, it lives its own life like the sea and the sky, and differs from them in that little or nothing can be done to it by ravages of silent agencies. . . . The mountain calls for courage on the part of those who are fated to live with it, for it is at all times indifferent to them, it asks no trust and no sublime hope against its cruelty, and like all great places of the earth calls for great sacrifice, and it is this element of hypnosis in nature itself which makes us cling to it as a relief from the vacuities of human experience.[23]

Intensely subjective, Hartley's words, like his paintings, show a simultaneous attraction to and alienation from the mountains he encountered. In New Mexico, where he spent much of 1918–19, his mountains vacillate between organic swellings and more geometric cubist-derived forms. Of the former type is his *Western Flame* (fig. 4), a New Mexico subject painted in 1920 shortly after he left the Southwest. Bare of incident, it has the reductivist quality of a painting made from memory. Yet it is as solidly painted as any of Hartley's on-site work. The painting's stark emptiness is exaggerated by low foreground shrubs, squatting like shaving brushes huddled in awe of the distant peak. The composition is unified in its rounded hill shapes—living forms, one feels, covered by the heavy folds of a blanket. Rising sharply at the center of the painting is the steep-sided pyramidal bulge that gives the painting its mysterious, sacred feeling. In a sexual context, it is ambiguous, as Hartley's paintings often were. Is it phallic, or perhaps a massive mother-earth breast? Hartley's title might well be a reference to Kandinsky's assertion that "vermilion has the charm of flame, which has always attracted human beings."[24]

The density of form in *Western Flame* contrasts sharply with Hartley's *New*

FIG. 4. Marsden Hartley, *Western Flame* (1920), oil on canvas, 22 x 31 3/4 in. (Courtesy Frederick R. Weisman Art Museum, University of Minnesota, Minneapolis, Bequest of Hudson Walker from the Ione and Hudson Walker Collection, 78.21.51)

Mexico Landscape (1919; fig. 5). Again, a steep-sided peak looms ominously in the center, but the whole is so loosely painted, so bare of incident that it seems to be a mountain in the process of erupting from a ghostly moonscape. Isolated, profound (as Hartley said) in its loneliness, the mountain could be cruel and indifferent. Yet within it energy surges actively upward, making the peak in *Western Flame* seem, by comparison, passive or sleeping. Patchy areas of color build up the form in *New Mexico Landscape,* similar to Cézanne's architectonic use of color in his many paintings of Mont Sainte-Victoire.

Hartley, like the Pueblos, felt the presence of life in many of nature's forms. Sometimes benign, sometimes malevolent, the New Mexico mountains drew deeply from his emotional reservoirs. Hartley's late series of "Recollections," painted years after his departure from the Southwest, sometimes exhibit a nightmarish quality—a mood reminiscent of a passage from the pen of Willa Cather. In 1926 Cather was in Santa Fe writing *Death Comes for the Archbishop,* a novel based on the life of New Mexico's first archbishop, Jean-

FIG. 5. Marsden Hartley, *New Mexico Landscape* (1919), oil on canvas, 18 x 24 in. (Courtesy Frederick R. Weisman Art Museum, University of Minnesota, Minneapolis, Bequest of Hudson Walker from the Ione and Hudson Walker Collection, 78.21.235)

Baptiste Lamy. In his imagination, Cather's archbishop creates a landscape from New Mexico's "monotonous red sandhills," the "conical red hills so exactly like one another that he seemed to be wandering in some geometric nightmare." Tired from the unrelenting brilliance of form and color, Cather's character sought relief from "the intrusive omnipresence of the triangle."[25] Again and again artists and writers refer to the triangle/mountain nexus.

During the same decade, the 1920s, D. H. Lawrence spent parts of several years in New Mexico. Though he had never seen Hartley's New Mexico paintings, Lawrence reacted similarly to the life force he felt within mountains. In 1922 he wrote of

Mountains blanket-wrapped
Round the ash-white hearth of the desert;
And though the sun leaps like a thing unleashed in the sky
They can't get up, they are under the blanket.[26]

Similar imagery was used by painters. In Ernest Blumenschein's *Indians in the Mountains* (1934), snow-striped mountains borrow their patterns from blanketed Indians passing by in the foreground. The riders are thus linked visually with their environment. But the union is a symbolic one as well: the Indians live in perfect harmony with the sacred environment they inhabit.

The Swedish-born painter B. J. O. Nordfeldt made many paintings of the Pueblo people during his two decades of residence in Santa Fe. Often he watched them dance. Prohibited from photographing or sketching during the ceremonies, Nordfeldt would return to this studio and paint them from memory. This, as Van Deren Coke has pointed out, may account for Nordfeldt's rearrangement of certain landscape backgrounds in a painting such as *Antelope Dance* (1920; fig. 6).[27] The same reason may hold true in his later *Thunder Dance* (1928; fig. 7).

FIG. 6. B. J. O. Nordfeldt, *Antelope Dance* (1919), oil on canvas, 35 5/8 x 43 in. (Courtesy Museum of Fine Arts, Museum of New Mexico, Santa Fe; museum purchase)

Black Mesa, between Santa Clara and San Ildefonso Pueblos, is the sacred hill seen in *Antelope Dance*. In *Thunder Dance* another mesa appears, placed exactly in the center between the two flanking buildings. Only a small space separates buildings and mesa; reading from left to right, the form-space sequence sets up a solid *ababab* rhythm, much like the constant thud-thud of drumbeats that propel the dancing feet. The adobe church and building opposite it on the left are largely undifferentiated from the mesa they frame. All three are unified by their firmly contoured masses, their identical materials. They are, after all, created from the same earth substance. According to Pueblo belief, these sacred hills, each aligned with one of the four sacred mountains, were made when the earth was still soft. Four pairs of the mythical brothers called *Towa e* each picked up some mud and slung it toward one of the cardinal directions, forming the four sacred *tsin*, or flat-topped hills.[28]

FIG. 7. B. J. O. Nordfeldt, *Thunder Dance* (1928), oil on canvas, 34 x 43 in. (Courtesy Fred Jones Jr. Museum of Art, University of Oklahoma; gift of Oscar B. Jacobson)

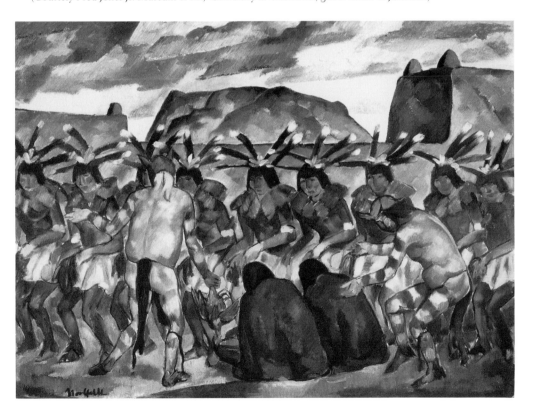

Nordfeldt, unknowingly, has projected the Pueblo view of things. By means of his formal unifications in color, contour, and mass, he has linked the Pueblo's internally symbolic architecture to nature's forms (the mesa). Human proportion and human needs are thus made visibly harmonious with the truncated sacred hill. Reinforcing that idea is the presence of the dancers, themselves inseparable from nature. As natural a part of the scene as the mesa or the air, the dancers here represent nature as much as they signify culture. Once again we encounter the matter-reveals-essence concept cherished by the Pueblo, by Kandinsky, and by many twentieth-century artists.

In Nordfeldt's painting the tension between material image and spiritual likeness is subtle; elsewhere it is highly dramatic. Will Shuster, one of Santa Fe's well-known Cinco Pintores in the 1920s, painted Black Mesa in a mode that compounds the specific allegorical meaning of the sacred *tsin* with a

FIG. 8. Will Shuster, *Black Mesa* (n.d.), oil on board, 23 1/2 x 29 1/2 in. (Courtesy Peters Corporation, Santa Fe, N.M.)

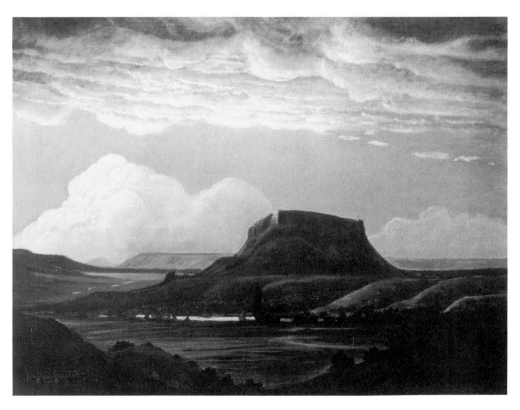

deliberate theatricality of presentation (fig. 8). The mesa does not merely *stand* for the divine; it *is* the divine.

Shuster was subject to twin influences in this instance: he was well aware of the Indians' reverence for the sacred in nature but had overlaid that knowledge with a dose of Eastern mysticism. Nicholas Roerich (1874–1947), a then-influential, later highly controversial Russian painter deeply involved in mysticism and Theosophy, had visited Santa Fe in 1921 and befriended the fledgling Cinco Pintores. Roerich marked the similarity between the landscape of Northern New Mexico and that of the Himalayas. A student of world mythologies, he was also struck by the symbolism of Pueblo religion and likened it to Asian spirituality.

Shuster and several of his colleagues incorporated certain influences from Roerich's thinking and his painting into their own work. Through him, their landscape painting acquired a new, spiritual dimension of wonder and purification. This they achieved in strong value contrasts, a studied quietism, and a vibrant luminosity (somewhat comparable to the luminism seen in the nineteenth-century American landscape painting of Church, Gifford, Kensett, and Lane).[29]

An adherent of Roerich's mystical associations with the landscape and of Kandinsky's spiritual attachment to color was Raymond Jonson, who settled in Santa Fe in 1924.[30] Armed with a sensitivity to geometric forms and an affinity for Cézanne and the cubists, Jonson pushed natural and human-made forms in the landscape to a new level of abstraction. In *Cliff Dwellings No. 3* (1928; plate 2), Jonson compresses tree, pueblo, and rock forms into a dense pyramidal structure that seems to rise upward against a stage set of variable blue.

In the same year Arnold Ronnebeck, a German-born painter who had befriended Hartley in Berlin and who subsequently settled in Denver, visited Taos. There, enveloped in an intense spiritual climate in the household of Mabel Dodge Luhan, he struggled to give visual form to the spiritual content of the natural surroundings. His lithograph *The Sacred Mountain, Taos* (1928; fig. 9) suggests its vigor and immediacy.

Even more simplified and abstract is Howard Cook's lithograph *Taos Pyramid*, which makes clear reference to the union of sacred geometry with the forms of Pueblo architecture. The artist has here tried out the role of cosmic geometer, once assigned to God. To medieval Europeans geometry was a divine activity; this concept inspired the architects of the great cathedrals. Now, far removed in time and space from the exquisite refinements of the Gothic

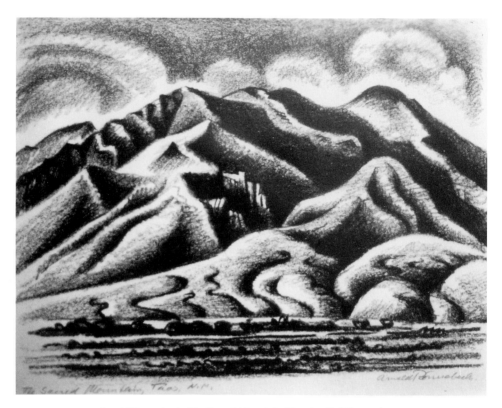

FIG. 9. Arnold Ronnebeck, *The Sacred Mountain, Taos* (1928), lithograph.
(Private collection)

style, artists in New Mexico could fuse its sacred concepts and numbers with
those of subsequent European mystics and the native peoples of the South-
west to produce new spiritual icons in the high desert.

These were big ideas—big to match the grandeur of the southwestern land-
scape. But they were not conceived parthenogenetically in the minds of these
disparate artists. The spiritual climate in certain areas of northern New Mex-
ico was as heady as its rarefied air. Most obviously, it was the circle of artists
and writers around Mabel Dodge Luhan at Taos who encouraged such think-
ing. Hartley, Lawrence, Brett, Ronnebeck, O'Keeffe—these were only a few
of the talented artists and writers she encouraged.[31] To some of them she
provided the initial exposure to concepts of Indian spirituality; the Pueblo
people, content with their oral tradition, lacked any written philosophical
discourse.

Influential individuals like Mabel Dodge did much to popularize the

myths and mysteries of Pueblo life. Her marriage to Tony Luhan, a Taos Indian, forged a lasting conduit between her artistic friends and her Pueblo neighbors. Herself a sophisticated veteran of the New York avant-garde, Dodge had immersed herself in exploring the newness of twentieth-century thought. Everything from radical politics to psychoanalysis interested her, and she had herself undergone Freudian analysis to unlock the secrets of her inner self. She could not fail to see the correspondences between Freud's id-ego-superego levels and the multiple states of being recognized by the Pueblo people. Like many other modernists, Mabel adhered to "cultural primitivism"—the belief that the Western world could be spiritually transformed by the "primitive" secrets of life. To accomplish this, the Pueblo culture must remain motionless at life's center.

In her 1925 essay entitled "A Bridge Between Cultures," Dodge explained that these "older brothers along the Rio Grande continue to live outside of time in a life of religious devotion." As Jackson Rushing has pointed out, Dodge believed that the Pueblo Indians possessed a secret doctrine passed down for millennia through certain races.[32] This doctrine, "the psychic key to Nirvana on earth," could be transferred from the Pueblos to the occidental world via a "bridge" or medium. Dodge became convinced that she was to be that bridge. She had been told by a New York mystic that great souls would be drawn to Taos, the center of a new birth of Western civilization.[33] And she promptly set about building a spiritual constituency that would preserve the Indian way of life while pointing White America toward a new utopian ideal. Within the shadow of the great sacred mountain at Taos, she spent decades working for that end.

Andrew Dasburg, called to New Mexico by Mabel Dodge in 1918, became the state's leading resident modernist painter. Beginning several years before he first visited the Southwest, Dasburg drew on the image of the mountain. His cubist-influenced *Sermon on the Mount* (1914–15; fig. 10) alluded vaguely to a spiritual content, though Dasburg preferred to regard it in more formal terms. After 1918 his abstracted landscapes of the New Mexico terrain often included the looming dark range of the Sangre de Cristos. In his last years Dasburg's landscapes—grown spare, reductivist, yet at the same time lyrical— revisited the subject of mountains (1979; fig. 11). Near the end of his life, in 1979, they took on a transcendent lightness: shapes hover, no longer anchored to the earth; solid form dissolves into limpid air. Matter has merged with spirit.

Outside the Luhan circle, other artists came independently to sense the power of the mountain. The celebrated American painter Agnes Martin,

FIG. 10.
Andrew Dasburg, *Sermon on the Mount* (1914–15), watercolor, 12 x 9 1/2 in. (Courtesy Permanent Collection, Roswell Museum and Art Center, Roswell, N.M.; gift of Mr. and Mrs. Donald Winston and Mr. and Mrs. Samuel H. Marshall)

FIG. 11. (*below*)
Andrew Dasburg, *Taos Mountain* (1979), lithograph. (Private collection)

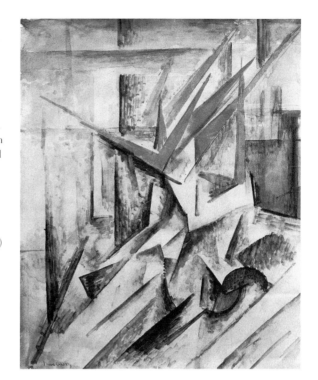

FIG. 12. Agnes Martin, *Landscape-Taos* (c. 1947), watercolor, 18 1/8 x 15 1/4 in. (Courtesy Jonson Gallery of the University of New Mexico; gift of Mercedes Gugisberg, 86.208.1)

whose serene minimalist grids are now her best-known work, settled for a long stay at Taos in the late 1940s. She too was struck by the visual power of Taos Mountain, which she painted with rays of light igniting its craggy peaks (fig. 12). In a style that owes something to the paintings John Marin had made of the Taos area in 1929 and 1930, Martin emphasizes the geometric patterning within land and mountains.

The power of myth to engage creative and thoughtful minds is clearly seen in a wide range of artistic and literary efforts produced in New Mexico. Some artists have fortified their forms or emotional instincts with anthropological information; others have superficially grafted such information onto currently fashionable styles. And still others have worked from inside, tapping into their own needs and into art's resurgent interest in reuniting myth with the most abstract conceptions of visual form. Painter Lawrence Calcagno put it this way:

In Taos I am drawn to the high country of New Mexico as one is drawn to his beloved. Remote and mysterious, challenging and uncompromising, the noble beauty and the deep spiritual aura which pervade this land shake me to my very roots and bring me face to face again with the risk of confrontation—with the immediacy of life and death. Of love and rebirth![34]

A motif like the sacred mountain, with its countless worldwide manifestations, mediates the conflict between historical awareness and an imagined universality of art. With its large-scale directness and its frequently geometric simplicity, the sacred mountain becomes a primal object, an Ur form. And as an expression of the continuing need to reintegrate mythical and ritual content with nature and with the origins of social life, it points to an even larger possibility: the reestablishment of coherent relationships, long ruptured, between sensation and idea, between nature and culture.

INTO THE
NEON SUNSET

A Look at the Sources and Significance
of Contemporary Cowboy Imagery

The scene could be Scottsdale, Santa Fe, or Dallas: the eyes of Luis Jimenez's epoxy bull flash with rage provided by red electric light bulbs.[1] Looking on coolly is Bob Haozous's stolid painted limestone Indian, called by the Apache sculptor *Last Great American Hero*. And opposite hangs a slick John Fincher still life of cowboy paraphernalia: boots, spurs, and bridle in an elegant arrangement of line and color. The imagined scene shouts of plastic macho, mock heroics, and an ersatz Old West mystique that never was, never could be. But the contextual surprises and haunting familiarity of the imagery demand that the use of regional, particularly cowboy, imagery now be looked at as something more than calculated nostalgia or as cashing in on the dollar-and-cents value of a highly marketable Wild West chic. The formal and technical accomplishments of the artists are, of course, reason enough for enjoying the work. And the current wave of enthusiasm for the trappings of the western cowboy has added impetus to the painting and sculpture while, paradoxically, obscuring deeper meanings behind the flashy facade erected by magazine critics and art-market taste makers. Americans, often accused of having little sense of their past, have always been able to replicate its veneer when the commercial signs are right. Who else could have created Disneyland?

But it must be clear to anyone willing to look beneath this smoke screen of camp and Pop-irony that within recycled southwestern imagery lies a

thoughtful, complex, and richly evocative substance. The artists themselves, for all their flippancy and glibness, recognize the opportunity and the dilemma they face: to manage and image the complexity of the modern world. But the added challenge—and the kicker for contemporary southwestern artists—is to do that using the "loaded" and specialized myths of times past.

Some have tried to explain the current spate of cowboy imagery as resurrected regionalism. Yes, admits John Fincher, "If you took this work to Los Angeles or New York it would be viewed as regional painting." But Fincher is careful to separate his own contemporary viewpoint from that of the "cowboy-and-Indian painters who cater to a type of nostalgia, documenting history after the fact, painting what they know little about because the time has gone."[2]

Fincher denies neither the appeal nor the success of that type of painting but clearly eschews the nostalgia-for-its-own-sake mode in favor of a style which recognizes that the innovations of modernist art have spawned an ocular originality that demands and informs an expression of its own. This treatment separates cliché from kitsch and melds any vestigial regionalism into a broader application to art and to the world at large. Fritz Scholder's cowboys and Indians are nearly as popular on both coasts as they are in the Southwest.

But, one wants to ask, if the art has transcended regional labels to become ingrained in mainstream American culture, why then is so much of it still produced in the Southwest? Perhaps the answer lies in the consideration that the Southwest remains as much a concept as a place, a concept that embraces the dreams, myths, and basic character of many of the American people.

Since colonial times, west has been the direction that for Americans connoted opportunity, freedom, and new beginnings. In the West, where vast open spaces swallowed up boundaries and rendered insignificant the dressed-up eastern world of appearances and social restraints, the cowboy epitomized an exuberant life of action. Virile and anti-intellectual, the cowboy was an authentic American hero in a distinctly American setting. Nineteenth-century American culture, straining for release from what were seen as enervating bonds with European tradition, made the cowboy a folk hero. And American artists, eager to sever ties with entrenched Old World academicism, saw in the Southwest a setting where an art true to place could develop. The cowboy became a hero to the artist too—a figure whose mythic bigness matched the vast openness of the sky and whose self-sufficiency challenged the desolate barrenness of the land. Like the cowboy, the artist in the Southwest has to survive through his own resourcefulness, trying to wrest from an obdurate landscape a solidity of sensation on canvas akin to the solidity of the terrain itself.

The pitfalls were many: the unbounded space and the dramatic contrasts of color and structure overpowered and disguised subtle nuances an artist must also find, while the clear air played tricks with distance perception. Painters complained that details were so sharp in the crystalline air that nothing seemed far off. Like mirages on a sunbaked stretch of highway, the southwestern landscape compelled and, as often as not, eluded the brush of the artist. He could identify easily with the mythic cowboy trying to tame a rugged land.

The cowboy's appeal was part romantic fiction and part history. Teddy Roosevelt, that inveterate Rough Rider, felt the nostalgic pull of cowboy life: "He [the cowboy] prepared the way for the civilization from before whose face he must himself disappear. Hard and dangerous though his existence is, it has yet a wild attraction that strangely draws to it his bold, free spirit."[3] The "wild attraction" is part of the romantic appeal of things exotic, primitive, and ineffable. Artists who came west in the early days sought an American counterpart to the color and exoticism of distant lands. Doubtless more than a few of them saw themselves as American Gauguins.

These days much of the color and wildness of the West has gone. Phoenix and Albuquerque are adolescent versions of Los Angeles, so raw and disjointed that they have no mature urban outlook, despite their burgeoning populations of transplanted eastern urbanites. Thus in these southwestern cities the competing urban-rural traditions are less clear-cut than elsewhere. The leveling, sometimes stultifying character of suburbia prevails.

Yet, even installed in the suburbs, the frontier cowboy-hero refuses to become obsolete. Indeed, as Marshall Fishwick, analyst of American cultural heroes, writes, "The cowboy may well have more influence as a social force now that his ethos has been destroyed than he did a century ago."[4] Clearly the cowboy answers a felt need in contemporary society. To a world hyped by kinetic information, television, drugs, and a sense of impending chaos, the cowboy—exhumed and refitted with an updated persona—reminds us that while the twentieth century's sheer velocity may have outrun many traditional values, there are those that survive. American pragmatism, optimism, individualism, and energy linger in the image of the archetypal cowboy. Solid and enduring, his image negates the drift toward planned obsolescence and an aesthetic based on impermanence. And if the cowboy symbolizes a frontier mentality that distrusts ease, contemplation, and the effete, another part of the cowboy myth (emanating from American folklore) allows for raw instinct, native intuition, exaggeration, and artifice—equally (and not incidentally)

essential to the artist—to surface. The part of the cowboy that is the hell-raiser, the boy who refuses to grow up and leave his world of fantasies, again overlaps the nonconformist, rebellious individuality a truly original artist must possess.

A century that has seen in its literature, politics, and popular entertainments the arrival of the common man and the outsider as heroes has allowed the outsider artist wider access to the public. Fifty years ago John Sloan, who for years summered in New Mexico, called American artists the unwanted cockroach in the kitchen of a frontier society. That is less true today, thanks to social changes that have to some extent erased the boundaries between art and life; to some extent, art has been brought down from its Olympian preserve into the realm of the quotidian. Artists, former acolytes of the High Art church, have thrust its symbols, myths, and images into the public arena. To be sure, there are those artists who still approach reverently the altar of Beauty, who equate verisimilitude and faithful narrative with art. For them, realism remains a moral imperative.

But other artists—those for whom the words "traditional" and "academic" are anathema—have mercilessly tested, reformulated, debunked, and discarded outworn artistic myths and modes. Style to these modernists must speak of the twentieth century. And heroes must now possess, in that overworked word, *relevance* to the modern era. I asked some contemporary southwestern painters who use cowboy imagery why that threadbare myth retains validity now. What does it offer an artist whose work has been touched, if not transformed, by an aesthetic whose most prominent feature is an out-of-hand rejection of the certainties of the past?

The modernist generally abhors the strictly narrative in art, concentrating instead on formal qualities that, carried to their ultimate conclusion, approach total abstraction and conceptual art. What then are artists whose concerns focus on line, color, shape, texture, mass, and void doing painting bucking broncos, sculpting old boots, and casting raging bulls?

Kirk Hughey is a Santa Fe painter who suggested some possible answers. Hughey's broad classical education and appreciation for mythology have brought him an unusual understanding of Old West imagery. For him, the cowboy provides access to the whole world of ancient myth and sources of the self. And as an artist Hughey feels lucky to be able to enter, through the images he creates, a whole mythic continuum extending from ancient heroes to their modern counterparts. Like Odysseus, the cowboy (and the artist, for that matter) is a self-styled adventurer who survives by his wits, who challenges

FIG. 13. Kirk Hughey, *Odyssey II* (1981), acrylic on canvas, 40 x 50 in. (Photograph courtesy the artist)

and subdues nature. It's a very Greek idea, explains Hughey, and a modern one as well. But what the ancient Greeks recognized, and what we have largely forgotten, is the residual power of myths. They are a way of identifying and managing chaos while retaining its potential power. Myths link humankind, individually and collectively, to something bigger, stronger, and more permanent than ourselves. And mythic heroes like the cowboy act out our fantasies and fears in the best Freudian-Jungian tradition.

Hughey translates his perceptions of myth into vivid painterly canvases, often of a horse and rider (fig. 13, *Odyssey II*, 1981). Being astride a horse enhances the presence and power of the human figure, as artists have known for thousands of years. In Hughey's painting man and animal are fused into an image that recalls the synergistic power of Marini's sculpted horses. The horse elevates, supports, and accelerates the personal power of its rider in an observable but at the same time mystical fashion best understood by artists and

cowboys. There must be an acknowledgment too of the sexual aspects of the subject, as when Hughey paints a female bull rider. The impact is powerful, whether we see her as the mythical Europa astride Zeus or as a rodeo queen. In fact, Hughey's inclusion of women is somewhat unusual within the misogynous realm of the cowboy, whose horse—not his woman—is essential for survival.

Hughey's riders, in true mythic style, are faceless; they suggest not only the southwestern cowboy, but other centuries and other horsemen who have ridden the earth. Ironically, this faceless cowboy hero while representing an exploration of personal freedom, has become a composite type rather than an individual. He is John Wayne, Teddy Roosevelt, Billy the Kid, Buffalo Bill, and Ronald Reagan. Or he is the artist himself. "You are painting your life," says Hughey; "you can't avoid it." And that is a risky business, like being a cowboy. Painters and cowboys (even mythic ones) *are* what they *do* more than most other people. So much self is involved in the work (and the myth) that success or failure as a person is virtually one with prowess as cowboy or artist.

Hughey's recognition of the sources of his painted cowboys adds a metaphysical dimension to his work. And to enhance the effect, he aims for a structural-formal nexus within the painting which will prompt the viewer to see more than paint on canvas. Color, in carefully measured doses of brights and neutrals, is a catalyst. It sets up a chromatic action counterbalanced by close attention to structure. Hughey wants to achieve an equilibrium of the intuitive and the ordered within his work. He acknowledges the simultaneous need for clarity and controlled chaos, the salient characteristics of myth and art.

We talked about the appeal of the machine age for the artist, and about the new heroes it has created. The astronaut, for example, is perceived as space pioneer, scientist, patriot, and consummate adventurer. Why has this modern Apollo not replaced the homely cowboy as America's archetypal hero? Hughey speculated that part of the reason might be a widespread perception of the astronaut as an integer in a military-industrial complex that intimidates us all. Solitary and serene in space, on earth he loses the magic of the voyage. He is a product of a technology touted as the doorway to new worlds and new freedom, but which has not invoked a brave new world. Instead, it brings us repeatedly to the brink of self-destruction.

Besides its ominous potential for damage to society, the dehumanizing character of unbridled technology threatens the individual as well. Allowances for the vagaries of individuals are antithetical to machine efficiency.

And art, that indecipherable activity of the Dionysian side of humanity, does not yield its secrets to the scientific method. Thus is not to say that artists have not found machine forms beautiful and compelling. Many twentieth-century artists, from the Bauhaus to broadly representative photographers, painters, and sculptors, have felt and expressed a new aesthetic born of the machine. But for the most part these have been formal appreciations, urban-inspired. For artists in the Southwest the machine has never rivaled the land or the local inhabitants as subject. There seem to be two reasons for this. One is the overwhelmingly self-assertive character of the landscape, which demands to be met on its own terms. The other is the resistance of most southwestern artists to a hard-edge mechanomorphic aesthetic born of industrialism and, more recently, of minimalist reductivism. In the Southwest ubiquitous organic forms seem to satisfy reductivist proclivities at a more immediate level. Those, like Georgia O'Keeffe, who have here sought purity of line and clarity of form generally have found it in the clean organic shapes present in the land.

And the mythic cowboy, natural as the wind and the grass, is a simplistic antithesis to the moral complexity of the present. As an essentially unilinear hero, he knew right from wrong with a certainty almost unknown to a modern world shaded in grays. Alexander Miller explains the residual longing among Americans for vanished moral absolutes:

> If just once I could stand in the dust of the frontier main street facing an undubitably bad man who really deserved extermination, and with smoking six-gun actually exterminate him—shoot once and see him drop. Just once to face real and unqualified evil, plug it and see it drop.[5]

For better or worse, exterminating "real and unqualified evil" with a smoking six-gun is as anachronistic today as the vision of rabidly realist cowboy painters who gaze nostalgically backward at the last century. But southwestern painters with their eyes on the present see that the cowboy has worked his way down from myth to romance to irony. These artists have been able to reinvent his image as part of a comprehensive overhaul of reality in modern art.

John Fincher's paintings demonstrate his receptivity to the old and new ironies inherent in his subjects—an unctuous, deliciously tactile painting of thorny cactus, for example. Like one of his artist-heroes, Wayne Thiebaud, Fincher celebrates the sensuous quality of vivid paint, juicily applied. But Thiebaud's famous painted pies and cakes sustain the tactile invitation.

Fincher's cacti, sharp knives, and spurs impose an oxymoronic dilemma: they are touchable but dangerous (Plate 3; *The Ring, Heart and Knife, Part 2*). This psychological barrier goes way beyond what used to be called "aesthetic distance," and Fincher—canny former teacher that he is—relishes the eye-stopping dualism he has created. "I do enjoy the tension," he explains, "of people wanting to touch the work . . . but this thorny, spiky element keeps them from doing it."

This overt discord between medium and subject is reminiscent of Claes Oldenburg's 1960s soft sculptures of hard objects, like typewriters and drum sets, that served (like Fincher's painted images) as metaphors for the human body. Fincher shares with the Pop artists some other techniques for arresting attention: brilliant color and objects blown up enormously, then cropped and brought uncomfortably close to the surface as in a cinematic closeup.

Although Fincher does not paint the cowboy as such, he explores the figurative aspects of, for example, the prickly pear cactus he paints. Their animation and built-in gestural qualities suggest life and movement. Seen as an ideogram, the cactus is very like our prototypical southwestern cowboy: tough, weather-hardened, ascetic, truculent, rather antisocial, defensive. Fincher's oversize anthropomorphic spur, as Bill Peterson has pointed out, is another painted synecdoche for the mythic cowboy (fig. 14, *Stalking Spur*).[6]

To someone who wants to find them there, Fincher's paintings are rich in symbolic meanings; his works have been called icons of the Southwest. They are also subject-matter clichés, but deliberately so. Fincher is keenly aware of the challenge of giving a freshness of immediate sensation to a tired subject. Like Cézanne, he wants to render a solid sensation while at the same time investing the image with a newness or "nowness."

Beyond their relationship to the Pop-art tradition, Fincher's subjects are part of his own background. Growing up in the Texas ranch country, Fincher had a firsthand acquaintance with the cowboy mystique. But the familiar trappings of the cowboy hold no intrinsic magic for Fincher now. Rather, the very triteness of boots, spurs, and ropes allows him to see them as commonplace still-life objects. Working directly from objects carefully arranged in his cleanly ordered studio, the artist belies the explosive color and handling often present in his paintings. A pair of soft leather chaps hanging languidly on a wall is another of Fincher's understated metaphors for the human form. Both literally and figuratively they are skin—soft, tactile, flaccid—but subjected to the artist's tour-de-force light and revved-up color they acquire a vigor and life of their own.

FIG. 14. John Fincher, *Stalking Spur* (1981), oil on paper, 30 x 22 in. (Courtesy Shidoni Foundry and Galleries; photograph courtesy the artist)

Concentrating on surface and process, Fincher gladly leaves to others whatever symbolic meanings they may find in his work. To interpret his own paintings, says Fincher, would be to abandon a certain self-imposed innocence or naïveté that, once dissected, would be impossible to restore. Asked about the

significance of the cowboy myth in contemporary society, Fincher allows that its roots lie deep within the American character, feeding upon generative American traits like optimism and pragmatism. Beyond that, however, he prefers not to overanalyze the myth or its personal significance, returning always to his overriding love of surface and paint.

Another artist who extrapolates the cowboy image from its matrix of kitsch and subjects it to formal surprises is Fritz Scholder. Best known for his Indian paintings, Scholder lists the cowboy and the woman as two of his other favored subjects. But, in an attitude that parallels Fincher's, he ranks all subjects below his concern with form and color. Unlike Fincher though, Scholder deals directly with the cowboy figure, which he sometimes paints as aggressive and potentially violent, as in *Portrait of a Cowboy*. At other times Scholder's cowboy is swift, faceless, caught only momentarily on his mythic cross-canvas voyage (Plate 4; *Horse #1*).

Scholder's fast painterly style and bold color underscore the potential violence inherent in the subject—a trait that, not incidentally, is also deep seated within the American character. The cowboy's shoot-'em-up style provides an avenue of acceptable violent behavior closed to most Americans but all too apparent in the high incidence of violent crime in our society. Much more than the modern policeman or soldier, the cowboy was a law unto himself, to whom violence was a frequent means of settling differences or getting what he wanted. Scholder clearly recognizes the tension of latent violence held in check but ready to explode. Formal tensions heighten the emotive impact of Scholder's painting, forcing the viewer to confront a visual immediacy that, like its social content, is deeply disquieting. These are not merely loaded images; they are overloaded.

Less disturbing than some of Scholder's dangerous cowboys are the tongue -in-cheek western images created by Luis Jimenez Jr. Growing up Hispanic in El Paso, he learned to interweave tales of the Mexican Revolution with popular conceptions of the Texas cowboy. Working in his father's sign shop, Jimenez absorbed the techniques and—though he minimizes this influence —the design elements of commercial art. The ability to execute on a large scale with strong design impact and a craftsmanlike attention to materials are residuals from that early training. Jimenez's further training in architecture is also evident; he can translate an image effectively into a sculpture that relates both to the scale of the viewer and to the space the piece will inhabit.

Jimenez's artistic heroes include the Mexican muralists, whose formal strength and social concerns have affected him, and Thomas Hart Benton,

preeminent American regionalist painter, whose rhythmic composition and interest in human muscle organization seem present in Jimenez's work. But unlike Benton, who wanted to turn back the clock to a simpler time, Jimenez's materials and Pop-ironic approach place him very much in the present. He may know, for their nostalgia value, subjects from the past, but these he renders in materials that poke fun at any lingering sentimental banalities. Who could lament the passing of an electrified epoxy cowboy? Jimenez's versions of the *End of the Trail (With Electric Sunset)* (Plate 5) expose the bathetic in the overworked myth of the Noble Savage and, like Fincher's southwestern icons, set up a deliberate incongruity of form and subject. Is Jimenez telling us we are a national case of arrested mythic development?

For myths do develop, and must change to suit the times and the character of their participants. In a society like ours, heroes can come and go as quickly as the current baseball season; fame is often as empty as it is carelessly bestowed. Little wonder then that we are so often disappointed in our heroes of the moment who, once elected or dissected, prove to be all too mortal and vulnerable. They are not, as we hoped, made of some special stuff that allows them to be better than the best in ourselves. When we elevate a contemporary to the status of hero, we ask too much. Like the ancient Romans, we expect a hero to conform to his own biographical archetype, to maintain indefinitely and artificially a heroic stance impossible to sustain. And we, like the Romans, find that our heroes are irremediably human; they cannot survive their own apotheosis from man to superman, and at some point let us down. Sherwood Anderson knew this when he wrote, "Oh, how Americans have wanted heroes, have wanted brave, simple, fine men!"

Well, if these heroes do not exist among us, perhaps we must look elsewhere—to our own mythology, for example. If we divest our heroes of their obligation to be literal and incarnate we can, like those wiser Greeks, make our heroes mythological metaphors for whatever we will. If we could re-mythologize our thinking—become a little less Roman, a little more Greek—we would not be disappointed so often.

Actually, these mythic American heroes already exist. The cowboy, as we have seen, is an authentic amalgam hero, expressive of past and present in this country. Long a repository of collective dreams and perceptions of ourselves, the cowboy, like all nourishing myths, lives on. He is periodically recycled and refurbished, sometimes with an updated persona, but always as a metaphor-bearer of power and directness. After all, the power of the gods is invoked through repetition of ritual; we are slow to tire of stereotypes. Emerson

suggested that the most salient characteristic of the heroic is persistency. He might have been describing the whole cowboy–Wild West mythic complex.

The avenues for creating and sustaining cultural myths have long been the art and literature of any society. We acknowledge that artists and writers are generally more sensitive than most of us; they are better able to translate into words or visual form their own perceptions and, by extension, to mirror society in general. Modern art has been chided for its occasional abandonment of meaningful subject matter. What is left, say its detractors, serves only as a garniture for prevailing aesthetic or formalist theories. But twentieth-century artists, like their predecessors, can hardly fail to reflect their environment, whether that be a conscious goal or a mere by-product of their work. The southwestern artists who have chosen to shift "regional" imagery into a contemporary mode have generally done so with a respectful understanding of the richness of their subjects, in both mythic content and visual possibilities. But as true children of this century, they have taken cowboy imagery, comfortable as old leather boots, and tested it against the attitudes and ironies of the here and now. If they can avoid the pitfall of confusing fashion and art, the result becomes a barometer of our own society: alternately despairing, hopeful, neurotic, disquieting, cliché-ridden, and—yes—heroic.

The contemporary artists of the Southwest, despite the temptations of ephemeral chic and the fast buck, have been able—at least the best of them—to invest the already loaded image of the cowboy with a visual excitement and mythic significance that carries it far beyond regional labels. Who says cowboys are kid stuff?

THE IRRESISTIBLE
OTHER

Hopi Ritual Drama and
Euro-American Audiences

No one knows how long the Snake Dance ritual has been performed at the mesa-top Hopi villages in northern Arizona.[1] Buried in prehistory, its origins long precede written records. But as part of the cycle of ritual dramas intended to benefit the Hopi people through weather control, fertility, and health, the Snake Dance speaks of collective needs both ancient and perennial.

Sixteenth-century visitors to the Southwest recorded ceremonies that may be antecedents of the modern Snake Dance. Both Hernan Gallegos in 1581 and Antonio de Espejo in 1582 reported seeing rattlesnakes used in rain dances in central and southern New Mexico.[2] But material evidence suggests that Snake Dance origins among the Hopi may go back well beyond the period of early Spanish contact. University of Chicago anthropologist Elsie Clews Parsons conjectured in 1940 that the design of a fourteenth-century Jeddito bowl represented a Snake Dance subject.[3]

It was Parsons, in her *Pueblo Indian Religion* (1939), who posited a relationship between ritual and creativity among the Pueblo. In an effort to control the unpredictable forces of nature, she wrote, Pueblo arts employed "poetry and song, dance and music and steps, mask, figurine, fresco and ground painting, beautiful featherwork, weaving and embroidery [as] measures to invoke and coerce, to gratify or pay, the Spirits."[4]

In ritual dramas such as the Snake Dance, a rich orchestration of color and

43

rhythm echoes the larger rhythm of nature that governs the Hopi cosmos and, indeed, their whole existence. Each season and its attendant ceremonies address certain communal needs, with the summer ceremonies largely devoted to the perennial need for rain. Anthropologist J. Walter Fewkes described the Snake Dance as "an elaborate prayer for rain, in which the reptiles are gathered from the fields, intrusted with the prayers of the people, and then given their liberty to bear these petitions to the divinities who can bring the blessing of copious rains to the parched and arid farms of the Hopi."[5]

Much of the ritual Snake Dance activity has always been closed to outsiders. The first eight days of the nine-day ceremonial were private, reflecting the widespread Pueblo ambivalence toward strangers in cosmic or tribal space and the possible introduction of evil accompanying their presence.[6] It is not possible to discuss complex implications of Hopi epistemology here, except to note that historically such questions of openness and secrecy have been central, but at the same time unresolved and often unenforced, among the Hopi.

At Walpi, the First Mesa village where the Snake Dance was long performed during odd-numbered years, private ritual activity centered in five rectangular kivas built into the rock. Entered by ladders from above, these kivas were usually, but not rigidly, off limits to Euro-American eyes and cameras.[7] For most visitors, the mystery surrounding the rites only enhanced their appeal. They focused their curiosity on the ninth, or public, day of the performance. Toward the end of the eight-day private period visitors began to arrive—a trickle before 1890, in later years a flood—to witness, discuss, sketch, photograph, and record rites unlike those performed anywhere else in the United States.

Most did not mind the long, jolting wagon ride over the seventy or eighty miles of corrugated roads leading from the rail points at Holbrook, Winslow, or Canyon Diablo, Arizona. After the turn of the century, when roads improved somewhat, intrepid motorists drove their cars the greater distances from Phoenix, Albuquerque, Santa Fe, or Taos. They camped below the villages, seeing what they could of the snake-gathering, waiting for the public culmination of ritual activity.

The appeal of the Snake Dance for late-nineteenth-century Americans is not difficult to understand: accompanying the disappearance of their own vanishing western frontier, Euro-Americans glimpsed the coming demise of the much-romanticized Indian. By 1890 his geographic containment by white political authority had already produced a tamer West, an expanded arena for

the exercise of white territorial ambitions. But it was also a diminished West, whose excitement, exoticism, and dangers were swallowed up in the web of rail lines and roads flung over it. Year by year its openness and imagined freedom receded, until only vestiges of its former wildness remained.

Scholarly and Scientific Accounts

Because of their relative isolation, untainted by sustained Euro-American contact, the Hopi and their ceremonials were widely regarded by scholars and artists as unbroken links to an ancient past—a past that anthropologists like Fewkes and Adolph Bandelier were trying to reconstruct. But beyond their historical appeal, remote and ancient ceremonials like the Snake Dance allowed early artists and ethnologists to glimpse cultural features so exotic that they could not be forced into an Anglo-Saxon mold. Fewkes, reporting on preparations for the 1891 Snake Dance at Walpi, commented on the attraction of the rites as exotic spectacle. In language that reveals the nearly ubiquitous ethnocentrism of his day, he recalled:

> The sight haunted me for weeks afterwards, and I can never forget this *wildest of all the aboriginal rites of this strange people*, which showed no element of our present civilization. It was a performance which might have been expected in the heart of Africa rather than in the American Union, and certainly one could not realize that he was in the United States at the end of the nineteenth century [emphasis added].[8]

Fewkes was by no means the earliest Euro-American visitor to record the Snake Dance; many outsiders, of diverse backgrounds and purposes, had preceded him to Hopi. Following an 1879 notation in *Masterkey* (perhaps the first written mention of the Snake Dance in modern times), word of the Snake Dance spread among the scholarly community. Many felt curious enough to make the long trek to see it for themselves.[9]

In 1881 Philadelphia artist Peter Moran (1841–1914) witnessed the Walpi Snake Dance with a party led by Captain John G. Bourke. This army expedition, sent to investigate ethnological aspects of the Pueblo Indians, resulted in Bourke's well-known book *The Snake Dance of the Moquis of Arizona* (1884).[10] Bourke notes that Moran made sketches "of everything of interest seen on our trip." Moran's *The Snake Dance, Walpi, Arizona* (fig. 15) made

The Smoke Dance.
Walpi

during that or another of his several trips to Hopi, records in pencil and watercolor the artist's reaction to the ceremony.[11] With a facility growing out of long practice, Moran rapidly put down four dancers in different aspects of the ritual. On the larger, left-hand figure he included details of the costume, enlarging elements such as the turtle-shell knee rattles and the feathered snake "whip." Written marginal notes tally the numbers and function of other ritual participants. Clearly, Moran's intent was primarily ethnological; he wanted to record as much as he could, both rapidly and accurately, of the visual drama.

But Moran's sketch (whether from 1880 or another year) did not go into the Bourke volume. Instead, Bourke used illustrations by another member of the party, Sgt. Alexander F. Harmer (1856–1925), who had studied at the Philadelphia Academy of Fine Arts. Since we cannot precisely date Moran's sketch, Harmer's illustration, dated August 12, 1881, may thus qualify as the earliest visual record of the Snake Dance (fig. 16).

Into one illustration Harmer has massed a great deal of visual information, crowding the Walpi plaza with dozens of dance figures (adults and children), onlookers, and animals. Harmer compressed the visual depth of the site, placing the mushroom-shaped snake rock, the kisi or bosque (a conical enclosure of leafy saplings wrapped by hide, where the snakes were kept just prior to the dance), and the dancers much closer together than they appear in contemporaneous photographs. By doing so, he was able to make his figures of relatively similar size, with nearly equivalent visible detail. Harmer added dozens of Indian observers, who look on from vantage points on walls, roofs, or along the perimeter of the plaza (these he could have drawn at leisure before the appearance of the Snake Dancers). Bourke estimated that perhaps 750 persons (including only a half-dozen Anglos) assembled for the Walpi Snake Dance that August day in 1881.[12]

Besides his collective view of the ceremonial, Harmer also prepared illustrations of some of its individual participants. His *Dancer Holding Snake in Mouth* (fig. 17) is attired in full dance regalia: from shoulder bandelier to turtle-

FIG. 15. *(opposite, top)* Peter Moran, *The Snake Dance, Walpi, Arizona* (c. 1880), pencil and watercolor on paper, 12 1/4 x 9 1/4 in. (Courtesy Permanent Collection, Roswell Museum and Art Center, Roswell, N.M.; gift of Senator Clinton P. Anderson)

FIG. 16. *(opposite, bottom)* Alexander F. Harmer, *Snake Dance of the Moquis. Pueblo of Hualpi, Arizona, August 12th, 1881.* (Original source, John G. Bourke, *The Snake-Dance of the Moquis of Arizona* [1884], plate 2)

FIG. 17.
Alexander F. Harmer,
*Dancer Holding Snake
in Mouth.* (Original
source, John G. Bourke,
*The Snake-Dance of the
Moquis of Arizona* [1884],
plate 14)

shell knee rattle, to fox skin and body paint, the dancer—with requisite snake
in his mouth—presents a complete picture.

For early artist-illustrators like Harmer and Moran, the rush to record ac-
curate details would have necessitated frantic sketching; the Snake Dance
itself lasted only forty-five minutes or so. That Harmer was able to produce
more than a dozen illustrations of various aspects of the snake ceremony is a
tribute to his rapid, disciplined draftsmanship. But like Moran, he also made

careful notes, which later enabled him to transcribe sketches and descriptions into highly finished oils and watercolors.[13]

Serenely confident of their right as government-approved "scientific" observers to make a visual record of all aspects of the ceremony, it would never have occurred to Moran, Harmer, or Bourke that there was anything improper about their activities at the Snake Dance. In the absence of objections from the Hopi themselves, they saw no reason to limit their investigations. Soon they pressed their inquiry even further. When Moran returned with Bourke to the Walpi Snake Dance in 1883, the two were permitted to spend some hours before the public ceremony in two of the estufas (ceremonial kivas) where Snake Dance altars had been set up. Moran later painted two of these altars, probably based again on careful notes he made that day. The precision of his own verbal description suggests that, even without on-site sketches, he would have had no trouble in preparing his later paintings. These were finally reproduced ten years later, along with Moran's description, in a government census report:

> We left this estufa after half an hour's visit and visited another one, and found therein only 1 person, an old man at work; here we found another altar about the same size as the one before described but different in design and color; the center was a gray ground, the upper portion of which had a series of circles running together and colored yellow, green, red and white; these represent clouds from which are coming 4 snakes, representing lightning, yellow, green, red and white. This center is surrounded by 4 bands of color, the same as snakes and clouds, as 3 sides of this square are. As in the altar before described, there were small sticks stuck into balls of mud and surmounted by corn, feathers, and the down of eagles or turkeys dyed a bright red. This was surrounded by a broad band of gray color; in the center and upper portion of this band were 4 stone implements, hammers and axes.[14]

When Fewkes attended the 1893 Snake Dances at Walpi, he brought with him artists Julian Scott and Fernand H. Lungren. Scott, whose experience as a special agent for the 1890 U.S. Census had given him much experience in the careful verbal description of Indian life, was a seasoned visual recorder as well. His colored plate of dancers at the 1893 Walpi ceremonial (fig. 18) accompanied the publication of Fewkes's account. Scott's painting is fluid, yet precise in its rendering of detail. The costumes of the snake priests, shown

FIG. 18. Julian Scott, *A Group of Snake Dancers, Walpi Pueblo, Hopi, Arizona* (1894), water-color. (Photograph courtesy Museum of New Mexico, Santa Fe; negative no. 149718; original source, J. Walter Fewkes, "The Snake Ceremonials at Walpi," *Journal of American Ethnology and Anthropology* 4 [1894])

from both front and rear views, are accurate down to the placement of hand on the shoulder and position of the snake's head in the V-shaped opening of the feathered "snake whip." At the right, Scott's unmistakable rendering of the snake rock confirms the location as Walpi.

Such early Snake Dance illustrations were prized as visual documents to accompany ostensibly objective ethnographic records. Yet the accounts were often tinged with Eurocentric bias: Bourke's book was subtitled *A Description of the Manners and Customs of this peculiar People, and especially of the revolting religious rite, the Snake-Dance.* But as attitudes toward Native Americans began to change, the terminology of the accounts and the visual interpretations changed as well. A growing cultural relativism was beginning to find in Native lifeways certain superior values antithetical to the consuming Anglo notions of progress and capitalism.

Now cast in a more positive light, the "wildness" and "primitivism" of tribal

life invited scholars (as well as artists and writers) to discard such adjectives as "peculiar" and "revolting" and to invent, instead, a new poetics of the exotic. Sociologist Mary Roberts Coolidge, who visited the 1913 Snake Dance at Walpi, expressed this view of the Pueblo people: "Their clear, brown skins, their quiet voices, their simplicity and reticence and dignity, their astonishing endurance, are a sharp contrast to our haste, excessive energy and restless search for novelty."[15]

Popular Accounts

But the appeal of the Snake Dance soon reached beyond scholarly circles, entering the American imagination through the fine arts and popular literature. To Hamlin Garland, the keen and sympathetic observer of Native American life at the turn of the century, the Snake Dance represented "the most complete survival of the olden days to be found among American Indians."[16]

Just whose "olden days" they were did not seem to matter much. The "discovery" of the Snake Dance coincided perfectly with an accelerating American search for an authentic national identity. Hungry for a cultural past distinct from that of Europe, Americans had begun to look for one among the indigenous peoples of their own continent. Onto ancient American roots (surviving visibly in Native American ceremonials like the Snake Dance), Euro-Americans began to graft their aspirations for a noble past.

At once exotic and authentically American, the Snake Dance (already valorized by the scholarly community) was ripe for appropriation—and frequent exploitation—by popular image makers. The scores of painters, photographers, and illustrators who began to flood into the Snake Dance plazas fed the curiosity of a distant public, most of whom would never see the dances personally.

Beginning about 1882, wide-circulation magazines, often illustrated with woodcuts and chromolithographs, carried stories of the Snake Dance. Trader Thomas V. Keam's account appeared in 1883 in *Chambers's Journal*, and Bourke's well-illustrated volume was widely reviewed in newspapers and popular journals following its appearance in 1884.[17] *Saturday Review*, in an extravagant exercise of American culture-boosterism, linked the Snake Dance to distant classical prototypes: "Athens, like a Moqi village, was accustomed to the spectacle of dancers waving snakes in the midday streets."[18]

Over the next decade the major newspapers of the United States carried

stories about the ceremonies: Chicago, New York, Washington, San Francisco, Los Angeles, Philadelphia, St. Louis, Cincinnati—all ran accounts, often sensationalized, of the Snake Dance.[19] They speculated on its dangerous, "primitive" aspects: How often were snake priests bitten? Did they possess an antidote? Had the snakes been de-venomized before the ceremony? Why were emetics used at the end of the dance? Since even scientific accounts of those years carried conflicting interpretations of these aspects of the ritual, it is little wonder that the popular press seized upon every exotic detail and embellished at will.

Snake Dance Photography

Once painters, illustrators, and photographers began visiting the Hopi villages, a steady stream of visual representations flowed from their brushes,

FIG. 19. Henry F. Farny, *Snake Dance of the Moqui Indians.* Illustration for *Harper's Weekly* from a photograph by Cosmos Mindeleff, 1885. (Photograph courtesy Museum of New Mexico, Santa Fe; negative no. 85574)

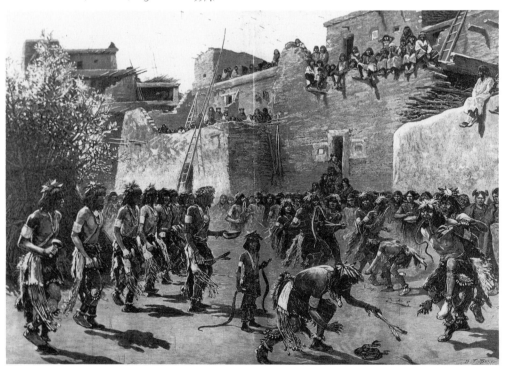

pens, and darkrooms. Starting about 1883 photographs of the Snake Dance had been made by Ben Wittick, then by W. Calvin Brown of Albuquerque (1885), and by Cosmos Mindeleff of the Smithsonian Institution (1885).[20] From Mindeleff's photographs, Cincinnati artist Henry F. Farny (who never visited the Southwest) created a full-page illustration for *Harper's Weekly*—the first such visual representation to appear in a magazine of national circulation (fig. 19).[21] Clearly feeding the appetite of its readers for action and excitement, the *Harper's* illustration intrudes unapologetically into the midst of the Snake Dance. With dancers arrayed on all sides, Mindeleff's camera-eye, mediated by Farny's pen, brings the viewer within inches of dangerous snakes. Safe at home in one's armchair, Farny's viewer can almost taste the dust, feel the thud-thud of padded feet, and savor, vicariously, the adventure of the Snake Dance. By contrast, Harmer's illustration, only four years earlier (fig. 16), is orderly, closed, and sedate.

Between 1885 and 1913, thousands of photographs were made of the ceremonials at Hopi. Besides the Snake Dance, the year-round Hopi religious cycle includes the Bean, Flute, and masked Kachina ceremonies. Though not the most important to the Hopi, the Snake Dance—in part because of its summertime occurrence, in part because of its vaunted danger and excitement—attracted the largest number of spectators. "From the 1890s on," writes William Truettner, "the Snake Dance was the most frequently described and photographed Indian ceremony in the Southwest."[22]

Near the close of the century the Santa Fe Railway, which had much to gain by promoting rail travel to the Southwest, saw an opportunity to stimulate tourism and to inform its passengers about excursions reachable from the Arizona stops along the way west. The Chicago-based railroad commissioned scholar Walter Hough to produce a volume titled *The Moki Snake Dance* (1898). Illustrated by sixty-four half-tone illustrations, the fifty-nine-page booklet reached printings totaling some fifty-five thousand by 1903. The text itself, described as "a popular account of that unparalleled dramatic pagan ceremony of the Pueblo Indians of Tusayan, Arizona," drew on the scholarly work of Fewkes, with much supplemental information provided by Hough.

To illustrate the railroad volume, Hough chose photographs of nearly every aspect of the snake ceremonials, including some made within the kivas. Photographs by Adam Clark Vroman, John K. Hillers, F. H. Maude, Rev. H. R. Voth, and George Wharton James were among those represented in Hough's volume. Vroman and James were members of the influential Pasadena Eight, whose widely reproduced photographs document both California history and

the Indian tribes of the Southwest. For the most part, their careful, objective photographs of Pueblo life complemented the patient work of the anthropologists. With the scholars, and with their painter-illustrator colleagues, the photographers shared a sense of recording a rapidly vanishing rite. Following the 1901 Walpi Snake Dance, James predicted, "It will not be long before one can write a learned and accurate paper from the standpoint of the scientific ethnology on the change in religious ceremonies owing to the camera."[23]

Based on the sheer number of photographs taken by the turn of the century, James's statement was plausible. Whether professional or amateur, the camera-wielding Snake Dance visitors increased annually, in numbers and boldness, until few ritual secrets remained unphotographed. By 1901 the hordes of invading spectators, painters, and photographers threatened to impede performance of the rituals. James described the overeager photogra-

FIG. 20. George Wharton James, *Snake Dance at Oraibi* (c. 1900). (Photograph courtesy Southwest Museum, Los Angeles, photo no. 36496)

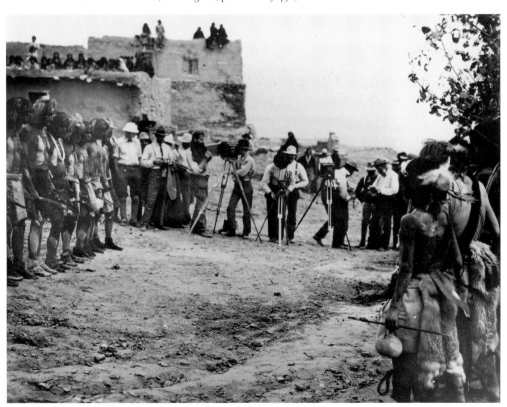

phers: "Every man had chosen his own field, and moved to and fro wherever he liked—in front of his neighbor or someone else; kicking down another fellow's tripod and sticking his elbow in the next fellow's lens." James's photograph made at Oraibi (c. 1900; fig. 20) gives a glimpse of the concentration of Snake Dance photographers at the turn of the century.

What James did not address were the potentially negative effects of so much camera intrusion into the ritual. But local officials could scarcely ignore the camera free-for-all. Recognizing that potentially disruptive documentation must be controlled, they decided, in about 1901, that "the photographers present—and they were legion—must be kept within a certain line, and that no one without a camera would be permitted in their preserves."[24] Photographs made after 1900 sometimes show the roped-off area for photographers.

Competing with James and his fellow still photographers for prime vantage points at the 1901 Walpi Snake Dance was a new breed of image maker. That year, for the first time, the ritual was recorded on motion picture film by one of Thomas A. Edison's motion picture crews.[25] A few years later Edward S. Curtis brought his own movie cameras to film the Hopi rituals.

Engaged in his monumental study *The North American Indian*, Curtis had begun to visit Hopi in 1900 and continued to do so every few years until the early 1920s. Working at Oraibi in 1904 and 1906, Curtis first recorded moving Snake Dance sequences. In the latter year he also made still photographs, which appear with those from other years in volume 12 of his massive work. There Curtis reproduced more than a dozen Snake Dance subjects copyrighted between 1905 and 1921. His introduction to volume 12, prepared for its 1922 publication, speaks wistfully of a simpler Hopi past—as if his own intense photographic activity had not contributed to its disappearance: "There is a subtle charm about the Hopi and their high-perched homes that has made the work particularly delightful. This was especially so in earlier years, when their manner of life indicated comparatively slight contact with civilization."[26]

It was, in fact, the abuses by photographers that led to severe restrictions on Snake Dance photography beginning in 1913. In that year the crowd numbered many hundreds at Walpi. Besides the usual compliment of the curious, there were some distinguished visitors in the audience that year. H. F. Robinson's photograph (fig. 21) isolates two of them: the large man, halfway up, in the white shirt and bow tie is Arizona's first statehood-era governor, W. P. Hunt. Next to him, leaning forward to speak to his son, is former president Theodore Roosevelt, intrepid outdoorsman and western enthusiast.

Unintentionally, Robinson's crowd photograph also captures, in the second

FIG. 21.
H. F. Robinson,
*Audience at Snake
Dance, Walpi Pueblo,
Hopi, Arizona, August
21, 1913.* (Photograph
courtesy Museum of
New Mexico, Santa
Fe; negative no.
37114)

row from the top, a movie camera. Luke Lyon notes that an edict that year from the commissioner of Indian Affairs in Washington had prohibited Snake Dance photography for commercial use. But when the local Indian agent, Supt. Leo Crane, arrived at Walpi that August day, he found two unauthorized movie crews. Crane promptly demanded written promises that their films would be used solely for historical documentation. One crew complied; the other sought to evade such restrictions. Their filming completed, the second crew attempted a nighttime escape through the rough country of the Hopi and surrounding Navajo reservations.

Whether due to Hopi imprecations or because violent thunderstorms often occur in the August rainy season, the furtive crew was soon stranded by flash-flooded arroyos. In short, as Lyon relates, they were summarily arrested and their film confiscated. Thoroughly piqued at the flagrant disregard of his partial ban, the commissioner pronounced an even sterner edict. Thenceforth, no photographs—whether "still, animated or out of focus"—would be permitted at the Snake Dance. This is not to say that photography at the Snake Dances ceased at once and altogether. A considerable number of photographers circumvented the restrictions into the 1920s, when stricter enforcement finally reduced the production of images.

Because many painters relied on photography as an aide memoire, they too were affected by the ban. But a significant number of paintings had been completed before the prohibitions began. E. Irving Couse (1866–1936), a New York painter who began to summer at the art colony in Taos in 1902, had a longstanding interest in the American Indian. In 1903 he spent some six weeks at Hopi, photographing and making oil sketches of the villages and the Snake Dance. The day after the Walpi public ceremony, Couse persuaded one of

FIG. 22. Eanger Irving Couse, *Moki Snake Dance* (1904), oil on canvas, 36 x 48 in. (Photograph courtesy Anschutz Collection, Denver)

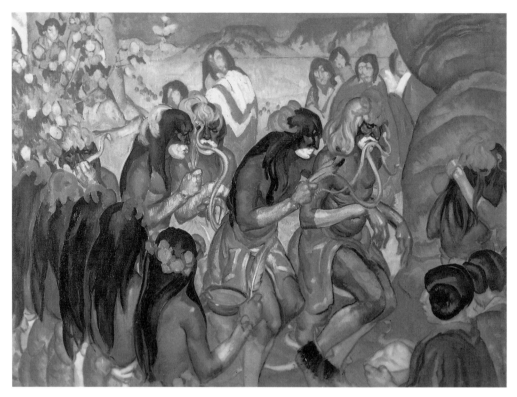

FIG. 23. William P. Henderson, *Walpi Snake Dance* (1920), oil on canvas, 41 x 53 in. (Private collection; photograph courtesy Museum of New Mexico, Santa Fe; negative no. 20117)

the snake priests to pose for his picture.[27] With this individual portrait and his many other studies in hand, Couse returned to his New York studio that winter, where he painted his monumental *Moki Snake Dance* (1904; fig. 22). Though completed months after the event, Couse's painting retains a visual immediacy unusual in his work, perhaps because of the superb photographs from which he worked. Yet it is also a painting full of somber mystery, as respectful in its religiosity as any crucifixion from the Christian tradition.

Other artists approached the Snake Dance from different aesthetic positions. Santa Fe painter William Penhallow Henderson (1877–1943) attended the Walpi Snake Dance, probably in 1919 during a three-week trip by train, automobile, and horseback through much of the Navajo and Hopi country. Accompanied by his friend Carter Harrison, the colorful arts patron and former mayor of Chicago, Henderson visited Canyon de Chelly, Chaco Canyon, and the western pueblos of Laguna and Acoma during this trip. By the

time of their arrival at Walpi, they had seen and experienced much. But even frequent attendance at earlier Indian dances had not prepared Henderson for the arresting visual drama of the Snake Dance. Like a growing number of sensitive artists, he bowed willingly to the prohibitions against sketching and photography, recording visual impressions only with his mind's eye. His resulting *Walpi Snake Dance* (fig. 23) painted from memory some months later, has a limited amount of detail but a flood of vibrant color and remembered rhythm. When this painting was shown with a group of Henderson's other dance paintings at the Santa Fe museum in 1921, Carl Sandburg wrote a foreword to the catalog. Henderson, wrote the poet,

> spent his best years mixing with the material here dealt with and was spiritually mortgaged to the still and living objects, the forms and gestures, colors and shadows. . . . He pays them for what they gave him by a setting forth of fine human and cosmic implications that rise behind and out of the portrayed Indians, mountains, houses, sparse trees. . . . Yes, the inevitable is over this work.[28]

Sandburg was not the only major literary figure to respond to the Southwest's Indian ceremonials. In 1924 D. H. Lawrence, by then many months in New Mexico, was taken by his hostess Mabel Dodge Luhan to the Snake Dance at Hotevilla. Lawrence, who wrote sensitively about many aspects of Indian life, had already been impressed by the big ceremonials at Santo Domingo and Taos. Now, with a legion of the curious three thousand strong, the Luhan-Lawrence party rumbled across the thirty miles beyond Walpi to Third Mesa. Watching the ritual—a dozen or so dancers whose every move was devoured by thousands of hungry eyes—Lawrence could not screen out the context to focus on the ceremony itself. What he perceived was the ghastly transformation of ritual drama into public spectacle. On the return to Taos he wrote down his impressions, mostly a biting characterization of the whole experience as a tawdry circus performance: "Oh, the wild west is lots of fun: the Land of Enchantment. Like being right inside the circus-ring: lots of sand, and painted savages jabbering, and snakes and all that."[29]

Mabel Dodge Luhan complained. Lawrence, she said, had written an account that was itself a dreary mockery of the performance. Apparently chagrined, he started over, producing a longer meditation on the Snake Dance. In milder tone he repeated his denunciation of the sideshow atmosphere. But he acknowledged that behind it, discernible to the seeker, lay an ageless ani-

mistic religion whose only commandment was (as Lawrence had once written) "Thou shalt acknowledge the wonder." "We dam the Nile and take the railway across America," he now wrote. "The Hopi smooths the rattlesnake and carries him in his mouth, to send him back into the dark places of the earth, an emissary to the inner powers."[30]

For many Americans, the dark mysteries of the Snake Dance held less appeal. Government Indian agents objected for decades to the Snake Dances on the grounds that the weeks of training and preparation before the dances kept the Hopi from "productive" agricultural pursuits. As early as 1891 artist Julian Scott noted that the Hopi had been warned of the government's intention to stop the Snake Dance.[31]

But many artists and writers spoke out in opposition to the government's position, and their arguments were heard far beyond the boundaries of the Southwest. Novelist Alida Sims Malkus, writing in the *New York Times*, deplored the proposed halt.[32] In a 1924 article, painter John Sloan delivered a stinging reply to those who charged that the Indian dances were "degrading," "demoralizing" "orgies," attended by "writers and artists, greedy for the retention of these dances for their own personal advantage."[33] Sloan cheerfully pled guilty to being one of those artists, adding, "I am truly sorry that there are not more people who have the same interest in the ceremonials, to write about them and paint them, for they have already proved a fine and refreshing influence for American art."

That influence had already made its way into Sloan's own work; in August 1921 he had visited the Walpi Snake Dance and made a powerful lithograph of the subject (fig. 24). The graphic possibilities of black and white are here well served; Sloan's vigorous draftsmanship brings drama and energy to the closeup view. Seated in the foreground, seemingly arm's length from the snake priests, an arc of spectators watch intently. Among the three white onlookers, the center figure (the man with the glasses) is probably Sloan himself, eyes wide open, hands clasped in front.

Sloan's interest in the dances was not limited to aesthetic appropriation. He tried to see beyond the confines of Euro-American paternalism to a respect for the deeply religious nature of the rituals. In short, he advocated a hands-off government policy with regard to the ceremonial life of the Indians so that "what is left of a beautiful, early civilization will be allowed to survive with its *soul* as well as its body intact." Dismissing as "piffling absurdities" charges that the dances were somehow offensive, Sloan worried instead about the negative effect of Euro-American life in the 1920s on the relatively un-

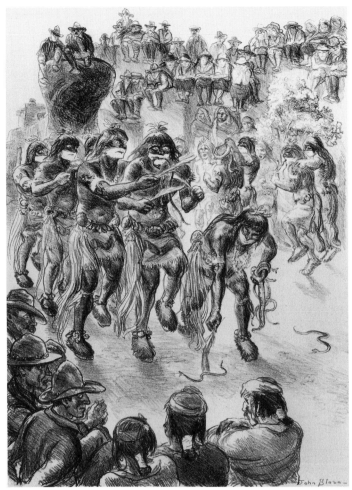

FIG. 24. John Sloan, *Snake Dance* (1921), lithograph, 12 3/4 x 9 1/4 inches.
(Photograph courtesy Delaware Art Museum; gift of Helen Farr Sloan)

corrupted Indian: "There can be no question but what these same Indians are profoundly offended with certain elements of our jazz dancing—dances which certainly have no beauty and no religious significance."

To point out the contrast between what he called the "aesthetic quality of Indian culture" and the excesses of the Roaring Twenties, Sloan caricatured the voracious, insensitive ceremonial visitors in several etchings made in the mid-twenties. In *Knees and Aborigines* he portrayed as ludicrous the flappers and flivvers at a ceremonial, while in his 1927 *Indian Detour* crowds of desultory tourists wander about a pueblo plaza where a circle of aggressive tour

buses, like some maddened modern-day wagon train, crowds in upon the handful of Indian dancers.

Paradoxically, the 1920s effort by artists and writers to preserve the dignity and mystery of the Indian ritual wrenched the Snake Dance out of its remote desert venue into the glare of Washington. As if absolute decontextualization would prove once and for all their harmlessness, a group of Hopi Snake Dancers was brought to the nation's capital in 1926. There they performed before Vice President Dawes, Alice Roosevelt Longworth, and five thousand other onlookers. Dancing in the white man's plaza, caught in the gaze of cameras and reporters, the five dusky snake priests seemed far less threatening to Euro-American values than their detractors had argued. Arizona's Senator Cameron, echoing John Sloan's contention, remarked to the *Washington Post* and *New York Times* that the Snake Dance was not as bad as the Charleston.[34]

Once the threat of its suppression was past, the Snake Dance slipped from notoriety back to the relative obscurity of the far-off Southwest. But if its political currency was spent, the Snake Dance continued to exercise its fascination for Euro-American artists. Each August brought a new group of spectators, struck by the austere setting, the costumes, body painting, and measured rhythms of the dance. Jan Matulka, Emil Bisttram, Leon Gaspard, Frank Applegate, Olive Rush, Tom Lea, Will Shuster—these and countless others have recorded their visual responses to the experience in every imaginable medium and style.

Among the most powerful of these responses is *Snake Priest* (fig. 25), by Canadian-born printmaker Frederick O'Hara (1904–1980). O'Hara's 1957 monoprint has a simultaneous sophistication and primordial quality: deliberately crude, distorted, richly textured, it is a figure outside the bounds of ordinary perception. Instead, it is a heroic, monumental being charged with the power of ritual. But O'Hara is a respectful keeper of secrets; his is a sensitive handling, purged by intent and technique of the literality that offends.

Other artists have been content to watch and listen, knowing that their visual interpretation could add nothing to a ceremonial expression complete as an aesthetic as well as a ritual act. Georgia O'Keeffe found the Snake Dance compelling, but she was, after all, not a figure painter. The closest she came to recording Hopi ceremonial life were her 1930s renderings of some kachina *tihus*, those spirit likenesses carved by the Hopi for teaching purposes.

A case apart are Fred Kabotie's watercolors of the Snake Dance, because they are renderings of Hopi ritual by a Hopi painter steeped in his traditional

FIG. 25.
Frederick O'Hara, *Snake Priest* (Series K #1) (1957), monoprint, 21 3/4 x 7 1/4 in. (Courtesy Permanent Collection, Roswell Museum and Art Center, Roswell, N.M.; gift of Frederick O'Hara Estate)

culture.[35] Born at Shungopavi at the turn of the century, Kabotie's artistic talent was encouraged by Dorothy Dunn at the Santa Fe Indian School studio. There he learned the studio's pictorial manner: flat application of decorative color, delicate linear separation of form, and overall attention to detail in the patterns of dress and body painting. In Kabotie's Snake Dance paintings these formal conventions dictate more than the *look* of the painting; they also affect meaning. Since no one detail is emphasized more than others, Kabotie's paintings (unlike most Euro-American paintings of the Snake Dance) sidestep the sensational visual focus on snakes carried in the dancers' mouths. To Kabotie, the snakes represent only one of many visual incidents within a composition that emphasizes the communal value of the dance.

In Kabotie's Snake Dance paintings we also see the studio's pan-Indian landscape manner. Nature here is merely symbolic; the ritual kisi, itself a constructed form, is the sole allusion to landscape. Nothing else—no ground line, no architecture, no stray shrubs—anchors the composition in temporal reality. Kabotie's imagined recreation of a timeless ritual act occurs outside measurable space and time, in a void that corresponds to the gap between the Hopi and Anglo worlds.

It is precisely there, in Kabotie's void, that certain troubling notions collide. He is, after all, Hopi. And even though his Snake Dance paintings may appear detached from life, his creative act was not. Kabotie's own experience—learning to move between the Anglo and Hopi worlds—was conditioned by Anglo economic support, first at the studio itself, later when he filled many commissions to record ceremonies and lore of the Hopi in murals and in easel paintings.

For better or worse, well-meaning Euro-American patronage has often produced changes in both the content and form of Native American art. For Kabotie, and for many Native artists since, the dilemma of satisfying the twin demands of tradition and audience has been problematic. Nelson Graburn, in his discussion of Fourth World arts, (usually produced, like Kabotie's, for outside consumption) describes the frequent double-coding in work that must respond to "more than one symbolic and esthetic system."[36]

Conclusion

Because it has been so well documented, the Snake Dance provides a useful historical example of the dissemination of cultural meaning through ritual

and art. Subjected to sustained outside approaches for well over a century, it has been described, photographed, painted, and satirized beyond counting. Admittedly, outside attempts to grasp its significance have focused all too often on its exoticism, constructing differences based on subtly ethnocentric systems of value.

Today's postmodern preoccupation with the twin crises of meaning and representation complicates issues that went virtually unnoticed when Kabotie (and Euro-American artists) were recording the rituals of the Hopi. Now, in the 1990s, anthropologists and artists struggle with questions of conquest, neocolonialism, and visual appropriation. New consciousness of symbols and acts sacred to others has made visual artists question the very basis for their representations and has made museum curators acutely aware of past offenses.

But amid these new-found concerns we must keep in mind that the interplay of visual referents, ritual, and decoration has undergone profound changes during more than a century of Snake Dance representations. Between Moran's sketches and the expressionist interpretation of Frederick O'Hara lie differences as vast as those between the covered wagon and the jet airplane. As we think about contextual differences, one caveat emerges clearly: we must be careful not to judge the artistic acts of past decades solely by the imperfect standards of our own.

What about the very act of writing about the Snake Dance—by early ethnologists, by D. H. Lawrence, John Sloan, or here, in the reconsideration of past images and texts? If such discussions are aimed at a Euro-American audience, do they necessarily perpetuate asymmetrical power relations between dominant and subject cultures? Will appropriation and neoprimitivism necessarily continue to further naturalize the entrenched self/other dichotomy? Yes, many scholars argue, if the discussion is framed in terms of Euro-American needs and values. To Robert Berkhofer Jr., there is no clear way out. In *The White Man's Indian* he has written that the *idea* of the Indian is destined to remain appropriative, part of what he calls "the recurrent effort of Whites to understand themselves, for the very attraction of the Indian to the white imagination rests upon the contrast that lies at the core of the idea."[37]

Lucy Lippard takes a slightly different view. In summarizing some of the pitfalls Euro-Americans have always faced in addressing other cultures, she cautions, "Well-meaning white artists and writers who think we are ultrasensitive often idealize and romanticize indigenous cultures on one hand, or force them into a Western hegemonic analysis on the other hand." But she

stops short of advocating a strict hands-off policy: "I am not suggesting that every European and Euro-American artist influenced by the power of cultures other than their own should be overwhelmed with guilt at every touch." But they should, concludes Lippard, maintain "an awareness of other cultures' boundaries and contexts" as one way of respecting "the symbols, acts or materials sacred to others."[38]

Lippard's admonitions reflect contemporary multicultural consciousness, as well as the perennial desire to find meaning through art and ritual. That desire, given free rein in the past, has been at the heart of the problem: Hopi "boundaries and contexts" have repeatedly been violated, often by persons oblivious of the negative effects their presence and representations generate. One poignant example is that of missionary and amateur anthropologist H. R. Voth, who lived at Hopi during the early years of the century. Over a period of years he photographed and described their ceremonial life in great detail. Voth was long thought (by white colleagues) to have the complete trust of the Hopi because he was allowed to enter kivas freely and to "collect" ceremonial images. Only later, in the autobiography of a Hopi leader, was it revealed that Voth's intrusions were blamed for a crippling drought among the people.[39]

More recently, media attention accompanying celebrated visitors (amplified a thousand fold since Theodore Roosevelt's 1913 visit) has nearly swallowed up Snake Dance performances in a sea of hype. Worse, it has again threatened access (reprising G. W. James's 1902 account) by the Hopi themselves to the dance's ritual significance. When Johnny Carson visited, one Hopi told me, it was the last straw. D. H. Lawrence's worst fears were realized: what began as ritual performance had been reduced to public spectacle, finally to a media circus.

In an effort to prevent the irretrievable loss of their ceremonial life (predicted almost a century ago by J. Walter Fewkes), the Hopi have closed the Snake Dance to visitors in recent years. Today it survives, in much-reduced form, a casualty of the impact of the twentieth century on the beliefs and ceremonial systems of the Hopi. Factionalism within the 7,600-member tribe has also affected the performance of the ancient ritual dramas. Tribal government, since 1936 in the hands of elected political leaders, has favored economic development and jobs over traditional religious concerns. In 1989, for example, the tribal council hired an Albuquerque construction company to build a road that destroyed part of the habitat for snakes used in the Snake Dance. Hopi traditionalists have called for, but not yet received, reparations.[40] Even if paid, monetary compensation could not replace land long sacred to the Hopi belief system.

Many factors have undermined performance of the Hopi Snake Dance. That it survives at all is testimony to the richness and meaning of the ritual to the Hopi themselves. To generations of outsiders who have been drawn to it, that ritual significance can never be experienced in precisely the same way. But to admit that is not to deny other levels of experience and meaning within the Snake Dance. As Susan Sontag argues, "Meaning is never monogamous"; one person's meaning is never precisely that of another. Besides, there is a critical difference between finding "meaning" and "a meaning," a distinction Roland Barthes made in discussing the aim of literature, but which applies equally to visual art.

Finally, if Carl Jung was right—that meaning exists only when shared— then the Snake Dance experience has the potential of enriching constantly enlarging circles of perception. And, one wants to ask, isn't there meaning enough in the Snake Dance to go around? If so, the long fascination of the Snake Dance performance, particularly to visual artists, has created meaning that extends well beyond the Hopi dance plazas. Their representations can thus be construed less as cultural robbery, more as openness—even homage—to alternative aesthetic and communal values.

But the Snake Dance representations have signified more than that. The rich variety of visual responses to a common experience has helped artists to rethink old questions of perception. And from their insistent urge to situate meaning in ritual and in art have sprung images that engage issues common to Hopi cosmology and to human artistic endeavor generally: a search for order in the natural world, the relationship of art and ritual, and the linkage of individual creative acts to beliefs about primal acts of creation.

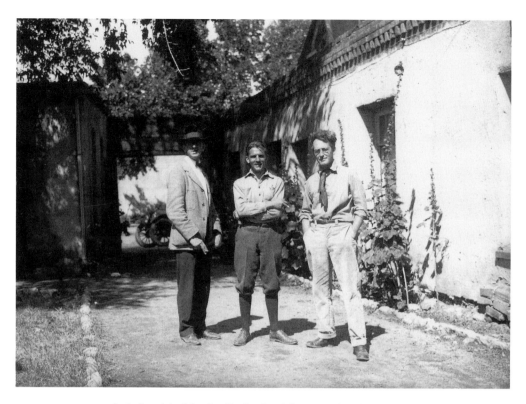

FIG. 26. Left to right: Marsden Hartley, Randall Davey, John Sloan. In patio, Palace of the Governors, Santa Fe, New Mexico, September 1919. Photographer unknown. (Photograph courtesy Museum of New Mexico, Santa Fe; negative no. 14232)

A canvas under left arm going down Canyon road at 10 A.M., a ready-to-cook chicken under left arm going up Canyon road at 5 P.M., amazing blue eyes, long nose, thin face, alert step, very alert—that was Marsden Hartley, famed artist and distinguished writer of prose and poetry.

Santa Fe New Mexican,
SEPTEMBER 9, 1943

SOUTHWEST PHOENIX

*Marsden Hartley's Search
for Self in New Mexico*

Curious eyes followed Marsden Hartley wherever he went. Striding along the streets of Santa Fe, New York, Paris, or Berlin, Hartley was a dandified, arresting, and eccentric figure (see fig. 26). He is now regarded as one of America's leading twentieth-century painters, but his obituary notice from the Santa Fe newspaper reminds us that Hartley (1877–1943) pursued a parallel career as poet, critic, and essayist. A brief part of that career was spent in New Mexico, where he Hartley passed a highly productive, if not untroubled, fifteen months in 1918 and 1919.

We know Hartley's haunting New Mexico pastels and paintings; they figure in prominent American collections and have been widely reproduced (figs. 32 and 33). Less well remembered are his writings from that period. Now, thanks to a rediscovered poem and photograph, we can more accurately place him and his thoughts in a New Mexico context.

For Hartley, painting and literary pursuits were closely interwoven, with many themes appearing first in one form, then another. To discuss Hartley's painting and poetry in the same context risks consideration of one as mere illustration of the other. Neither should be regarded, he felt, as dependent upon the other. And certainly the poetry and painting each stand firmly on their own merits. Nonetheless, there are instances in which themes appear strongly and repeatedly in both his poems and paintings, offering correspon-

FIG. 27.
Marsden Hartley,
El Santo (1919), oil
on canvas, 36 x 32 in.
(Courtesy Museum of
Fine Arts, Museum of
New Mexico, Santa Fe)

FIG. 28. *(below)*
Marsden Hartley, *New
Mexican Landscape*
(1918), oil on board, 23
7/8 x 31 3/4 in. (Photo-
graph courtesy Barbara
Mathes Gallery, New
York)

dences that enrich interpretations of each form of expression. One such instance is the starting point for our inquiry here.

Hartley often wove together painting and writing in the course of a single day. It was the condition of light that determined whether he painted or wrote during certain hours, and it was a search for light, paintable landscape, and a sympathetic companion or two that led Hartley across continents and oceans for much of his life. Restless and peripatetic, he sampled new environments the way some people try out new restaurants. As an adult Hartley never lived in one place for more than ten months at a time. To longtime friend Mabel Dodge Luhan he once described "the quality of [his] wonder in being not really quite anywhere at all times." Until he finally settled in Maine in the 1930s, Hartley had difficulty feeling truly a part of places and people.

Hartley began and ended his career in Maine, but the intervening years held sojourns in Germany, France, New York, Bermuda, Mexico, California, and New Mexico. The landscape in each place often provided the initial stimulus for his work, inspiring powerful paintings of nature's forms and forces. No landscape affected Hartley more profoundly than New Mexico's, but his first attempt to interpret it was in literary, not visual terms. When he discovered that no significant literary treatment had been accorded to Taos (this was well before D. H. Lawrence, Willa Cather, or Mabel Dodge Luhan had rhapsodized in print about the state's natural charms), he began a book of poetic pieces he called "Altitudes." Intending to submit it to Harriet Monroe at *Poetry* magazine, Hartley described "Altitudes" to her as "the outcome of the influence of the beautiful material west upon my jaded sense."[2]

The "Altitudes" project was never realized. A gradual, predictable disillusionment with Taos overtook Hartley in the coming months. As had happened in other places, his initial enthusiasm waned, replaced by the slow realization that neither the landscape nor the artists at Taos now seemed as distinctive as he had first found them. Even the elevation, initially a strong stimulant for the artist, began to undermine his physical and emotional well-being. To Monroe he announced his discontent with Taos and his plan to move on to larger Santa Fe:

It [Taos] is the stupidest place I ever fell into. Lovely landscape here and there, but the society of cheap artists from Chicago and New York makes the place impossible, and they tell themselves that the great art of America is to come from Taos. Well there will have to be godlike changes for the better in this case.[3]

FIG. 29. Marsden Hartley, *Blessing the Melon, The Indians Bring the Harvest to Christian Mary for her Blessing* (1918–19), oil on board, 32 1/2 x 23 7/8 in. (Courtesy Philadelphia Museum of Art, Alfred Stieglitz Collection)

Settling in Santa Fe in the fall of 1918, Hartley found new companions and his mood brightened. He resumed drawing, painting, and writing poetry. One memorable effort in verse was "The Festival of the Corn," written after Hartley's experience of the great Green Corn Dance at Santo Domingo Pueblo.[4] A fragment of the poem summarizes its portrayal of the overlay of Christianity on the ancient ceremonial practices of the Pueblo Indians:

Give him a leaf of corn in his hand—
Let him dance!
Dance, Domingo, dance!
Jesus won't care;
For a little while.

Here Hartley is expressing a theme that parallels his own contradictory impulses in life. On one hand he was self-consciously "primitive" in his approach to art, nourished by his own spiritual inclinations and a genuine response to animistic nature. Throughout his life he maintained an interest in the vigorous expressions he encountered in collections of tribal and folk art. He admired its rootedness to native soil and its authentic roughness and immediacy, which he strove to emulate in his own painting and poetry. Suffused with strong color and emotional content, Hartley's best work is both passionate and primitive (fig. 29).

At the same time, Hartley was a sophisticated aesthete, a member of the Stieglitz circle of advanced artists in New York. Like others in that group, his innate refinement and cultivation at times made him distrust his own intuitive responses. He admired the Indians' immersion in ritual, but often he held himself to a cerebral, apollonian view of life. At these moments he deliberately drew back from his own imagination, seeking to eliminate from his own work any traces of the personal or idiosyncratic. In this frame of mind Hartley—at times deeply introspective and mystical—imposed a conscious restraint on himself.

One such moment occurred during Hartley's second summer in New Mexico, and it caused him to destroy much of the poetry he had written in the state. After a four-month hiatus in California, he returned to Santa Fe, writing to Harriet Monroe,

I have since my return destroyed much of last winter's and last summer's effusions, and feel very heroic at this hour. I am eliminating all reference

or possible inference of the soul that I can. . . . I have but one interest now, and that is the coldest clearest thing I can put down.[5]

Thus it happened that most of his poetic outpourings were excised from the center of one of Hartley's most productive periods.[6] During his remaining months in New Mexico he turned instead to writing art criticism and painting still life and landscape subjects in the Santa Fe area.

Then, even as he began to plan his departure for New York, Hartley met the remarkable Eva S. Fenyes. Arts patron, seasonal resident of Santa Fe, Mrs. Fenyes (like her better known Taos contemporary Mabel Dodge Luhan) "col-

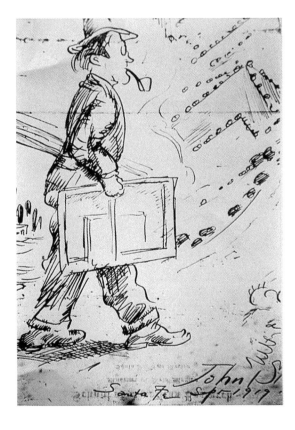

FIG. 30.
John Sloan, Untitled (Self-Portrait Sketch), Santa Fe, 1919. (Courtesy Fenyes Papers)

lected" artists—specifically, their self-portraits. She began the practice at her home in California, asking many artists and writers there to provide her with a written, drawn, or painted portrait of themselves. These self-portraits she compiled into scrapbook volumes.[7]

Santa Fe in 1919 was a particularly rich collecting-ground for Mrs. Fenyes. In addition to the local crop of artists and writers, two painters of national reputation—Hartley and John Sloan—were working in the town that summer. Each would find his best-remembered artistic achievement in other locations, but their New Mexico visits—Hartley's single stay of more than a year, Sloan's annual summer visits spanning some thirty years—would provide unique subject matter, if not a demonstrably broader effect. The two were in many ways of opposite temperament and artistic orientation, Sloan essentially an urban realist, Hartley a symbolic abstractionist and later expressionist. Sloan later would remark in his diary that Hartley's mysticism was "a little too much for me."[8]

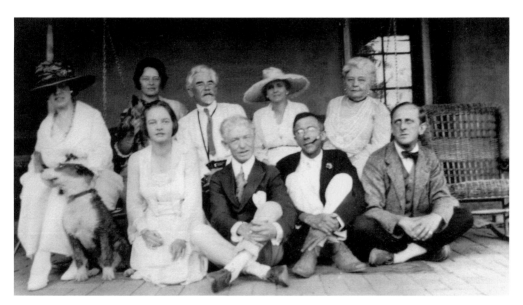

FIG. 31. Photograph taken at the home of Mrs. Leonora Curtin, Santa Fe, New Mexico, September 1919. Front row, left to right: Leonora Frances Curtin, Warren E. Rollins, Gustave Baumann, Marsden Hartley. Back row, left to right: Mrs. Rolshoven, Mrs. Thomas E. Curtin, Julius Rolshoven, Mrs. Rollins, Mrs. Fenyes. Photographer unknown. Rollins, Baumann, and Rolshoven were well-known painters in Santa Fe. (Courtesy Fenyes Papers)

Nonetheless, the two artists, who had known each other earlier in New York, found themselves together in 1919 in the then-remote Santa Fe art colony, where nearly all the visiting painters associated with each other. Both Sloan and Hartley occupied studios at the Palace of the Governors that sum-

mer, and probably crossed paths frequently. Perhaps Hartley made it clear to Sloan that he had recently abandoned his radically mystical inclinations, embracing artistic realism instead. In any case, their Santa Fe association was cordial. Sloan painted a lively dance scene at a local hotel in which Hartley appeared, and the two posed with a third painter, Randall Davey, for a photograph outside their museum studios (fig. 26).

When asked by Mrs. Fenyes for a self-portrait, Sloan provided a charming sketch of himself, canvas in one hand, portable easel in the other, striding out for a session of painting in the Santa Fe hills. It is signed and dated September 1919 (fig. 30). During the same month Hartley provided Mrs. Fenyes with his own self-portrait, perhaps on the occasion when he was photographed with Mrs. Fenyes, her daughter (Mrs. Leonora Curtin), and granddaughter amid a group of well-known Santa Fe artists and their wives (fig. 31). A caption in the scrapbook notes that the photograph was taken on Mrs. Curtin's Canyon Road verandah in September 1919.

Though he had drawn self-portrait sketches before, Hartley now chose to present himself in a poem instead of in visual form.[9] And Hartley's self-portrait is considerably more complex, considerably less sanguine than the affable Sloan's. Hartley's self-portrait poem, which he provided to Mrs. Fenyes in both holographic and typescript forms, is signed on both copies. The typed copy bears his handwritten notation "Santa Fe / N.M. / September 22, 1919." Hartley also appended an inscription over his signature: "Very cordially and with best wishes / For Mrs. Fenyes, one of the most charming of women." Clearly Hartley's poem was furnished specifically in response to her request for a self-portrait.[10] The poem reads as follows:

PORTRAIT EFFIGY.

L'Oiseau de feu—Feuervogel "Sioux."

Two pools, where rainbow fishes
Swim and dream, and there themselves
Reflected see;
Two shafts of sky, with certain sky complacencies
Therein,
Console themselves with farthest radiance involved
Before swart shadows fall upon their fins,
To leave them wraithfully in gloom.

Hands clutching every shining lucent thing
With avariced envying silences;
And there, the half shut-door, from whence
The polished semblances of things too brave
To mention on an autumn afternoon,
Do glide away like doves from lattices left open,
With very certain loves not distantly in view,
And hopes not too forlorn.
Strong feet are shod with shoes of ancient fire,
All buckled down with silvers from the sun.
They walk straightforwardly to every shape they crave,
And with them run the stairways of the sky
Like eagles whispering their secrets in corridors of clouds
Upon a cliff somewhere, calm lips and heart

Do gorge themselves on morsels they have pilfered
From a very willing world.

The bird of fire is never fearful of his flames.
He devours all their sweets, and cleans his beak
With branches of a morning
Made for him.

Once again Hartley draws upon two long-running streams within his psyche: his profound identification with nature and his admiration for the Indian, whose lifeways and world view perfectly embodied that identification. The "rhapsodic nature verse of [Hartley's] youth" (in Gail Scott's words) had revealed him as an intensely experiential poet; here that quality is wedded to his ardent primitivism. In "Portrait Effigy," Hartley has clearly tried to express these qualities in poetic images. Looking both inside and outside himself, he draws on multiple sources for that imagery. Up front, in his subtitles for the poem—"L'Oiseau de feu" and "Feuervogel 'Sioux'"—Hartley gives clear clues for those broad cultural associations.

As the titles suggest, Hartley had first encountered the mythic firebird in French and German contexts. During his stay in Paris and Berlin between 1912 and 1914, Hartley found a cultural setting that celebrated myth and folklore in modernist settings. It was the moment, for example, of Stravinsky's musical triumphs with the Ballets Russes in Paris. His collaboration with impresario Sergey Diaghilev resulted in Stravinsky's scores for the ballets *The*

Firebird (first performed in 1910), *Petrushka* (1911), and *The Rite of Spring* (1913). All were successes much talked of in Paris and highly influential among the avant-garde on both sides of the Atlantic.

The Firebird, which won immediate fame for Stravinsky, was based on a Russian fairy tale with roots in the mythology of ancient Egypt and classical antiquity. With a life-span of at least five hundred years, the firebird, or phoenix, was the size of an eagle, with brilliant gold and scarlet plumage. Before its approaching end, the legendary bird made itself a nest, set it on fire, and was consumed in the flames. But a new phoenix sprang from the ashes, in an act of regeneration widely interpreted in the ancient world as an allegory of resurrection.

To the romantic, doom-haunted Hartley, the image resonated with his own life experience in overcoming obstacles. Rootless, often lonely, plagued with financial difficulties, Hartley fancied himself a survivor, a phoenix rising perennially from the flames. And the image gained even more poignancy for Hartley when conflated with powerful bird legends of the Western Hemisphere: those of the eagle and the mythical thunderbird of the American Southwest, as well as the feathered Aztec Quetzalcoatl, whose dual status as deity and culture hero bridges the world of spirit and body. Someday, says the legend, Quetzalcoatl will return from the flames to claim his kingdom, as Lord of the Dawn.

Hartley's mingling of the legends was no accident, for the themes and culture of aboriginal Americans were widely popular among the European intelligentsia during Hartley's early years in Paris and Berlin. The Indians' material culture was known from artifacts in European collections: in Paris's Trocadero and at the Museum für Völkerkunde in Berlin Hartley saw firsthand the pottery, religious objects, and costumes of the American Indian. As early as 1912 (long before he visited the Southwest) he painted a still life of Indian pottery in Paris, a composition based on a Pueblo bird design.

Working in Berlin during 1914 and 1915, Hartley incorporated the Germans' (and his own) intense interest in American Indian art into strongly symbolic *Amerika* compositions. One of these is his *Indian Fantasy* from 1914 (fig. 32). Here a great stylized bird, brilliant in its patterned plumage, arches its wings over a symmetrical display of stereotypical American Indian images.[11] A central tipi dominates the composition. But this tipi, adorned with cosmic symbols, is no mere physical shelter; it functions also as a great symbolic triangle or pyramid, the centerpiece of Russian painter Wassily Kandinsky's theories of spirituality in art.[12] Like many other artists, Hartley was profoundly in-

FIG. 32. Marsden Hartley, *Indian Fantasy* (1914), oil on canvas, 46 x 39 in. (Courtesy North Carolina Museum of Art, Raleigh; purchased with funds from the state of North Carolina)

fluenced by Kandinsky during these years, investing his subjects with abstract symbolism, allusive color, and a desire for transcendent experience.

But Hartley, drawing an important distinction between himself and his European colleagues, often rooted his approach to the spiritual in his own American experience (however vicariously or stereotypically perceived). Nowhere is this more clearly seen than in *Indian Fantasy*. On either side of the tipi/triangle float decorated canoes whose occupants wear long-feathered warbonnets. They drift along a body of water filled with multicolored fishes. Along

the bank are bonfires, hunting and ceremonial objects associated with the American Indian.

Like others of Hartley's *Amerika* series, *Indian Fantasy* is a complex product of Hartley's love for colorful, abstract patterning, cosmic mystical references, and a distant dream of the beauty and harmony of primitive Indian life. That year, 1914, Hartley wrote Stieglitz that he wanted to paint his face with Indian symbols, go west, become Indian, and face the sun forever.[13]

It would be four years before Hartley could test his fantasies of American Indian art and life against the reality of their existence in the American Southwest. "I am an American discovering America," he wrote during his first months in New Mexico.[14] In all, Hartley wrote five essays on Native American culture during or after his stay in New Mexico. In them, he rhapsodized on the authenticity and beauty of Native American culture. Collectively, they are a testimony of Hartley's modernist cynicism concerning Euro-American culture and a romantic escapist's twin desires to fuse with nature and to experience the exotic.

Seen superficially, Hartley's romanticism is that of generations of American artists and writers concerned with celebrating the lifeways of (presumably) disappearing Native peoples. Like his colleagues, he was sometimes careless in documenting differences among Indian groups and artifacts. On the other hand, Hartley approached the broad spiritual legacy of Indian art with visible reverence. The Indian, he argued,

> is the one man who has shown us the significance of the poetic aspects of our original land. . . . He has indicated for all time the symbolic splendor of our plains, canyons, mountains, lakes, mesas and ravines, our forests and our native skies, with their animal inhabitants.[15]

Important lessons for Euro-American artists lay in the art and lifeway of the Native American. This Hartley argued repeatedly. But he also acknowledged its private meaning: "It is from the redman I have verified my own personal significance," he wrote. It is this internalization, combined with the "symbolic splendor" of the land and its animal inhabitants, that find a new voice in Hartley's highly personal "Portrait Effigy." Uniting visual and verbal streams of his earlier thought, he revives the darting rainbow fishes and solitary eagle of his Berlin *Indian Fantasy*. With gliding doves they now share Hartley's stanzas in a highly personal musing on his own capacity to dream, love, hope, and consume life. Lucent pools, windswept cliffs, and cloud corridors are the refuge of the legendary firebird, become Hartley himself.

FIG. 33. Marsden Hartley, *Cemetery, New Mexico* (1922), oil on canvas, 31 5/8 x 39 1/4 in. (Courtesy Metropolitan Museum of Art, Alfred Stieglitz Collection, 1949 [49.70.49])

Particularly in the last lines of the poem, Hartley portrays the essential qualities of the self-as-artist: the need to derive sustenance from the world, to devour what life has to offer in the process of finding one's ultimate expression. Firebird, phoenix, survivor, Hartley would survive many small spiritual deaths during a life in which painting and poetry were as much catharsis as profession. For Hartley as for Quetzalcoatl—the New World's own phoenix— a morning "made for him" will find the firebird unafraid, reborn to a new time and place.

Within two months after he presented his poetic self-portrait to Mrs. Fenyes, Hartley boarded a train for Chicago and New York. He would never return to New Mexico, but he often thought of the land he called both "beautiful" and "difficult." During the next decade the Southwest lingered in his mind; in New York and Berlin he painted it anew, with a clarity he attributed

to separations of time and distance (fig. 33). It was as if Hartley now saw the larger mythic structure of the land and savored the chaotic geography that so closely replicated the terrain of his own mind.

Born again and again to adventures of the spirit, Hartley pursued them to the end with a determination "never to let life down, to take every smell and taste of it that we are capable of taking." And with a tone at once wistful and resigned, he at last admitted, "I have been pursuing the phantom for the most of my life, because that is chiefly all the artist is made for."[16]

BEHOLDING THE
EPIPHANIES

Mysticism and the Art of Georgia O'Keeffe

Undeniably, the development of modern painting has been nourished by ideas from a common pool of mystical thought. As an alternative to the dominant current of pragmatic materialism in America, artists have frequently pointed to a long history of antimaterialist philosophy that included Whitman, Thoreau, and Emerson. Visual antecedents appeared in the work of Blake and Ryder. Yet it was not until the organization of a 1986 exhibit entitled *The Spiritual in Art: Abstract Painting 1890–1985* at the Los Angeles County Museum of Art that art historians began to acknowledge fully the pervasive influence of mysticism within American art.[1] Since that epochal show, new light has been shed on the ancient and modern sources from which mysticism derived.

To clarify the concept of mysticism, understood differently by artists and art historians than by theologians, let us adopt the useful framework established by the catalog of the Los Angeles show. As outlined by Maurice Tuchman, mysticism is a "search for the state of oneness with ultimate reality," while occultism "depends upon secret, concealed phenomena that are accessible only to those who have been appropriately initiated." Tuchman has identified some ideas common to most mystical and occult views:

> The universe is a single, living substance; mind and matter also are one; all things evolve in dialectical opposition, thus the universe comprises paired opposites (male-female, light-dark, vertical-horizontal, positive-negative);

everything corresponds in a universal analogy, with things above as they are below; imagination is real; and self-realization can come by illumination, accident, or an induced state: the epiphany is suggested by heat, fire or light. The ideas that underlie mystical-occult beliefs were transmitted through books, pamphlets, and diagrams, often augmented by illustrations that, because of the ineffable nature of the ideas discussed, were abstract or emphasized the use of symbols.[2]

These kinds of illustrations contain five visible impulses, according to Tuchman: cosmic imagery, vibration, duality, sacred geometry, and synesthesia (the overlap between the senses). Over many centuries, manifestations of the spiritual in art have been more or less visible, depending on political, sociological, and religious contexts. Occasionally they have erupted with unusual vigor, as in Europe with the late-nineteenth-century occult revival, then again around 1910, when artists on both sides of the Atlantic gave renewed currency to the presence of the spiritual. In groups or as individuals, visual artists began to move away from perceived reality toward signs, from direct observation to ideas, from natural to symbolic color. They did not dismiss meaning outright, but instead tried to draw upon deeper and more varied levels of meaning.

Even some mainstream American art histories began to reflect the union of the abstract and the spiritual. From Arthur Jerome Eddy's treatises, continuing through Sheldon Cheney's in the 1920s and 1930s, the mystical was an accepted component of modern American art.[3] But its halcyon days were brief; by the late 1930s mystical and occult beliefs came increasingly under suspicion in America because of their political associations with fascism and Nazism. By then purely aesthetic issues had replaced interest in alternative belief systems, and soon a tidal wave of formalist criticism had begun to engulf the popular view of modern art in America. From the 1930s to the 1960s its chief spokesman was critic Clement Greenberg, who argued that modernist practice in art should be objectively verifiable and should follow certain unchangeable laws. In 1946 he castigated the art of Georgia O'Keeffe, for example, alleging that her painting "has less to do with art than with private worship and the embellishment of private fetishes with secret and arbitrary meanings."[4] Greenberg blamed what he termed O'Keeffe's "errors" on a misreading of advanced European art—either cubism, fauvism, or German expressionism—that took place decades earlier, when Picasso and Matisse broke with nature. Again according to Greenberg, the misguided early American

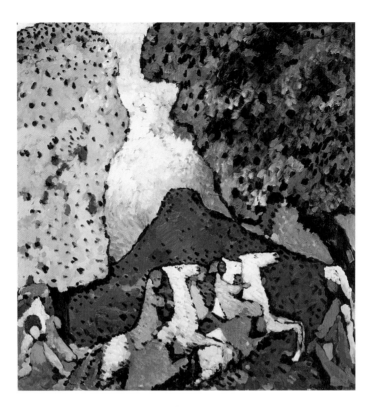

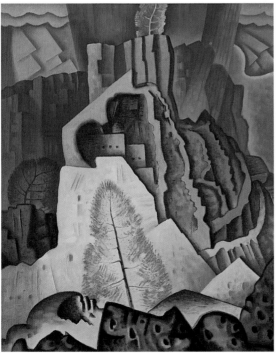

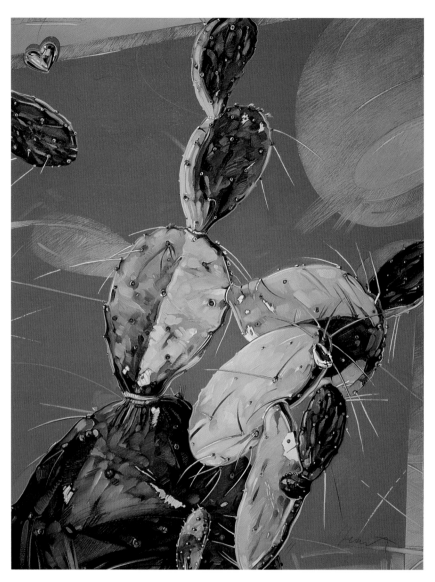

PLATE 3. *(above)* John Fincher, *The Ring, Heart and Knife, Part 2* (1981), oil on canvas, 48 x 36 in. (Private collection; photograph courtesy the artist)

PLATE 4. *(opposite, top)* Fritz Scholder, *Horse #1* (1983) oil on canvas, 20 x 16 in. (Photograph courtesy the artist)

PLATE 5. *(opposite, bottom)*Luis Jimenez, *End of the Trail (With Electric Sunset)* (1971), fiberglass, polychrome resin, electric lighting, 84 x 84 x 30 in. (Courtesy the artist, Frank Ribelin, and Damian Andrus)

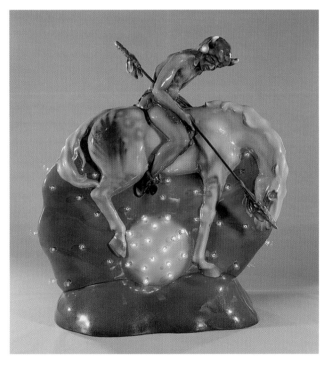

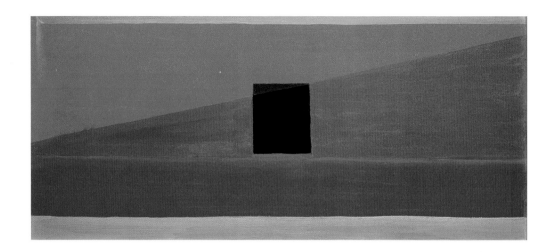

PLATE 6.
Georgia O'Keeffe, *Patio Door—Green and Red* (1951), oil on canvas, 12 x 26 in. (Private collection; photograph courtesy Mr. and Mrs. Gerald P. Peters, Santa Fe, New Mexico)

PLATE 7.
Eliot Porter, *Georgia O'Keeffe, Glen Canyon, Utah, August 1961*, dye transfer print. (Copyright Amon Carter Museum, Eliot Porter Collection, Fort Worth, Texas)

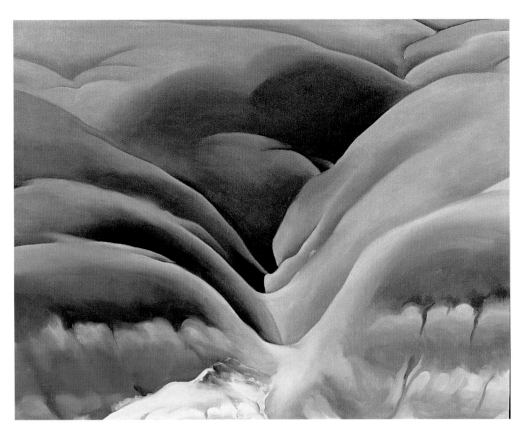

PLATE 8. Georgia O'Keeffe, *Black Place II* (1945), oil on panel, 24 x 30 in. (Private collection; photograph courtesy Mr. and Mrs. Gerald P. Peters, Santa Fe, New Mexico)

PLATE 9. Page Allen, *Birds and Stars* (1990), gouache with collage on paper, 22 x 30 in. (Private collection; photograph courtesy the artist)

PLATE 10. Page Allen, *Torso, I* (1990), oil on linen, 36 x 28 in. (Private collection; photograph courtesy the artist)

PLATE 11. Woody Gwyn, *Rock Embankment* (1988), oil on canvas, 72 x 108 in. (Photograph courtesy the artist)

modernists, led by Alfred Stieglitz, took the new nonnaturalist European art and transformed it into a vehicle for an esoteric message, a signal, in Greenberg's words, "for a new kind of hermetic literature with mystical overtones" that thenceforth tainted the work of O'Keeffe, Arthur Dove, Marsden Hartley, and others. It was also the stimulus, wrote Greenberg, for O'Keeffe's rapid incursion into the abstract shortly after her earliest encounters with modernist art.

Such criticisms could be deadly in 1946, when mysticism and the spiritual had become anathema to many Americans. But now, nearly half a century later, thanks to the pendulum's swing away from narrow modernist dictates, it is possible again to discuss the spiritual content in modern art and to reassess O'Keeffe's affinities for the mystical in her work. What Greenberg decried in O'Keeffe's work in 1946 is exactly that spiritual element that interests us here. It is the contention of this writer that O'Keeffe did indeed absorb mystical concepts starting about 1915 and that these attitudes and symbols—largely unacknowledged by the artist—pervaded her art for decades. Little has been said of this in the O'Keeffe literature, for three major reasons. First, because of its inherently slippery and various nature, the presence of the mystical is difficult to pin down. Second, O'Keeffe's firm denial of such otherworldly influences has quashed most such discussion. Finally, the paintings themselves, with their visual clarity and precise focus, have conspired to mask any ethereal intent.

But we will see that O'Keeffe's training, her associates, her reading and—not least—her longstanding attachment to New Mexico served her mystical inclinations. Her intensely personal approach to painting and her prolonged absences from New York have much to do with the events of her personal life, as her biographers have clearly shown, but I believe her periods of geographic isolation can be linked also to her affinity for mysticism, which required a degree of interiority. O'Keeffe needed periods of privacy in her pursuit of self-realization. Through O'Keeffe's letters (gradually becoming accessible to researchers, as in the 1987 publication of *Georgia O'Keeffe: Art and Letters*), through her actions, and through the paintings themselves these developments will be traced.[5]

First, a word about the structure of the discussion. It is useless to try to proceed in strict chronological sequence; O'Keeffe's time is not historical and linear. The orbit of her artistic development, circular like the shapes she often used in her paintings, brought her back into contact with subjects and ideas first considered years or decades earlier. Wassily Kandinsky, for example,

influenced various aspects of O'Keeffe's thinking at various times and must be addressed in multiple contexts. O'Keeffe's development corresponds to what French feminist philosopher Julia Kristeva has called "women's time" — cyclical (i.e., repetitive or naturally rhythmic) and monumental (eternal, mythic, outside of time). This kind of time, Kristeva notes, has long been associated both with women and with mystical cultures.[6]

O'Keeffe wanted to be seen as an American original, and, for the most part, she got what she wanted. With the help of her dealer-husband Alfred Stieglitz, she took pains to present herself as independent, free of entangling theory. As a result, she has been viewed as such in the literature. Typical is the assessment of William Innes Homer, who wrote:

> By deliberately remaining independent of artistic cliques and fashions, she was able to preserve her original vision. In this light, her artistic achievement of the years 1915–1917 is all the more significant, for much of what she did came from her own imagination.[7]

O'Keeffe's imagination may have been her own, but her skills as an artist were honed by a series of remarkable teachers. William Merritt Chase, Alon Bement, and Arthur Wesley Dow were all strong influences on the young O'Keeffe. Dow, one of the most important art educators of his time, taught her at Teachers College, Columbia University, in 1914–15. Dow (who had studied Asian aesthetics with Ernest Fenollosa in Boston) advocated a design system that was both harmonious and expressive of human emotion.[8] Using fundamental elements of line and color, along with the Japanese Notan system of composing through the oppositions of light and dark, students were encouraged to discard descriptive realism in favor of flat decorative composition.

Along with an education in aesthetics, O'Keeffe absorbed from Dow the rudiments of mystical thought. Dow had long been associated with Sarah Farmer, who founded a rural retreat in Maine for people pursuing mystical ideas. At Green Acre, Farmer's camp, the celebrated Theosophist Madame Blavatsky and various other mystics were widely discussed and revered. Dow's youthful involvement with mysticism reached its apex when he undertook a spiritual pilgrimage, guided by Theosophists, to sacred sites in India in 1903–4.[9] These experiences, a clear attempt to fuse Eastern mysticism and art with Western thought, were passed along to his students (who included Max Weber, Arthur Dove, and O'Keeffe) for years afterward. O'Keeffe's interests in Eastern art, mysticism, and abstraction would remain sustaining influences throughout her long life.

Still another influence of O'Keeffe's training with Dow was an exposure to principles seen in synthetist-symbolist painting. Symbolism, the mystical wing of the postimpressionist generation, became—along with fauvism and cubism—the chief roots from which abstract art grew. Though we have long known that in her youth she read the most advanced theorists of her day, it is clear from the recent publication of O'Keeffe's letters that—contrary to W. I. Homer's statement—hers was much more than a casual brush with modernist theory. And modernism, especially as practiced among her New York associates, impinged at many points on mystical thinking. O'Keeffe wrote of "laboring on Aesthetics—Wright—Bell—DeZayas—Eddy—All I could find—everywhere—have been slaving on it since in November—even read a lot of Caffin—."[10]

These theorists of twentieth-century aesthetics adopted slightly different points of view, but they shared several similar principles. Bell, DeZayas, and Caffin, for example, argued for an internal motivation and significance in art; they believed that new forms, whether figural or abstract, presented the artist with new possibilities for expression.

In addition, Caffin emphasized that intuition and instinct rivaled reason in their importance to humanity. This idea carried great appeal to many introspective artists and writers of the era. Paralleling the theory of French philosopher Henri Bergson, whose work *Creative Evolution* was a vital text within the Stieglitz circle, thinkers ranging from Marsden Hartley to Gertrude Stein asserted the primacy of the intuitive in art and life—a primacy also important to mystics. Modernists acclaimed Bergson's work because it supported their desire to break with traditional representation.

Arthur Jerome Eddy saw art moving into a new realm, calling for "the attainment of a higher stage in pure art [which] speaks from soul to soul [and] is not dependent upon one use of objective and imitative forms."[11] Wassily Kandinsky, too, had seen a new world dawning in the arts: "The great epoch of the Spiritual which is already beginning, or, in embryonic form, began already yesterday . . . provides and will provide the soil in which a kind of monumental work of art must come to fruition."[12] Even before she met Stieglitz, O'Keeffe had twice read Kandinsky's *On the Spiritual in Art*.[13] First published in English in 1914, this germinal treatise had begun to make its influence felt on the Stieglitz circle several years earlier. Moreover, Stieglitz had purchased a Kandinsky abstraction, *Improvisation No. 27* (1912) from the 1913 Armory Show with an intent to educate his '291' gallery confreres.

Central to Kandinsky's thinking was that artists worked according to spiritual necessity and that their creations, in turn, expressed the inner spiritual

essence of their creator. Simple on the surface, this position (which preceded the views of the British and American theorists O'Keeffe studied in 1916–17) marked a watershed in aesthetics everywhere. For the many who encountered his paintings and his musings on art, Kandinsky became the chief apostle of abstraction. He argued that art should be freed from its traditional bonds to material reality. Just as musicians do not depend upon the material world for their music, so artists should not have to depend upon the material world for their art. "The more abstract is form," he wrote, "the more clear and direct is its appeal."[14]

Clarity and directness were already part of the artistic ideals O'Keeffe had inherited from Dow. Affirmed in this direction by her reading of Kandinsky, the theorist, and Robert Henri, whose pragmatic follow-your-own-road advice she had absorbed secondhand, the young O'Keeffe began to seek an original, inventive style based on abstraction. While teaching at Columbia, South Carolina, in 1915–16, she produced a group of remarkable charcoal drawings, mostly abstract. Their vocabulary of forms suggests an organic relationship to nature, but it is a consonance of shape rather than specific referents that speak of possible sources. Wavy lines, bulbous egg-shaped forms, and saw-tooth planes are reminiscent of Kandinsky's free abstractions (and of the even earlier *Thought-Forms* [1901] by Theosophists Annie Besant and C. W. Lead-beater), but they also begin to set down a personal visual syntax upon which O'Keeffe would draw for the next six decades.[15]

When O'Keeffe returned to New York and enrolled in one of Alon Bement's classes at Columbia, she was exposed firsthand to the then-popular principle of synesthesia. An idea that has long engaged artists, it has an even longer history in mystical circles. In O'Keeffe's case the clearest instance of synesthesia was an occasion she herself recalled when, hearing low-toned music coming from Bement's classroom she entered and was directed with other students to make drawings from what they heard. Here she discovered that music could be translated into visual form. Out of that insight came several remarkable paintings, including *Music Pink and Blue I* (1919) and *Blue and Green Music* (1919).

Such ideas often found their first American audiences on the pages of experimental publications such as Stieglitz's *Camera Work* or *291*. There, and within the walls of his progressive galleries, O'Keeffe met and mingled with the major figures of the American artistic avant-garde and grew conversant with the latest European and American painting, sculpture, and theory.[16] Try as she might to downplay her early immersion in the sources of modernist

thought—or with aesthetics and intellectual matters in general—it is clear, as will be seen, that the thoughts and mystical attitudes of such pioneer modernists as Kandinsky remained a vital force in her art.

O'Keeffe's personal associations after 1915—both inside and outside the Stieglitz circle—did much to establish the spiritual as part of her world view. Chief among these was Stieglitz himself, whose interest in the psychic and mystical has been documented by both Sue Davidson Lowe and Roxana Robinson. As Robinson writes, Stieglitz "was as mystical and baffling as an Oriental sage—a comparison he welcomed."[17] She adds that his interests in the mystical and occult extended to astrology and numerology and that his Intimate Gallery in 1925 contained little else besides paintings and a table that held a crystal ball. Through Stieglitz, O'Keeffe was exposed to many new and esoteric ideas. It was he, for example, who got her thinking about the mystical polarities of masculine and feminine, opposite but complementary. They came to know each other first through their correspondence, which demonstrates a difference in expression they both connected to gender. Stieglitz's letters to O'Keeffe are thoughtful, voluminous, analytical. Her letters, by contrast, are spontaneous, direct, almost stream-of-consciousness in their lack of regard for the niceties of punctuation and syntax. She recognized the differences, and noted at the same time that her art reflected both her personality and her gender. She wrote to her friend Anita Pollitzer in 1916 about her new drawings: "The thing seems to express in a way what I want it to but—it also seems rather effeminate—it is essentially a womans feeling—satisfies me in a way—."[18] Stieglitz reinforced these attitudes: he claimed from the first moment he saw her work that he could identify it as a woman's—pure, fine, and sincere.

One of the universal paired opposites common to mysticism, this distinct male/female duality allowed O'Keeffe the clarity to pursue her feminist concerns in art and life.[19] She could argue on the one hand that women were as competent artistically (and otherwise) as men, while accommodating at the same time the belief that there were certain immutable differences in their natures.[20] In praising new work by John Marin, for example, she wrote, "I must add that I dont mind if Marin comes first—because he is a man—its a different class—."[21]

Another conduit between O'Keeffe and certain kinds of cosmic thinking was Claude Bragdon (1866–1946), an influential New York architect-designer. Bragdon was a Theosophist who wrote the treatises *A Primer of Higher Space* (1913) and *Four-Dimensional Vistas* (1916); he also translated Ouspen-

sky's *Tertium Organum.* Bragdon lived at the Shelton Hotel, where Stieglitz and O'Keeffe moved in November 1925. The three often shared ideas while dining together at the Shelton.[22] Other mystically inclined associates during their New York years were the Davidsons—Stieglitz's favorite niece Elizabeth and her husband Donald—who were devotees of Hinduism. At times O'Keeffe and Stieglitz saw a good deal of Marcel Duchamp, whose interests in alchemy and the mystical have been well documented. Later O'Keeffe became very close to Louise March and Jean Toomer, both followers of Gurdjieff.

O'Keeffe's affinity for the metaphysical were also nourished by other artists within the Stieglitz circle, especially Hartley and Dove. Hartley, like Dow a frequent visitor to Sarah Farmer's Green Acre, often wrote to Stieglitz about his intense involvement with the spiritual, claiming that he was the first artist to use modern painting as a vehicle for mysticism. In the years preceding World War I, Hartley lived in Berlin, where he painted several series of emblematic portraits. In these and in concurrent spiritual abstractions he tried to merge three enthusiasms: oriental mysticism, Christian symbolism, and Native American spirituality.[23]

Hartley also wrote art criticism. In his 1921 study *Adventures in the Arts*, he devoted a section to O'Keeffe; he remarked on the intensely personal quality of her painting, saying that she was "impaled with a white consciousness."[24] O'Keeffe saw Hartley's 1916 exhibition at 291 and borrowed from Stieglitz a Hartley painting she admired. Many years later she wrote, "I have had much of Hartley in my life as you know and I have chosen one of those German ones to keep."[25] Of all Hartley's subjects, the most meaningful to O'Keeffe remained his esoteric symbolic abstractions produced in Germany.

Arthur Dove's longtime goal in painting was extraction from nature, the distillation of its essence. Starting with his first abstractions in 1910, natural phenomena—like waves, wind, and lightning—often inspired Dove to create abstract paintings of great rhythmic power. And, as Maurice Tuchman has pointed out, the impetus for these transcendent qualities lay in mysticism: "Dove's paintings before 1920 coincide with his interest in vitalism; works after 1920 were directly inspired by Theosophy and reflect his interest in astrology, occult numerology, and the cabala."[26]

O'Keeffe began to incorporate similar ideas and forms into her paintings during the late 1910s. In *From the Plains I* (1919), serrated forms reminiscent of Dove suggest, as Charles Eldredge writes, "the turning of the cosmic sphere." "Through their pictorial imaginations," he continues,

O'Keeffe and Dove transported themselves from the mundane plane to a God's-eye view, witnessing the world wheeling in the infinite. Through their abstractions they sought to capture the vital essences of nature, a unity of micro and macro, of man and universal spirit. In this endeavor they were part of America's spiritual tradition.[27]

Though it is now clear that O'Keeffe was seeking connections with first causes and primal forces, she would not have said so openly. Except for a few brief catalog statements, O'Keeffe rarely communicated with the public in written words. As late as 1937, Dove told Stieglitz that he "hardly knew that she could read and write."[28] It suited O'Keeffe's public image to be so regarded. Seeming intuitive, subjective, even a bit naïve freed her from the obligation to refute critics and—more important—from the expectation that she would somehow "explain" her paintings. Besides, O'Keeffe had been wounded by the critics. She was bothered by the things they said about her work, from the psychosexual readings given her flower paintings in the 1920s to Greenberg's dismissive statement quoted above. Throughout her career, O'Keeffe often insisted that her paintings should speak for themselves. Asked at age eighty to discuss the meaning of her art, she snapped, "The meaning is there on the canvas. If you don't get it, that's too bad. I have nothing more to say than what I painted."[29]

Such acerbity reflects more than a desire for privacy. More fundamentally, O'Keeffe believed that art was both ineffable and, paradoxically, a private language—a means of communicating between two people.[30] The belief that art constituted a language of its own was common in modernist thinking early in this century. But it was also a much older idea. The young Michelangelo was immersed in Neoplatonism, whose myths were deliberately couched in exotic language, and—according to his contemporary Pietro Aretino—desired that his images be understood only by a few.

Throughout her career O'Keeffe vacillated between her twin desires for public understanding and her need for a private expression. When she made highly subjective "abstract portraits" of friends (a few years after Hartley's), they seemed to her photographically real: "I remember hesitating to show the paintings, they looked so real to me. But they have passed into the world as abstractions—no one seeing what they are."[31]

Over the years O'Keeffe became extraordinarily skilled in disguising the strong subjective content in her work. In a typically dualistic fashion, it became important to her to be understood on one level, but not on all: "I have

a curious sort of feeling about some of my things—I hate to show them—I am perfectly inconsistent about—I am afraid people won't understand—and I hope that they won't—and am afraid they will."[32]

Another concept central to the complexity of modernist painting was that of the fourth dimension, conceived in many ways but linked to the visual arts especially as it was popularized by Theosophy.[33] By denying a clear reading of three-dimensional space and objects (as in cubism), some artists hoped to suggest a higher dimension. These were the ideas conveyed in Claude Bragdon's writings but discussed even earlier in Europe. Picasso and Apollinaire, among the avant-garde in Paris, were puzzling over the fourth dimension shortly after the turn of the century. Before she came to know Bragdon's writings, O'Keeffe had encountered the idea of the fourth dimension through an influential essay by Max Weber published in *Camera Work* in 1910. Weber, who had studied with Dow and shared his interest in the spiritual aspects of art, had spent the years 1905 to 1908 in Paris. There he heard discussions of the fourth dimension-modern painting nexus. His article in 1910 included a discussion of the "dimension of infinity": "In plastic art, I believe, there is a fourth dimension which may be described as the consciousness of a great and overwhelming sense of space-magnitude in all directions at one time. . . . It is the immensity of all things."[34]

For more than half a century, this desire for the infinite manifested itself in O'Keeffe's life and art. In a way remarkably similar to Weber's description, she wrote to Anita Pollitzer in 1915 of having "something to say and feel[ing] as if the whole side of the wall wouldn't be big enough to say it on and then sit[ting] down on the floor and try[ing] to get it on a sheet of charcoal paper."[35] Reducing cosmic immensity to human size would preoccupy O'Keeffe repeatedly. More than forty years later she again wrote about questions of scale and vastness that still echo Weber's mystical statement: "When I stand alone with the earth and sky feeling of something in me *going off in every direction into the unknown of infinity* means more to me than any thing any organized religion gives me" (emphasis added).[36] Clearly she allied the vastness of the western sky with Weber's "space magnitude." For O'Keeffe, her life and her art were an adventure into the unknown, the infinite. She longed, as mystics do, to achieve a state of oneness with ultimate reality by venturing into the unknown:

I feel that a real living form is the natural result of the individuals effort to create the living thing out of the adventure of his spirit into the unknown—

where it has experienced something—felt something—it has not under-
stood—and from that experience comes the desire to make the unknown—
known.[37]

O'Keeffe's desire for merger with the unknown encouraged her to explore
it both inside and outside herself. Dreams, that mysterious realm of oddly jux-
taposed visions and words, were a source of much inspiration. As she learned
to trust her vision, O'Keeffe could allow her mind to move freely between
dream and external reality. She recognized that her paintings depended on
both: "I hadn't worked on the landscapes at all after I brought them in from
outdoors—so that memory or dream thing I do that for me comes nearer re-
ality than my objective kind of work—was quite lacking—."[38]

What O'Keeffe seems to be saying is that memory or dream is usually a
component of her abstract work—the catalyst that transforms objective, phys-
ical vision into a larger reality. Imagination was as real to O'Keeffe as objects.
As easily as she could call up remembered outdoor scenes, O'Keeffe could in-
voke the presence of absent persons. After the death of Stieglitz, O'Keeffe
often imagined his presence at her homes in New Mexico, where he had
never visited. In 1956 she wrote to a distant friend: "This seems to be the week
you have come to my house tho you were only present in thought—Maybe
that is as real as anything."[39] Here again, she equates dream with reality,
thought with matter. Still echoing in her words are Weber's, written nearly a
half-century earlier: "Only real dreams are built upon. Even thought is mat-
ter. It is all the matter of things, real things or earth or matter."[40]

As the years passed, Stieglitz did much (perhaps without intending to) to
stimulate O'Keeffe's metaphysical thinking. His own work moved from a firm
grounding in the physical world to a somewhat more ethereal approach. In
his famous *Equivalents* series of cloud photographs, Stieglitz silently ap-
proached the mystical concept that mind and matter are one. In the clouds,
he wanted to show that his photographs transcended subject matter concerns
to become more of a metaphysical expression. In his photographs and in his
beliefs, Stieglitz referred often to sharp visual contrasts—the black and white
of seeing. Though he felt himself sometimes "gray" in being, he thought of
O'Keeffe as "Whiteness," a quality described by Roxana Robinson as "a meta-
physical purity based on her clarity of vision and the lucid wholeness of her
mind, which set her apart from other women and, in fact, all other people."[41]
Using language similar to that of Hartley, noted above, Stieglitz envisioned
her pure artistic spirit as white, and, as he wrote in 1923, "I have a passion for

Whiteness in all its forms."[42] A few years earlier he had written of O'Keeffe's surroundings:

> Her room is a Whiteness
> Whiteness Opens its Door
> She Walks into Darkness
> Alone[43]

Stieglitz's imagery must have made a deep impact on her, for O'Keeffe used it repeatedly in her future paintings and her letters. She carried her "whiteness," that is, her spirit of artistic discovery, with her into the dark unknown. As she wrote in 1930, "My feeling about life is a curious kind of triumphant feeling about—seeing it black—knowing it is so and walking into it fearlessly."[44] Walking into blackness is suggested vividly in a number of O'Keeffe's paintings. *The Flagpole* (1923; reproduced in *Georgia O'Keeffe*, no. 35) abstracts a few elements of a small building at the Lake George family compound, where she and Stieglitz summered. Used by Stieglitz as a darkroom, the interior of the little building looked black through the open door. When O'Keeffe painted it, she accented its black rectangle of a door. Beyond the visual impact lies a certain symbolic aspect. In one sense, the small black door represents the unknown, the future. But it also signifies a mysterious, dark place where creativity could flourish—where Stieglitz could bring forth his photographic images. As much as O'Keeffe liked the door in a formal sense (demonstrated in her decades-later repetition of the motif; *Georgia O'Keeffe*, pl. 36) its symbolic value in *The Flagpole* must be counted at least as significant.

The formal "punch" of a single door in a simple wall appears in number of later paintings of her home in New Mexico. She bought her house at Abiquiu, New Mexico, she maintained, because of its patio door. And she recorded that shape—sometimes a dead-end black rectangle, sometimes as a mystical passage through to the light—in paintings that seem more than studies of form (see figs. 80–83 in *Georgia O'Keeffe*).

Walking into blackness is suggested vividly in a number of O'Keeffe paintings, where doors are certainly a metaphor for moving between realms. To Aaron Copland, whose music did not touch her sensibilities as she wished, O'Keeffe lamented, "Maybe I can get to the music one day—It is to me as if our worlds are so different that I dont seem able to get through the door into yours—."[45] Like recurrent musical motives, the mystical dualities of black-

ness and whiteness continued to appear in O'Keeffe's paintings for years. *Black and White* (1930), *Black Abstraction* (1927), and *Lily—White with Black* (1927) all exemplify some of the universal paired opposites central to mysticism.

When she explored the landscape of northern New Mexico and Arizona, O'Keeffe found places where the physicality of blackness and whiteness entered the land itself. Driving through Navajo country in 1937, she came across the "Black Place," and between 1940 and 1949 she painted some fifteen works inspired by this natural formation. Recurrently, she used a **V** configuration, with lights and darks zig-zagging through like lightning or, more gently, folding into each other to express both the physical undulations and the dualities of forms flowing together.

The "White Place," located in a rocky cliff face near O'Keeffe's Ghost Ranch home, has an austerity and majestic verticality about it that links this natural rock formation to the human-made monumentality of Greek temple columns or the pale monochrome towers of a medieval cathedral, with its cool dark interior an enclosure for sacred spaces or veiled cult images. The metaphor is not unlike the outer and inner aspects of O'Keeffe herself.

But even while exploring the implications of value opposites she began to engage the more complex spiritual affinities of color pairings. Again, she turned to Kandinsky. In his *Concerning the Spiritual in Art*, O'Keeffe had read Kandinsky's comments on the duality between certain pairs of hues; for example:

> The relationship between white and yellow is as close as between black and blue, for blue can be so dark as to border on black. Besides this physical relationship, is also a spiritual one (between yellow and white on one side, between blue and black on the other) which marks a strong separation between the two pairs.[46]

A look at O'Keeffe's *Black Spot No. 3* (1919; fig. 34) instantly confirms that O'Keeffe must have been experimenting with Kandinsky's theories.[47] Wedged diagonally into the composition is a motionless rectangle of black, trailing off into gray. Edging in against it from several directions are bulging, organically derived shapes in blue, pale yellow, and green—all made more distinct and alive through their juxtaposition with the inertia, the inorganicity of black. Using a color scheme nearly identical to that noted above by Kandinsky, O'Keeffe has attempted more than a study of shapes. She has married the spiritual with the physical properties of color, achieving a union of

FIG. 34.
Georgia O'Keeffe,
Black Spot No. 3 (1919),
oil on canvas, 24 x 16
in. (Courtesy Albright-
Knox Art Gallery, Buf-
falo, New York; George
B. and Jenny R. Math-
ews and Charles
Clifton Funds, 1973)

image and sensual effect. By translating them into abstract forms, O'Keeffe could express an equivalence of mood (as Stieglitz had done) denied to most painters of representational form.

On the rare occasions when she could be persuaded to say a few words about color in her work, O'Keeffe sometimes provided an extraordinary insight—perhaps without meaning to. Asked by the director of the Cleveland Museum to comment on their just-purchased painting *White Flower, New Mexico*, the artist addressed several issues pertinent here: "The large White Flower with the golden heart is something I have to say about White—quite different from what White has been meaning to me." What white had previously meant to her, as we have seen, refers to the admixture of ideas she acquired through Kandinsky, Stieglitz, and Hartley. But she had painted

FIG. 35.
Georgia O'Keeffe Near "The Pink House," Taos, New Mexico (1929). Photographer unknown. (Photograph courtesy Museum of New Mexico, Santa Fe; negative no. 9763)

white flowers before. What was different about this flower, this "White"? She continued:

> I know I can not paint a flower. I can not paint the sun on the desert on a bright summer morning but maybe in terms of paint color I can convey to you my experience of the flower or the experience that makes the flower of significance to me at that particular time.[48]

What was significant about this particular bloom may not have been the flower itself, or even its whiteness, but a set of new experiences that surrounded it. For this is one of the first flowers O'Keeffe painted in New Mexico. Outside her door at Mabel Dodge Luhan's Taos compound stretched a

whole carpet of these blooms, inviting her consideration of their presence in a high-desert setting where the mere presence of wildflowers is reason for pause, for joy.

At Taos in 1929, the world looked new to O'Keeffe (fig. 35). Released from Stieglitz's shadow, she stepped into the transforming sunshine of New Mexico. She had known for a year that a change was necessary; to a friend she confided, "When I saw my exhibition last year [1928] I knew I must get back to some of my own ways or quit—it was mostly all dead for me—Maybe painting will not come out of this—I dont know—but at any rate I feel alive—and that is something I enjoy."[49]

Feeling alive meant that O'Keeffe wanted to experience every new thing she could in New Mexico. Away from the sometimes stifling nurture Stieglitz provided, she could choose her own friends, her own subjects, and her own life-style.[50] With her friend Rebecca Strand she witnessed Indian ceremonials, camped out, learned to drive, and visited scenic wonders in nearby Arizona, Colorado, and Utah. Mabel Dodge Luhan was away from Taos for much of the summer, but her Pueblo husband Tony Luhan often accompanied O'Keeffe and Strand. On one occasion the three drove to a rodeo in Las Vegas, New Mexico, where they consumed some bootleg whiskey. To Mabel, who had once experimented with peyote, O'Keeffe wrote that the next morning she had experienced a state of unusual mental clarity.

Out of that heightened state of consciousness came an enigmatic painting she called *At the Rodeo—New Mexico* (fig. 36). Its direct visual source may lie in the circular concha decoration on an Indian headdress, as Roxana Robinson has suggested, but the image suggests much more. Pulsating with cosmic energy and vibrations, O'Keeffe's painting is strongly reminiscent of mystical diagrams or mandalas common in the work of Ouspensky (known to O'Keeffe via Bragdon), Blavatsky (a favorite source for Hartley), and Buddhist philosophy. (see pp. 22–23 in *The Spiritual in Art*). Like a great kaleidoscope, like the opening iris of an eye, like a Lamaist mandala to be studied in preparation for meditation, O'Keeffe's circular form evokes the presence of a kind of sacred geometry. Common as a means of describing nature and identifying life-forms, the circle has often been linked with various mystical tenets, especially the belief that the universe is a single, living substance.

Another compelling visual consonance (probably unknown to O'Keeffe) lies in the cosmic imagery of Hildegard von Bingen, the twelfth-century German abbess and mystic whose visions, the product of mystical contemplation, were recognized by the papacy and established her as a prophetic voice

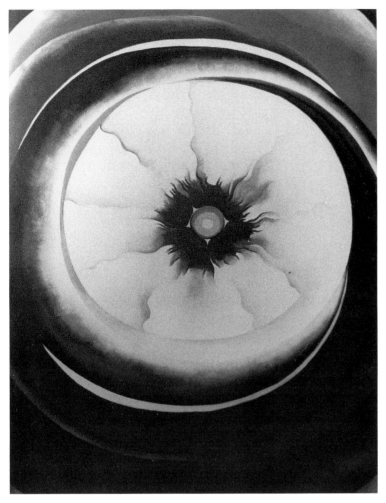

FIG. 36. Georgia O'Keeffe, *At the Rodeo—New Mexico* (1929), oil on canvas, 40 x 30 in. (Private collection; photograph courtesy Andrew Crispo Gallery, New York)

within the medieval Catholic church. Hildegarde's visions, recorded in vivid paintings of ovoid or circular form, encompass much of the scientific and religious knowledge of her day. Her *Scivias* ("Know the Ways of the Lord") appears to be one of the first medieval manuscripts in which the artist uses line and color to reveal the images of a supernatural contemplation. In the twentieth century Charles Singer and others have dismissed her visions and the paintings made from them as nothing more than auras of chronic migraine. But whatever their immediate source, they retain a remarkable similarity to

the circular cosmic imagery found in mystical diagrams and in the work of O'Keeffe. Robinson, incidentally, cites an instance in 1916 when O'Keeffe explained to Stieglitz that the shape in a drawing had come to her while she had a headache.[51]

In Theosophical terms, O'Keeffe's rodeo painting preserves a moment of self-realization—perhaps the first in a long process of discovery that spanned five decades of O'Keeffe's presence in the Southwest. Such self-realization can come, according to mystics, by illumination, accident, or an induced state; O'Keeffe's rodeo experience may qualify as all three.

Other O'Keeffe paintings from about the same time exhibit similarly conscious preoccupations with rhythmic geometry and color. *Pink Abstraction* (1929) is similarly conceived, as is *Abstraction, Blue* (1927). She probably also knew Dove's *Distraction*, a 1929 abstraction based, according to Maurice Tuchman, on circular forms borrowed from the mystical William Blake.[52]

O'Keeffe's longstanding affinities for the mystical were perfectly congruent with a certain transcendent quality often remarked upon by visitors to New Mexico. Critic Paul Rosenfeld, who had written several articles on O'Keeffe in the early 1920s, visited the state in 1926. In a mystical fashion, he called New Mexico "the penetralia of the continent, the secret essence of America, the mysterious projection of a long dormant idea."[53] During her early years in New Mexico, O'Keeffe gravitated to sensitive, like-minded individuals who sought the spiritual content of the land. During the same summer she visited the rodeo she traveled around the state with Marie Tudor Garland, poet, painter, and author of *Hindu Mind Training* (1917) and *The Winged Spirit* (1918). Two years later, in 1931, they again shared responses to the land when O'Keeffe spent the summer at Garland's Alcalde, New Mexico, ranch.

Also present in New Mexico during those years was feminist writer Mary Austin, whose concerns with women's issues and training as a naturalist grew into "a passionate mystical identification with the land and an outrage against the misuse of women's gifts."[54] Austin wrote of "American rhythms" based on the spiritual harmony of the Indian lifeway with that of the earth itself. She also wove eloquent metaphors of the land as woman; in *Lost Borders* she might have been describing an O'Keeffe landscape, decades before it was painted: "If the desert were a woman, I know well what like she would be: deep-breasted, broad in the hips, tawny, with tawny hair . . . eyes sane and steady as the polished jewel of her skies."[55]

Austin, O'Keeffe, and Mabel Dodge Luhan, all highly conscious of the

spiritual content of the land, expressed it in highly individualized terms. Lois Rudnick has noted that Luhan wrote an unpublished novel, "Water of Life," in which she deals with Eastern religious references.[56] Luhan too was an outspoken apologist of the lure of New Mexico. She rhapsodized to O'Keeffe and to the world in general the virtues of the untouched, harmonious life possible in isolated Taos.

At one time O'Keeffe hoped that women writers like Mabel Dodge Luhan could provide the kind of sensitive, personalized account of her work denied her by most male critics. In an article published in 1931, Luhan saw O'Keeffe's creative process itself as a manifestation of the mystical. According to Luhan, Taos was a catalyst for O'Keeffe's artistic and spiritual growth:

> Certainly her painting, following its secret flow from her brain and hand, was intensified and deepened there in Taos and God knows she needed, to our more ordinary vision, no more intensity or depth. Yet in her work she added to them, and more significant still—let us never forget it is more significant—in her being she became intensified and deepened.[57]

Unfortunately, other of Luhan's attempted criticism only perpetuated the kind of psychosexual interpretations O'Keeffe's work had been given by male critics in the 1920s, and which she abhorred. In an unpublished article, Luhan wrote that O'Keeffe "externalises the frustration of her true being out onto canvases which, receiving her outpouring of sexual juices, . . . permit her to walk this earth with the cleansed, purgated look of fulfilled life!"[58] Probably more to O'Keeffe's liking, though it too remained unpublished, was an article about her by Taos painter Lady Dorothy Brett. Titled "Remembered Life," it began with the intriguing line, "Man thinks *about* Life—Life thinks in Woman."[59] Brett's own mystical inclinations opened the door to that aspect of O'Keeffe.

Absent when O'Keeffe arrived at Taos, but surviving vividly in his writings, was D. H. Lawrence, whose works O'Keeffe read throughout her life. Lawrence, whose sense of place was highly mystical, had spent much time in the Taos area between 1922 and 1925. He wrote, "I feel like a Columbus who can see a shadowy America before him: only this isn't merely territory, it is a new continent of the soul."[60]

Another of O'Keeffe's favorite writers during her years in New Mexico was James Joyce, whose aesthetic theories corresponded closely to her own. Joyce's formula for the esthetic experience was that it does not move you to want to

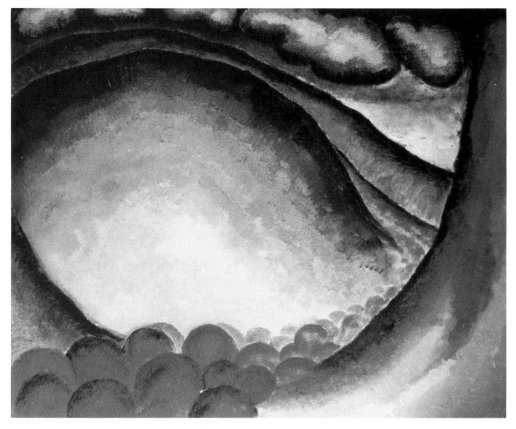

FIG. 37. Georgia O'Keeffe, *Special No. 21* (1916), oil on board, 13 x 16 in. (Courtesy Museum of Fine Arts, Museum of New Mexico, Santa Fe)

possess an object, but rather to hold it and "frame" it. Then you can see it as one thing, while observing the relationship of part to part, the part to the whole and the whole to each of its parts. This is the essential aesthetic factor for Joyce—the rhythmic relationships. When discovered by the artist, he believed, there occurs a radiance, an epiphany.

In mystical thinking the idea of epiphanies is suggested by heat, fire, or light. O'Keeffe often used such imagery in her paintings, starting long before she came to New Mexico, when she wanted to transcend the literal. *Special No. 21* (1916; fig. 37) and *Light Coming on the Plains I and II* (1917) are watercolors of effulgent, disembodied light, removed from their source in the West Texas landscape.

Similar is the effect of her *Red Hills, Lake George* (1927; fig. 38), in which

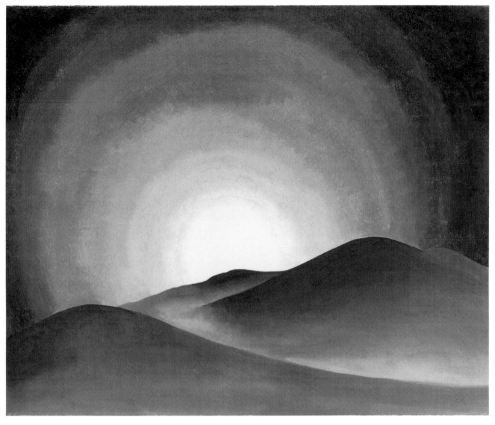

FIG. 38. Georgia O'Keeffe, *Red Hills, Lake George* (1927), oil on canvas, 27 x 32 in. (Courtesy Phillips Collection, Washington, D.C.)

soft rings radiate outward, seeming to ignite a fiery redness in the hills below. This Lake George painting, which presages many of her New Mexico works, is one of O'Keeffe's most disembodied landscapes. Surely a landscape of the mind, this painting strongly suggests the epiphany released by heat, fire, and light.

In New Mexico O'Keeffe sometimes invented or combined landscapes that enhance the spiritual effect of her paintings. She wrote of the experience of painting Penitente crosses in the hills:

> It was in the late light and cross stood out—dark against the evening sky. If
> I turned a little to the left, away from the cross, I saw the Taos mountain—
> a beautiful shape. I painted the cross against the mountain although I never

saw it that way. I painted it with a red sky and I painted it with a blue sky and stars.[61]

She continued, "I painted a light cross that I often saw on the road near Alcalde. . . . I also painted a cross I saw at sunset against the hills near Cameron. . . . The hills are grey—all the same size and shape with once in a while a hot-colored brown hill. . . . For me, painting the crosses was a way of painting the country." They were, she added, "like a thin dark veil of the Catholic Church spread over the New Mexico landscape." Charged with spiritual content and complexity, yet pristine in their geometric spatial divisions and their balance of horizontal and vertical elements, they are at once material and immaterial.

For O'Keeffe the sun was a mystical source of life, passion and health.[62] In 1932 she did not summer in New Mexico; then, in the fall, following a series of difficult events, she experienced the onset of an emotional illness. She wrote to a friend in New Mexico, "I miss the sun—that sun that burns through to your bones."[63] And she had remarked earlier on the lack of passion—of fire—in her friend Charles Demuth's work. She described a group of his paintings as "very fine—Only maybe I begin to feel that I want to know that the center of the earth is burning—melting hot." She wanted, in other words, to experience the epiphany released by heat, fire, and light.

But it was not all drama and passion. The quiet openness of the plains in Texas, experienced in her youth, and her later encounters with the vastness of the New Mexico high desert all inspired peak experiences for O'Keeffe, who let the profound silences speak to her: "My world here," she wrote from Abiquiu, "is a world almost untouched by man."[64]

But if the silences nourished her search for self, so did the rhythmic aural relationships cherished by Austin and Joyce. In 1954 O'Keeffe painted a reprise of her 1919 *From the Plains I.* Thirty-five years after she left Texas, she experienced a cyclical reencounter with its haunting, unforgettable sounds. It was a wordless drone, like the endless throbbing of the universe, but rising out of the flatness of the Texas plains. O'Keeffe described it thus:

> The cattle in the pens lowing for their calves day and night was a sound that has always haunted me. It had a regular rhythmic beat like the old Penitente songs, repeating the same rhythms over and over all through the day and night. It was loud and raw under the stars in that wide empty country.[65]

The silence out of which the sound comes, back into which it goes, is a

FIG. 39. Georgia O'Keeffe, *Pelvis with Moon* (1943), oil on canvas, 30 x 24 in. (Courtesy Norton Gallery of Art, West Palm Beach, Florida)

metaphor for the eternal, the infinite, the sublime. Prodigious expanse of space is sublime, as are the storms, the wind, the burning sun of the Southwest. Difficult to express, distinct from the beautiful, the sublime appears repeatedly in O'Keeffe's work. In *From the Plains* I and II it finds synesthetic expression—sound given visual form.

In the 1930s, when she began to exhibit paintings based on animal skulls

and bones, O'Keeffe intended them as another definition of her feeling about the Southwest. "To me," she wrote,

> they are strangely more living than the animals walking around—hair, eyes and all with their tails switching. The bones seem to cut sharply to the center of something that is keenly alive on the desert even tho' it is vast and empty and untouchable—and knows no kindness with all its beauty.[66]

When she painted *Pelvis with Moon* (1943; fig. 39), O'Keeffe combined powerful symbols that add up to an experience of the infinite. The holes in animal bones through which O'Keeffe framed the vastness of the sky are, like the doorways in her house, passages to other states of mind. Clear, always in focus no matter how far away, they frame and hold (as Joyce said) an aesthetic experience. And they engage the viewer in visual play: held up against the sky, which are the solid forms, which the negative spaces? Zen scholar Alan Watts, with whom O'Keeffe had contact in her later years, equated such concepts with Buddhist philosophy: "form is emptiness, and emptiness itself is form."[67] In the end, they become interchangeable.

Another element here and in many other O'Keeffe paintings is the moon. Circular symbol of continual rebirth, the moon is an image of cycles and seasons associated since prehistory with women (as are the animal horns, ancient attributes of the Great Goddess, so often seen in O'Keeffe's paintings). Below the moon is O'Keeffe's beloved Pedernal, the mountain she jokingly said God had promised to give her if she painted it often enough. (The Pedernal's distinctive truncated shape, incidentally, is nearly an exact duplication of Kandinsky's symbolic painting *Blue Mountain* (plate 1).

Lucy Lippard has pointed out that the Navajo believe the Pedernal to be the birthplace of their legendary "Changing Woman," who represents both earth and time—literally "a woman she becomes time and time again."[68] Female too are the contours and surface Lippard and Roxana Robinson have seen in O'Keeffe's paintings of the land, though the artist stopped short of making such direct connections. There is, however, an undeniable sensuality in her surfaces, an eroticism more subtle than the flower paintings, but there just the same, uniting living forces in earth, plant, and human. In her serene, meditative paintings O'Keeffe quietly celebrated these connections, and on rare occasions made oblique verbal comments; describing the mud-plastered surface of her adobe home at Abiquiu—soft, warm, and pinkish like human skin—she wrote, "Every inch has been smoothed by a woman's

hand." These are the kinds of primal connections O'Keeffe intuited, linking ancient truths to the present in a land that encouraged the cyclical, mythic transcendence of time into the eternal.

Pelvis with Moon is a painting full of the mystery of life and death—a religious painting in the sense that *religion* means linking back the phenomenal person to a source. O'Keeffe denied formal religion, yet she made intensely spiritual paintings. When a prominent Catholic priest visited her at Abiquiu, she remarked that compared to the "rock" of her life, the church seemed like a mound of jelly.[69] By this time O'Keeffe had left the vestiges of Roman Catholicism in her upbringing far behind. Building on the early influences absorbed from Dow and Hartley, she immersed herself in Zen Buddhism and in Eastern mystical texts like *The Secret of the Golden Flower, a Chinese Book of Life*.[70] In its extensive commentary by Carl Jung she could again consider the congruencies and conflicts between Eastern and Western thought. And it gave her new ways to think about herself as woman and to understand the profound relationship she felt to the land.

As Jung interpreted the *Golden Flower* text, the Anima found within it was "called *p'o*, and written with the [Chinese] characters for 'white' and for 'demon,' that is, 'white ghost,' [who] belongs to the lower, earth-bound, bodily soul, the yin principle, and is therefore feminine." By contrast, noted Jung, the Animus or *hun*, is written with the characters of 'clouds' and 'demon,' that is "'cloud-demon,' a higher 'breath-soul' belonging to the yang principle and therefore masculine."[71] It is tempting, again, to look for such symbolism in O'Keeffe's paintings. Did she consciously identify herself with the lower, feminine earth forms in her New Mexico landscapes? Are the floating clouds or suspended sky-forms masculine? These are intriguing questions, but highly speculative ones—unanswerable with any satisfying degree of certainty. More probable are loose resonances with her longtime mystical affinities: paired opposites, analogies of things above with those below, the reality of imagination, and the ultimate unity of mind and matter. In *The Secret of the Golden Flower* the Chinese duality of a feminine earth and masculine sky must have reminded O'Keeffe of her musings back in 1916 on masculine/feminine color and value oppositions. Now, nearly half a century later, it might also have suggested the well-known Mother Earth/Father Sky duality familiar to Native Americans in the Southwest (and elsewhere in history).

To O'Keeffe, as to Carl Jung, religion itself could become a barrier to religious experience. In other words, when religion is reduced to concepts and ideas, it can block the path to transcendent experience. The image of God it-

FIG. 40. Todd Webb, *Ladder and Wall, O'Keeffe's Abiquiu House* (1956). (Courtesy Museum of Fine Arts, Museum of New Mexico, Santa Fe)

self becomes the final obstruction. These ideas, of course, are basic to both Hinduism and Buddhism, as O'Keeffe recognized in her later years. It is also mysticism in its most stringent application: that in doing away with images altogether comes an unmediated vision of the Godhead. Yet, in actual practice, mystics through the ages have found images useful in constructing a kind of pictorial approximation of their visionary world or as aids to meditation. O'Keeffe's well-known *Ladder to the Moon* is such a painting, reminiscent of medieval apocalyptic manuscripts in which the heavens open to receive the saint, climbing upward on a ladder. But O'Keeffe's immediate inspiration was from the reality of her surroundings, caught in 1956 by photographer Todd Webb (fig. 40), who positioned O'Keeffe's ladder against her patio wall near the celebrated black door. In its spare simplicity of forms, the photograph (like O'Keeffe's eye) isolates the abstractions in her lovingly arranged world at Abiquiu. She relished their apparent contradictions; the abstractions are at once formally pure and intensely personal. "The abstract," O'Keeffe concluded, "is often the most definite form for the intangible thing in myself that I can only clarify in paint."[72]

O'Keeffe came to realize that the ultimate mystery can be experienced in two senses, one without form and the other with form. She drew the distinction herself in a 1951 letter: "I am really most fortunate that I love the sky—and the 'Faraway'—and being so rich in those things—tonight I'll send you the moon—"[73] The "Faraway," as she called it, was O'Keeffe's personal metonym for the mystical as revealed in nature. And the impulses of mysticism expressed visually—cosmic imagery, vibration, duality, synesthesia, and sacred geometry—are all there in O'Keeffe's work. Whether one calls them peak experiences, epiphanies, philosophical monism, or encounters with the sublime, they were moments of self discovery. And, thanks to her ability to give form to the infinite, she left us with a powerful visual record of that search.

MODELS OF
CONSCIOUSNESS

Myth and Memory in the Work of
Georgia O'Keeffe, Eliot Porter, and Todd Webb

Painting and photography—what do they have to say to each other in the 1990s? Now, when breakdown of media barriers has blurred formerly discrete categories, we concern ourselves less with the separate character and capabilities of each. But that wasn't so a century ago. From photography's inception in the mid-nineteenth century, a great debate surrounded the new medium and its relationship to painting. At first photography sought to emulate painting, even as it challenged painters with new ways of seeing. All that has been too well documented to need repeating here.[1]

With the advent of a modernist aesthetic in the visual arts late in the nineteenth century, new formal languages developed, drawing on (among other sources) the vocabularies of both painting and photography. Nowhere was this better seen in the United States than in the circle around Alfred Stieglitz, a photographer himself, and an advocate of modernism in both painting and photography. His protégés included Georgia O'Keeffe and Paul Strand, who in the late 1910s were pressing questions of abstract composition and design in their work.

Several writers, including Barbara Rose, Charles Eldredge, and Robert Hughes, have asserted the primacy of photography in shaping O'Keeffe's modernist vision. Hughes said it most succinctly:

Her main stylistic affinities are less with other American or European painting than with photography: the work of Stieglitz, but especially of her

friends Paul Strand and Edward Weston, obsessed with sharp focus, clear emblematic shapes of stone, bone and weathered root, the far telescoped into the near.[2]

Almost from the beginning O'Keeffe acknowledged her connections to photography. Not long after she had first seen Strand's work she commented that she was "making Strand photographs for myself in my head."[3] O'Keeffe also recognized the longtime cross-fertilization of her work with the photographs of Stieglitz. Writing on his 1924 photographs of clouds, she said, "He has done with the sky something similar to what I had done with color before. . . . it is amazing to see how he has done it out of the sky with the camera—."[4] These early formative influences have been studied.[5] Less well known are O'Keeffe's later affinities with photography and photographers, and it is that aspect of her career that I want to discuss here.

In the Southwest, where she spent increasing periods of time after 1929, O'Keeffe's professional and personal connections with photographers continued. There is much we can learn from looking at her associations with Ansel Adams, Edward Weston, and Laura Gilpin, for example. But here I'd like to focus on two other photographers, Eliot Porter and Todd Webb, who shared important formal and subject interests with O'Keeffe.

Porter (1901–90), like O'Keeffe, was a transplant to the Southwest who had been born in the Midwest and lived long in the East. They met in the 1930s when Porter, then a research physician at Harvard, showed his photographs to Stieglitz. In 1938 Porter exhibited his nature photographs at An American Place; immediately critics saw in his work his affinities with painting. The *New York Sun* critic wrote, "Mr. Porter is unquestionably an artist who looks upon nature with the appreciative eye of a painter. . . . [he] gains a rank at once among our serious photographers."[6]

With that kind of critical reception and the backing of Stieglitz, it's not surprising that Porter (fig. 41) soon resigned his scientific post for a life in photography. (He recalled, years later, "It seemed obvious to me that I was a better photographer than scientist, and so I resolved to give up teaching and research for photography."[7]) When the Porters moved to New Mexico, their friendship with O'Keeffe deepened, in part due to a mutual reverence for the Southwest landscape. Over the years they traveled together, among other places to Mexico in 1951.

On O'Keeffe's part, that trip seemed a good idea for several reasons. Since Stieglitz's death in 1946 she had spent many months settling his estate, dis-

posing of his vast collections of photography and paintings, and looking forward to the time when she could resettle permanently in New Mexico. Her two homes there, at Ghost Ranch and at nearby Abiquiu, beckoned her to a

FIG. 41. *Eliot Porter in New Mexico* (c. 1940s). (Shaffer Studios photograph; courtesy Harry Ransom Humanities Research Center, University of Texas at Austin)

life of quiet, simplicity, and concentrated work. Though she transferred her permanent residence to New Mexico in 1949, it was not until she finally closed An American Place in December 1950 that she felt the tentacles of her New York life beginning to let go. To her friend William Howard Schubart she wrote late in 1950, "I can not tell you how pleased I am to be back in this world [New Mexico] again—what a feeling of relief it is to me."[8] With the arrival of her stored books, papers, and paintings from the gallery came all the memories of her thirty-year relationship with Stieglitz; at present she was content to stack the boxes and close the door, as she said, on the past. What she needed now, with the approach of a new year, were fresh experiences—both personal and visual—to rejuvenate her enervated creative impulse.

Some of those new experiences would come with the opportunity for increased travel. As the New Mexico winter closed in late in 1950, she thought of escaping the cold. Her first idea was Hawaii, where she had painted in 1939: "I wanted to go to Hawaii again," she wrote, "—this is the first winter I

could go but it doesn't seem a very sensible thing to do with times as they are—So I think of Old Mexico."[9] Learning that Eliot and Aline Porter planned a trip south in February, O'Keeffe and her friend Spud Johnson arranged to drive in tandem with them. Temperatures had plunged to 25 degrees below zero on recent nights in northern New Mexico, and the prospect of missing the last of a bitter winter confirmed the decision. With Porter's camera equipment in their car and a suitcase of painting materials in Georgia's Jeep station wagon, they headed south. At the border, while waiting for tourist cards, O'Keeffe spotted a muralist working on a high scaffold. A frustrated muralist herself, she began shouting up questions about the kind of paint he used and his techniques.

O'Keeffe's curiosity about the country and her pleasure in the new landscapes, the architecture, and the markets seemed boundless. As they motored south on the Pan American Highway toward Mexico City, they stopped at places whose names chronicle the rich mosaic of Mexican history: Santo, Tamazunchale, Jacala, Zimapan, Actopan. Where there were churches of special interest—with imposing sculptured or brilliantly colored facades— Porter's camera came out. Occasionally O'Keeffe pulled out her sketch pad, but mostly she just looked, reveling in the profusion of color or picking trumpet flowers to take along. Porter's photographs from this and a trip five years later eventually became the basis for two books, *Mexican Churches* and *Mexican Celebrations*.

Based historically on European models, Mexico's churches reflect changes that parallel Renaissance, Baroque, and Rococo architecture as it developed across the Atlantic. But distinctive regional variations of these styles appeared in Mexico. As Donna Pierce explains, "Artistic freedom in Mexico allowed the Baroque style to flower in new ways and to absorb a colorful and emotional character."[10] Facades ranged from complex sculptural programs to multicolored tile surfaces in the Puebla region to simple flat facades called espadañas, "often painted in bright colors to enliven the flat surfaces."[11] It was the latter kind of facade, exemplified by Porter's photograph of a Chiapas church (fig. 42), that appealed most to O'Keeffe's reductivist taste. Divided into relational geometric modules, the surface is adorned mainly by its brilliant color wash. In Spud Johnson's journal of the 1951 Mexico trip he recalls their mutual pleasure in a "sweet little white-washed church kalsomined outside in sky blue and white."[12]

Church facades, folk art, fabrics, and murals continued to attract O'Keeffe and Porter during the 1951 trip. O'Keeffe twice visited Frida Kahlo in her stu-

FIG. 42. Eliot Porter, *Facade of San Diego Church, San Cristóbal de las Casas, Chiapas, February 13, 1956.* Copy print from original dye transfer print. (Copyright Amon Carter Museum, Eliot Porter Collection, Fort Worth, Texas)

dio, renewing an acquaintance begun thirteen years earlier during a New York exhibition of Kahlo's work. In Mexico City's National Palace she studied the murals of José Orozco and Diego Rivera and visited her old friend Miguel Covarrubias, watching him paint on the walls of a former church, transformed into a museum. Later, in the Lake Chapala area south of Guadalajara, O'Keeffe and Spud stopped to see Orozco murals in a small library at Jiquilpan. In his journal entry that day Johnson described them as "quite beautiful striking paintings, most of them in stark black & white like enormous charcoal drawings. . . . one of the other panels had 2 great planes of red with the black and white."[13]

The geometry, scale, and chromatic intensity of the Mexican wall paintings and church facades lodged firmly in O'Keeffe's brain. Unlike Porter, who brought back dozens of vivid color photographs from Mexico, O'Keeffe

FIG. 43. Eliot Porter, *Georgia O'Keeffe's Entrance Door, Abiquiu, New Mexico, October 8, 1949.* (Copyright Amon Carter Museum, Eliot Porter Collection, Fort Worth, Texas)

had to rely on her sketches and her prodigious visual memory. But that memory had served her well in the past, and she trusted it now. Besides, it was not detail she needed; not for her the teeming, strident social rhetoric of the Mexican muralists. O'Keeffe had long subsumed her own rigorous moral vigor into a pursuit of formal purity.

Still the Mexican walls themselves—starkly simple or punctuated with a blaze of color, lingered in her mind. Soon after her return from the South she began to look at the walls of her Abiquiu home with a new sense of possibility. As early as the mid-1940s she had begun using a camera to formulate compositional possibilities using the simple adobe wall with its dark doorway—the doorway she said she compelled her to buy and restore the ruined Abiquiu house. From these early camera studies she began her *Patio* series in 1946.[14]

Meanwhile, Porter also trained his lens on the inky blackness of O'Keeffe's patio doors, framing a severe geometric shape through the opening of an outer weathered wooden entrance (fig. 43). More than O'Keeffe's paintings, Porter's photograph contextualizes that rarefied space, allowing us a momentary glimpse into the cloistered privacy of O'Keeffe's world. It is a photograph rich in textural and value contrasts.

O'Keeffe also used value contrasts to strong effect in her early *Patio* series paintings. Now, in 1951, with the color of Mexico fresh in her mind's eye, she wondered how that wall would look with its door transformed into a simple plane of color. She remembered an evening in Mexico when "the sun went down very red into a pale green sea" and began to paint such visual memories.[15] Over the next several years her *Patio* paintings often sang with revved-up color: *Patio Door—Green and Red* (1951; plate 6) pulsates with the hot, acidic color of the South. Like her modernist colleague Marsden Hartley, whose palette had blazed with intense reds and greens during his year in Mexico, O'Keeffe briefly embraced its fiery, saturated color.[16] A year later she still mused on color in architecture: *Wall with Green Door* (1952) extends her experiments with color planes in the patio. When *Patio Door—Green and Red* was exhibited at the Downtown Gallery in 1955, Fairfield Porter (a painter, gifted critic and brother to Eliot), reviewed the show for *ArtNews*. He was the first to see in O'Keeffe's work an anticipation of the next-generation color field work. Fairfield Porter pointed out the "abstract quality of [O'Keeffe's] realism," as well as her "scale and emptiness and Romanticism"—qualities he also saw in the work of color-field painters like Still and Reinhardt. "And her division of space in *In the Patio*," added Fairfield Porter, "has in it some of the design of Rothko. These painters may or may not have been influenced by O'Keeffe, but she did come first, and our present familiarity with these painters should help us to see O'Keeffe's work freshly again, with its sense of the immensity of space."[17]

After a lapse of a few years, O'Keeffe returned to the motif, in her customary fashion, to resume the dialogue with architectural color she had begun in

Mexico. In *White Patio with Red Door*, (1960) the sensibility is at once playful and formally serious, with spare, floating fields of color. The extent of O'Keeffe's influence on American color-field and minimalist painting is arguable; what seems clear is that her Mexican experience (in company with Porter) inspired new chromatic directions in her own work.[18]

FIG. 44.
Todd Webb, *Georgia O'Keeffe Sketching at Glen Canyon, 1961.*
(Courtesy Museum of Fine Arts, Museum of New Mexico, Santa Fe)

Glen Canyon, 1961

Their 1951 trip to Mexico was not the last travel experience O'Keeffe and Porter shared. Joined by photographer Todd Webb and a group of family and friends, they rafted down the Colorado River in 1961. While Porter and Webb photographed, O'Keeffe pulled out her sketchbook (fig. 44). All knew that the Glen Canyon Dam would soon begin to fill the gorge, submerging forever the fiery red walls nature had required centuries to carve.[18] Before it vanished, Porter was determined to preserve a testament of the place. With his camera he recorded the confessions of its violent origins: the layers still visible on its

sandstone walls, he wrote, "evoked visions of thundering torrents, brown with silt and sand, carried down the side canyon from the desert above during the wet period of the last continental glaciation."[19]

Theirs were not the last eyes to gaze at the walls of Glen Canyon, but they were among the most famous. Afloat on the silent rafts the artists drifted past delicate stratifications, shadow patterns, ribbons of intense blue hovering above, and the fresh green river-bottom vegetation whose colors vied for notice with the pervasive redness of sandstone. Abandoning her usual severe black and white, O'Keeffe donned a bright red dress, her own contribution to the floating feast of color.

When the rafts were moored on sandbars for the night, the group spread out sleeping bags under canyon skies. The weather proved capricious; to her friend Ansel Adams, O'Keeffe wrote, "One night there was a fine sand storm—the next night hours of rain with 5 waterfalls roaring down just a bit beyond our heads—but it was good."[20] On sunnier days O'Keeffe wandered along the water's edge, picking up and pocketing the smooth stones she loved to display at Abiquiu (plate 7). Porter, busier with photographing than with collecting, happened upon a rock the color of midnight, water-polished to smooth perfection. O'Keeffe wanted it for herself and asked him outright for it. The photographer demurred, saying it was for his wife. Visiting the Porters' home months later, O'Keeffe spied the coveted rock and pocketed it, to the amusement of the Porter family, who had placed it on a table to tempt her. Eventually, they presented it to her with good grace, and she pronounced it her favorite rock, placing it among the treasured specimens she had begun to paint in the 1930s.[21]

To both Porter and O'Keeffe, the shared experience of Glen Canyon was a momentous one. Exploring connections with the natural processes that have shaped the environment, rendering nature humanly intelligible—these had been longtime preoccupations for both. Each possessed a sensibility capable of fresh and vivid responses to the natural world. And in both cases the work sprang more directly from specific experience than from the secondhand isms of the art world. It is those interpretations of specific experience, along with the long friendship, professional respect, and particularly the formal rigor of their images—that call us to consider their work side by side.

FIG. 45. Georgia O'Keeffe, *Grey Hill Forms* (1936), oil on canvas, 20 x 30 in. (Courtesy University of New Mexico Art Museum; gift of the Estate of Georgia O'Keeffe; copyright 1995 The Georgia O'Keeffe Foundation/Artists Rights Society, New York)

The Black Place

Even before the trips to Mexico and Glen Canyon, O'Keeffe and Porter had ranged separately over the expanses of the Southwest in search of its characteristic topographies. More than once, sharing a love of the spare, dramatic high desert, they found common visual fuel in the same slice of landscape. Beginning in the 1930s, for example, O'Keeffe traveled repeatedly to the Black Place, about 150 miles from Ghost Ranch in northwestern New Mexico.

A place of mystery—dark, massive, nearly bare of vegetation—its voluptuous spareness drew her back again and again. She lost count of the trips she made there, and of the paintings that resulted; her estimate was some twelve to fifteen (see fig. 45). In this landscape, largely unsoftened by vegetation and unchanging amid the cycles of seasons, the very origins of the earth seem to be revealed. Looking around one cold, rainy dawn at the Black Place, O'Keeffe described the scene: "As dismal as anything I've ever seen—everything grey, grey sage, grey wet sand underfoot, grey hills, big gloomy-looking clouds, a

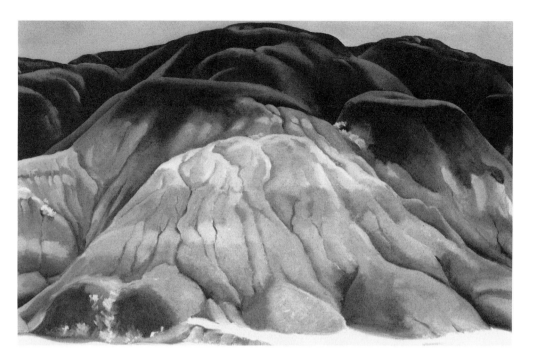

<small>FIG. 46.</small> Georgia O'Keeffe, *Grey Hills* (1942), oil on canvas, 20 x 30 in. (Courtesy Indianapolis Museum of Art; gift of Mr. and Mrs. James W. Fesler)

very pale moon—and still the wind."[22] For O'Keeffe it was a dream of a subject, a place where silence (to borrow John Ashbery's phrase) is the last word. Her multiple versions of it celebrate quite different aspects of the place.

After some initially straightforward renderings of the striated hills at the Black Place in the early 1940s (fig. 46), O'Keeffe began to move away from the banded configurations of the land into a studies of a few favorite spots where color and contour merged in **V**-shaped clefts. In *Black Place I* (1944; fig. 47)and *Black Place II* (1945; plate 8) she first sharpens, then gentles her treatment of its rhythmic joinings. By the time she painted *Black Place Green* (1949; fig. 48), O'Keeffe has reduced the great dark cleft into a massive asymmetrical **V** shape, extending her dialogue with interiority and observed form, with space insistently aspiring to shape. The black and white passages hover, winglike, on a picture plane in which figure and ground move into and out of each other. It is as if she is remembering her teacher Arthur Wesley Dow's advice, based on Japanese design principles, to suppress roundness and nature-imitation in favor of the flat relationship of two-dimensional forms.[23]

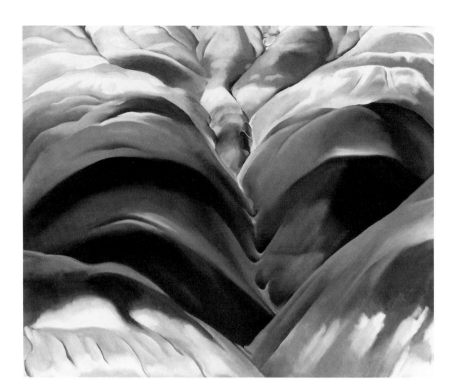

Remembered too is O'Keeffe longtime use of the **V**-shaped cleft—sometimes smooth, often jagged—as a central ordering motif in her compositions. Looking back at her 1920s work, it appears assertively in a pastel like *Lightning at Sea* (1922) and in the great flower blooms and flower-derived abstractions from that decade. *Red Canna, Flower Abstraction* (1924), *A Celebration* (1924), and her multiple paintings of iris blooms all employ the shape and energy of the **V**-shaped cleft.

In her flower blooms and in her paintings of the Black Place, O'Keeffe captured the stirring energies of nature, suffused with a force many critics of her day called sexual. That these paintings marry nature's forces to, in Theodore Stebbins's words, "the abstracted sexual forms of the human body" is difficult to deny today, though O'Keeffe did so insistently during her lifetime.[24] Such protestations, made in a world more prudish than our own, are too well known to need repeating here. Yet we must grant to her denial genuine conviction, for her imagery was always more instinctual than intellectual, without conscious intent as symbol.

Whatever their intent, these paintings strip off layers of detail down to essences which remain, as Malevich wrote of his own austere compositions, a "desert of pure feeling." O'Keeffe's *Black Place* paintings, though rooted in observed reality, *recreate* the site, reshaping raw materials of color and form with the confidence of a primeval female creatrix. Held in check by what Paul Rosenfeld called O'Keeffe's "safeguarding purity of edge," their intensity smolders visibly beneath their very restraint.[25] By the time we consider *Black Place Green*, we know, with Paul Valéry, that "seeing is forgetting the name of the thing one sees."

In the end, questions of artistic intent must be weighed against the persistence of residual painted form. O'Keeffe's great refusal of the symbolic becomes a phenomenon full of its own meaning, a liberating absence. As Susan Sontag describes it, "That absence is really presence, emptiness repletion, impersonality the highest achievement of the personal."[26]

However personally we may construe O'Keeffe's images, we find them preceded always by vision—either external or internal. Kafka once said, "We photograph things in order to drive them out of our minds."[27] It's a statement

FIG. 47. *(opposite, top)* Georgia O'Keeffe, *Black Place I* (1944), oil on canvas, 26 x 30 1/8 in. (Courtesy San Francisco Museum of Modern Art; gift of Charlotte Mack)

FIG. 48. *(opposite, bottom)* Georgia O'Keeffe, *Black Place Green* (1949), oil on canvas, 38 x 48 in. (Promised gift to the Whitney Museum of American Art, New York)

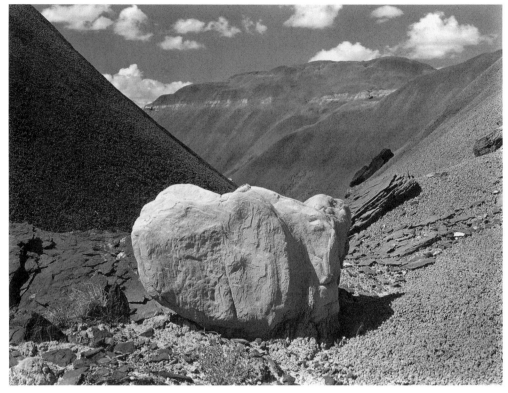

FIG. 49. Eliot Porter, *White Boulder, Black Place, New Mexico* (September 1945). (Copyright Amon Carter Museum, Eliot Porter Collection, Fort Worth, Texas)

reminiscent of O'Keeffe, who remarked more than once that she often painted shapes lodged in her head. When she found a site like the Black Place, where those memory-embedded shapes were visibly replicated in nature, she had added reason to return to it again and again. Like the Chinese painters she so admired, in each thematic reworking O'Keeffe kept the residue of the old, adding seeds of the new; each painting is at once autonomous and part of a mythic continuum.[28]

O'Keeffe commended the Black Place to Porter, writing him in the 1940s after one of her many trips that the most recent three-day visit had been "very good indeed."[29] By then Porter had already seen it for himself. His photographs of the Black Place record an otherworldly expanse of smooth clefts and rough joinings, shaped by elemental forces briefly violent, then calm, abandoning the place to paralyzed lava flows. He wrote of such sites, describing them as "beautiful desolate country, with its sparse beauty, sharp outlines,

cleanliness, and if it is permissible to speak of nature in those terms, its unaffected simplicity."[30]

In Porter's 1945 photograph *White Boulder, Black Place, New Mexico* (fig. 49), the outline of a sunstruck white rock fills the angular vertex of sharply descending hills. On the left side the boulder's irregular contour challenges the pristine geometry of a dark triangle of hill. The rock, whose size is unknowable in the absence of human referents of scale, muddles questions of focus—of nearness and distance. We think, oddly, of O'Keeffe's 1927 painting *Black Abstraction*, her visual memory of a tiny pinpoint of light shrinking into a **V**-shaped black void as she slipped into surgical anesthesia. It is a subject equally ambiguous in scale and focus, but made so by an even more extreme absence of telling detail. Nonetheless—perhaps through its insistent lapidary surfaces—Porter's photograph testifies in a way that O'Keeffe's paintings do not, that the scene has been, unarguably, before the lens. By its very nature, as Susan Sontag points out, a photograph is "a material vestige of its subject in a way that no painting can be."[31] Or, as Roland Barthes described it, the photograph's subject and referent are stubbornly fused, like "laminated objects whose two leaves cannot be separated without destroying them both."[32]

With dispassionate ease, a photograph freezes subjects both static and ephemeral. In Porter's photograph the mineral inertia of rock represents a frozen absolute of time, the clouds a fleeting counterpoint. Geology and weather—incremental markers at opposite ends of time's continuum—thus are both fixed in Porter's photograph. Taken together, they suppress their separate existential doubts: the rocks anchor the cloudscape in ancient permanence; the sky's incidents confer momentary immediacy on what Barthes would term an "intense immobility."[33]

Looking at Porter's *Eroded Hills, Black Place, New Mexico* (1945; fig. 50), we see him moving in to focus more closely on the rounded contours of hills—contours we have to believe are the same as those in O'Keeffe's *Black Place* I and II painted so near the same time. Here, like O'Keeffe, Porter has filled the frame completely with the measured undulations of earth—eerily organic, like ribs under a taut surface of skin. His lens exposes a visual paradox: we are given an initial illusion of surface smoothness, but his sharp focus simultaneously captures an insistent, palpable roughness. It is a simulated texture, like the sham coarseness of photographed sandpaper. Porter extends the ambiguity when he deliberately decontextualizes the landscape, eliminating sky and suppressing "nowness" by minimizing shadows cast by directional sunlight. We feel suspended in an unearthly zone of visual contradictions.

Though Porter at times focused on a wide slice of nature, as in *White Boul-*

FIG. 50. Eliot Porter, *Eroded Hills, Black Place, New Mexico, September 1945.* (Copyright Amon Carter Museum, Eliot Porter Collection, Fort Worth, Texas)

der, Black Place, New Mexico, his more passionate record is the intimate one—the close up portrait of natural details. "The big view," he explained, "conveys less information about the quality of a subject—the forces that shaped the Western landscape—than does close focusing on a particular rock, eroded cliff, or gnarled tree trunk."[34]

Like O'Keeffe, Porter returned to the Black Place time and again. In 1953 he made a photograph even more close up, more intimate than his *Eroded Hills.* In *Eroded Clay and Rock Flakes on Bentonite, Black Place, New Mexico* (fig. 51), Porter frames details and magnifies the easily overlooked, unassertive detail into the knowable, the irrefutably present. In this and dozens of other Porter closeups of natural detail, we sense the taxonomic precision of a scientist. Porter, we feel, could name everything in the photograph, with the same care that he recorded each species of bird he photographed.[35] Like Stieglitz

FIG. 51. Eliot Porter, *Eroded Clay and Rock Flakes on Bentonite, Black Place, New Mexico, July 20, 1953.* (Copyright Amon Carter Museum, Eliot Porter Collection, Fort Worth, Texas)

and like Walt Whitman, another patron saint of American modernists, Porter found truth in fact, examined and dissected. There is a quality of experience in his photographs that is here both anecdotal and phenomenological.

O'Keeffe's impeccably painted fragments show that she shared Porter's belief in synecdoche—the capacity of the part to stand for, or distill the qualities of the whole. "I often painted fragments of things," she wrote, "because it

FIG. 52. Eliot Porter, *White Formations, Black Place, New Mexico, August 25, 1948*. (Copyright Amon Carter Museum, Eliot Porter Collection, Fort Worth, Texas)

seemed to make my statement as well as or better than the whole could."[36] Still another Porter photograph, *White Formations, Black Place, New Mexico* (fig. 52), made in 1948, approaches that aesthetic. Immediately we are reminded of her painting *Grey Hills*, made at the site in 1942 (fig. 46). Here Porter zeroes in on the wrinkled surface of its white hills, likened by O'Keeffe to a long row of elephants. But now Porter reverses his earlier evenness in values, juxtaposing the whiteness of the earth itself to dark surrounding shadows that isolate and separate forms. O'Keeffe's painting is essentially frontal; Porter's composition is based on strong intersecting diagonals that seem to compress space and deny access into the rocky interstices.

In their paintings and photographs of the Black Place, O'Keeffe and Porter test the extremes of focus, of temporality, and of visual permanence. Nature's record remains, still readable by the sensitive eye. And through the imposition

of stasis on history, here achieved by means of painting and photography, nature subsumes history and becomes art. With that transformation, Barthes believed, the mythic was invoked.

In another account of the mythic narrative of change and stasis, Claude Levi-Strauss emphasized the spatial rather than the temporal.[37] His is a conceptual model eminently relevant to O'Keeffe's and Porter's images of the Black Place. For collectively, the painter and photographer have made a record of the mythic space at Black Place that is both *real* (i.e., verifiable through on-site sensory experience) and *allegorical*. It becomes, finally, less a summation of visual facts than a record of mythic meaning.

Besides their common experiences in Mexico, Glen Canyon, and the Black Place, Porter and O'Keeffe shared many other New Mexico subjects: crosses, bones, antlers, churches, blasted tree stumps, mesas, rivers, sand dunes, and roads. These await discussion in a larger context. For now, though, I'd like to turn to a pair of Porter photographs of O'Keeffe made at her Ghost Ranch home in September 1945.

By 1945 O'Keeffe had been painted and photographed countless times. Beginning in 1908, when she posed for her fellow-student Eugene Speicher at the Art Students League, she had been portrayed, caricatured and abstracted by a number of artists, mostly photographers. Stieglitz alone had made some five hundred photographs of her. She had even been carved in alabaster by her friend Gaston Lachaise in 1927, but always thought it an unsatisfactory likeness.[38] Her own experience with sculpture was sporadic and slight, perhaps because Stieglitz and her modernist colleagues were more engaged in two-dimensional pursuits.[39]

True, in the early years she had experimented a little with sculpture, and in 1917 had exhibited a small abstract plasticene piece along with her paintings and drawings at Stieglitz's '291' gallery.[40] That O'Keeffe had no special reverence for traditional sculpture became clear in 1927, perhaps as a result of the unsatisfactory outcome of the Lachaise bust. That summer, while staying at the Stieglitz summer place at Lake George, she and a friend kidnapped and secretly buried a family-owned plaster bust of the biblical Judith. To the young modernist, the sculpture was an irritating presence—a piece of dated Victorian bric-a-brac that symbolized all the pomposity and pretense of that visually cluttered era.

The heroic, hapless Judith would never resurface, but by 1945 O'Keeffe had become something of a heroic figure herself—or at least a celebrity. She had already achieved major recognition for her painting: in 1943 she had

FIG. 53. Eliot Porter, *Georgia O'Keeffe and Head by Mary Callery, Ghost Ranch, New Mexico, September 1945.* (Courtesy Amon Carter Museum, Fort Worth, Texas)

been given a full-scale retrospective at the Art Institute of Chicago. And, fiercely independent, she had pursued a life of her own making, spending most summers since 1929 in the Southwest. There, in the Ghost Ranch house O'Keeffe had purchased in 1940, sculptor Mary Callery made a summer visit in 1945. When Callery proposed making a portrait bust of O'Keeffe, the fifty-seven-year-old painter agreed to sit for her friend.

On a sunny September day Eliot Porter photographed the two artists as Callery's bust neared completion. One wonders how the session came about at all, for Porter seldom trained his camera's gaze on people. Willing to wait hours for the right landscape light, he found human subjects less amenable to his slow, maddeningly precise photographic ways. Perhaps it was the light

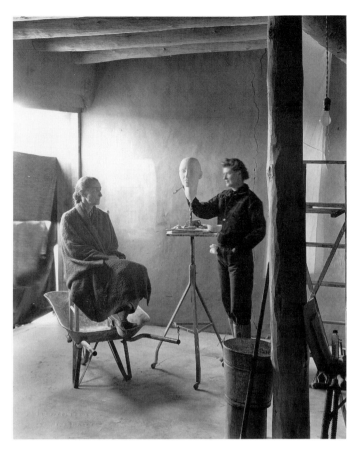

FIG. 54. Eliot Porter, *Georgia O'Keeffe and Mary Callery, Ghost Ranch, New Mexico, September 1945.* (Courtesy Amon Carter Museum, Fort Worth, Texas)

in the studio that prompted him to try, or perhaps it was the unusual opportunity to capture a working four-part artistic dynamic that was irresistible to Porter. In any case, he set up his camera and began to photograph, keeping two of the resulting negatives and eventually reproducing one of them (fig. 53) as the only portrait in his volume *Eliot Porter's Southwest.*

But let's turn first to its pendant photograph (fig. 54), shot earlier according to Porter's careful numbering system. What we notice at once is the wealth of contextual information here. Composed with an eye to spatial depth, it has the kind of internal framing and Albertian perspective often said to be painting's legacy to photography. Rigorous verticals and horizontals define the space, established primarily by the supporting post and ceiling, sec-

ondarily by the ladder and hanging light bulb at the right. Such objects are visual cues that encourage our perception of touch and texture, as well as sight; the space becomes experiential or phenomenological.

But the space is also described by light and by the careful control of light. Blocking and gentling three-quarters of the light from the open doorway at the left is a double-hung frame of fabric. Above it, a brilliant rectangle of light expands geometrically as it sweeps across the far wall, scouring every surface it strikes with clear directional illumination. We notice immediately, too, the positioning of O'Keeffe—elevated, amusingly, absurdly, on a straight chair supported by a wheelbarrow. Relaxed in what might seem a precarious position, she gazes benignly in the direction of Callery and of the bust, her self's *other*. Both artists are positioned slightly below the level of the bust itself, which becomes something like a rarefied third personage in the room. It stands

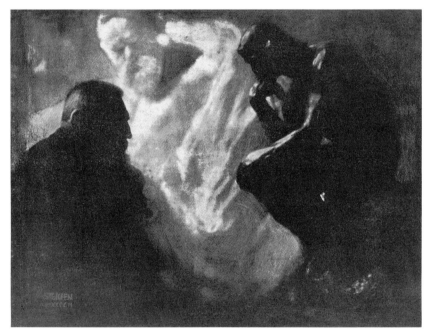

FIG. 55. Edward Steichen, *Rodin—Le Penseur* (1902), photogravure, 6 1/16 x 7 5/16 in. (Courtesy Museum of Modern Art, New York; gift of the photographer)

coolly between them, skeletal but strong, balanced firmly on its triangle of legs. In its primacy of place between the two artists, the sculpture quietly mediates between the two visible beings and, unseen, the photographer and his

camera-eye. Together, the three living beings confer artistic identification on the sculpture.

As we watch, we catch a glimpse of how allegory occurs: the bust of O'Keeffe starts as the object of a collective gaze, gathering in acknowledgement of its resemblance to something real. But as they accumulate, the gazes layer onto the sculpture an identity separate from mere resemblance. It takes on a new reality of its own, moving from object to allegory, in the way all art must. What is unusual here is our opportunity to *watch that process* through the power of the photograph. The photograph, rendering permanent the gaze of the photographer, is the vehicle for the transformation of object into allegory. Beyond the walls of this room, it anticipates the larger subsequent transformation of O'Keeffe from image to icon. Victor Burgin explains this phenomenon when he writes, "The photograph, like the fetish, is the result of a look which has, instantaneously and forever, isolated, 'frozen,' a fragment of the spatio-temporal continuum."[41] All this in an extraordinary moment orchestrated by Porter, who perhaps accomplished more than he knew.

That O'Keeffe was made into an icon is not news. And that her iconic stock rose dramatically via photographs is not unique to her. The medium of photography had been apotheosizing artists since its inception. Worth comparing is the example of Auguste Rodin (fig. 55). Photographed in 1902 by Edward Steichen (another of Stieglitz's protégés) in Rodin's studio, the already-celebrated sculptor is profiled in near-darkness at the left; looming nearby are two of his great works—Victor Hugo in the center and *Le Penseur* at the right.[42] Steichen printed the photograph from two negatives, using the gum bichromate process to manipulate the tones of the print.

Porter's photographs are a much more straightforward endeavor, and they differ from Steichen's in that Rodin is represented with his own work, O'Keeffe with a representation of herself. Still, the dark, triangular silhouettes of Rodin and O'Keeffe are markedly similar, each seen against the light behind. Both have strong facial profiles, ennobled by the effect of halation—a vestigial romantic trope for the immortality of the artistic imagination. Steichen's pictorialism (which he called *peinture a la lumière*) harmonizes with Rodin's painterly surfaces, while Porter's crisp clarity recalls the clean lines of O'Keeffe's bust and, unseen, her own spare paintings.

In the second version of the Porter photograph (fig. 53), we shift from narrative to a purified view of the apotheosis of painter into icon. In this view Porter has moved closer and around to the left, eliminating the sculptor as well as most detail in the room. O'Keeffe's head and her mythic other are now

nearly at right angles to each other, with O'Keeffe's level gaze and the slightly downward one of her bust intersecting somewhere between them. Pristinely, the white head rises, hovering gently above the clutter of tools that made it. Alongside, her famous hands hidden within the folds of a rough shawl, O'Keeffe's keeps her own silent counsel. Both O'Keeffes are pensive, their thoughts veiled behind shadowy masks of flesh and marble. But the flicker of a smile plays about the mouth of the fleshly O'Keeffe as if she knows exactly what is happening. As a lifelong maker of representations, perhaps it amused her to find herself occupying a space with a represented self.

More, O'Keeffe knew well that she lived in an era of unbelief that "prefers the image to the thing, the copy to the original, the representation to the reality."[43] If a society, as Susan Sontag suggests, "becomes 'modern' when one of its chief activities is producing and consuming images," has O'Keeffe in fact become a victim of her own modernity?[44] Reproduced, represented, and consumed in a deluge of images that has swelled beyond her mere physical passing, might she have been considering, way back in 1945, where all this image making might lead? Was she, even then, anticipating her own ultimate canonization in American art and laying plans for controlling the destiny of her work and her reputation from beyond the grave? What Eliot Porter's portraits so visibly and yet so eloquently capture is the process, not merely the products, of representation. These portraits ask vital questions about focus, perception, and narrative.

Between them, O'Keeffe and Porter mapped a great deal of visual and iconic territory in the Southwest. The charge has been leveled against both that in their insistence on the primacy of the land itself and in their denial of material excess, they have omitted complex social realities from their work. On the surface, I believe that may be true. But looked at more deeply, especially in the subtle implications of Porter's portraits of O'Keeffe, they grasp many social and cultural issues. Eventually, they move beyond visual discourse to question the multiple natures of reality and art. On this level they incarnate thought as well.

O'Keeffe and Todd Webb

That we see O'Keeffe's face everywhere, photographed by such luminaries as Stieglitz, Ansel Adams, Yosuf Karsh, and Laura Gilpin, does not begin to account for her own continuing interest in photography. We have already noted

O'Keeffe's use of photography to facilitate compositional studies for the *Patio* series, and we know from O'Keeffe herself that she picked up a camera in the 1960s to study the sweeping curves of roads in her winter world:

> For one of [the photographs] I turned the camera at a sharp angle to get all the road. It was accidental that I made the road seem to stand up in the air, but it amused me and I began drawing and painting it as a new shape. The trees and mesa beside it were unimportant for that painting—it was just the road.[45]

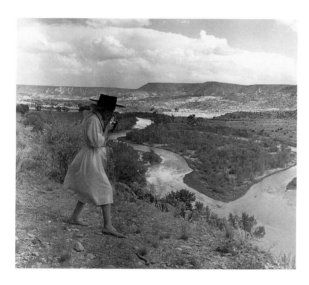

The camera served O'Keeffe as both an aide memoire and as a compositional tool to simplify shapes, to frame and crop them inventively, and to eliminate distracting detail. Even after Stieglitz's death, the frequent presence of photographers in her life reminded O'Keeffe of the camera's usefulness. Besides Porter, Todd Webb (b. 1905) was another photographer who could be counted on for friendship and a shared enthusiasm for the West. Younger than O'Keeffe by some eighteen years, Webb is an affable, knowledgeable student of the region.[46] When he and his wife moved to Santa Fe in 1961, Webb joined the Colorado River trip.

That same year Webb photographed O'Keeffe on a New Mexico hillside as she made a photographic study for one of many paintings of her beloved Chama River (fig. 56). O'Keeffe, who had begun painting the Chama in the 1930s, reprised it in the 1960s, inspired in part by her travels around the world

FIG. 57. (right)
Todd Webb, *Georgia O'Keeffe
Photographing Indoors* (n.d).
(Courtesy Museum of New
Mexico, Santa Fe)

FIG. 58. (above)
Todd Webb, *Georgia O'Keeffe
Photographing in Northern New
Mexico* (1960s). (Courtesy Mu-
seum of New Mexico, Santa Fe)

FIG. 59. (right)
Todd Webb, *Georgia O'Keeffe
in Twilight Canyon, Lake Powell*
(1964). (Courtesy Museum of
New Mexico, Santa Fe)

FIG. 60. Todd Webb, *O'Keeffe Sculpture in the Roofless Room, Abiquiu House, New Mexico* (1981). (Copyright Todd Webb; courtesy Evans Gallery, Portland, Maine)

in 1959 and 1960. Glimpsed from airplane windows, O'Keeffe's drawn fragments of meandering rivers from around the globe complemented her photographic efforts with sections of the Chama.

In 1964 O'Keeffe acquired a Polaroid camera. When Webb delivered it to her he recalled, "She was like a kid with a fine new toy. She said it was better than Christmas."[47] That camera was a special pleasure to O'Keeffe, affording her instant access to the photographic studies she made; but she used a Leica camera as well, both indoors and out (figs. 57 and 58). Later in that summer of 1964 she and Webb joined friends for another trip to Lake Powell, which had by then inundated Glen Canyon. There Webb photographed her again within the towering canyon walls (fig. 59). During those years O'Keeffe turned her camera's lens on the photographer as well. Though she had no wish to be known as a photographer, O'Keeffe could handle a camera well enough to produce a creditable portrait of Webb. He used her photograph of him in a 1965 catalogue of his work.[48]

Webb published a whole book based on the environment he shared with O'Keeffe, released in 1984 as *Georgia O'Keeffe: The Artist's Landscape.* Many portraits of the painter are included, along with interior views of her New

FIG. 61. Todd Webb, *Pelvis and Pedernal, O'Keeffe House, Ghost Ranch.* (Courtesy Museum of New Mexico, Santa Fe)

Mexico homes. They document eloquently the connection between O'Keeffe's visual surroundings and the art she made in New Mexico. One of Webb's photographs is particularly summary, both for its own formal qualities and for the way it extends our consideration of sculpture in O'Keeffe's life. It is *O'Keeffe Sculpture in the Roofless Room, Abiquiu House, New Mexico* (fig. 60). With the sun slanting through the irregular latillas above, Webb records shadow patterns that would have pleased Strand or the young O'Keeffe in her most abstract phase. The sculpture itself was begun in 1945, the year Mary Callery made the portrait bust Porter had photographed. A convoluted swirl of white lacquered bronze, O'Keeffe's *Abstraction* frames and holds negative space, much in the manner of her contemporaneous paintings of pelvis bones against the blue. Despite a depth of more than eighteen inches, the sculpture reads as an essentially two-dimensional form; perhaps it remained anomalous

in O'Keeffe's work because she rediscovered in struggling with three dimensions her own powerful predilection for two.

The presence of photography and photographers in her life added richly to O'Keeffe's visual experience of the world. Her early encounters have been well documented, but in Eliot Porter and Todd Webb she found colleagues with whom to continue her long dialogue on nature, time and the pleasures of sight in the West. In their sensitive photographs of the painter and her surroundings, they help us to understand the remarkable integration of O'Keeffe's life and work (see fig. 61).

In considering the varied responses to place made by these three artists, we see that while each was descended from the American landscape tradition, each struggled to find in it an authentic twentieth-century response. In the end, there is a retroactive completeness about their work. Though O'Keeffe and Porter have died and Webb now resides in Maine, each worked long enough in the Southwest to create a body of unforgettable images; it is work that comes to seem, finally, inevitable. To talk of an "integrity of spirit" in art (as Elizabeth McCausland did in that of Stieglitz and O'Keeffe), or to link art with morality, are—these days—highly unfashionable. But if art's moral dimension lies, as Susan Sontag suggests, in its intelligent gratification of consciousness, then Porter, O'Keeffe, and Webb partake of that kind of exemplary morality.[49] Even now, their absence, like the paradoxical repletion of their vast empty spaces, lingers as presence.

PAGE ALLEN AND THE
MYTHIC LANDSCAPE

Page Allen is not the first artist to discover that she can tap into a collective unconscious through the objects scattered about her own mental terrain. The imagery of her paintings, explicit in its graphic firmness—is at the same time strangely hermetic. What is one to make of these horses, handprints, angels, birds, roads—are they quotations from some portentous allegory or an invocation of private ghosts? Allen is a connoisseur of enigmatic conjunctions, fully conscious of her stance at the place where abstraction, figuration, and symbolism meet.

Allen has thought hard about her own cultural heritage, about the doubt, self-consciousness, and megalomaniacal narcissism that trivializes much of late-twentieth-century painting. She works against that grain, resisting the fashionable and the overintellectualized in art. It is a conscious rejection, based on a thoughtful and sophisticated approach to painting rare in artists today. Allen has taken deep soundings of past and present, reading widely in poetry, philosophy, and theory. From those disciplines and from the art of the past she has mined ideas and metaphors that help her transpose present realities into a higher key.

"I celebrate and eulogize the life I see around me," she writes. "It is passionate work and thus terribly out of fashion. I eschew the knowledgeable, self-conscious look, and thus can appear naive."[1] Any semblance of naïveté in Allen's work is due in part to her use of familiar animals and objects in her

paintings. But for this artist, specific, recognizable imagery is a springboard from here to there—a way to synthesize the material world with the world of spirit and mind. With Carl Jung and anthropologist Loren Eiseley, she takes an expanded and liberating view of things, knowing that images enhance, not diminish each other through their association and contextualization. Myth and metaphor, symbols and stories are alive and kicking in Allen's work. They are, she says, rich realities of the human mind, to be respected and mined deeply.

Animals—like the humble toad, for example—are treated on multiple levels in Allen's painting. Broadly speaking, the toad represents a union of water and earth, an organic wholeness within the living world. But, from its frequent position in a lower corner of Allen's painting or monoprints, the toad is also an observer—intuitive, knowing, sometimes humorous—a mediator between painting, artist, and viewer.

The animals in Allen's paintings are part of what she calls a hierarchy of consciousness. Their way of knowing, their lore, their place in the universe falls on a continuum that embraces all of life, including humanity. Using animal imagery and human imagery is really all the same, says Allen, because there is a still-unfolding mythology that includes each one of us. In a cycle where distinctions between levels in the great chain of being are unimportant, the animals may serve to dramatize the human condition or may replace the human altogether. She explores the sensory life of animals—their vitality, their awareness, their kinship to the environment. They leave us wondering what it means to be wild, to be fully alive.

Allen works serially, not sequentially, making paintings that are connected, not repeated. It is a way of working she credits to Jasper Johns, who has shown many contemporary artists this subtle distinction. Allen has assembled in her work a repertory of beings who reappear, like a cast of characters, in new narrative and formal settings. She has drawn them again and again, refining and simplifying until she has found within a silhouette the quintessential bird, or antelope, or toad. This becomes a template, used to reintroduce the discovered rightness of the form in new contexts. The animals are usually faceless, individualized at times by color and internal markings, but retaining the universality necessary to trigger their symbolic function.

Her favorite human template is more specific: it is a pointing angel, borrowed from a fifteenth-century Sienese painting by Sano di Pietro. With the angel, says Allen, "I wanted to retrieve a piece of our symbolic heritage that is as apparently distant and corny as angels are." Holding in one hand a burn-

ing torch or leafy branch and pointing downward with the other, the angels serve as guides, witnesses, or judges. But in their studied sweetness, these Christmas-card angels are refugees from an era of faith set adrift in a modern sea of doubt. Are they in some way metaphors for Allen's feelings about her own crises of faith in art? She seems to be playing here with art history, invoking simultaneously the fifteenth-century's simple faith in the existence of angels and Gustave Courbet's blunt pronouncement, "Show me an angel and I will paint one."

The templates, including that of the angel, add welcome tension to Allen's work. At once concrete and ethereal, they allude to a ageless metaphysical struggle that questions the very nature of reality. If painting is, as Courbet believed, an essentially concrete art, consisting only of the representation of things both real and existing, then where can romantic invention, fantasy, and reverie find a home in art? With a foot in each camp, Allen honors both painting and human perception. Through the angels and symbolic animals she invites us to question the literalness of the world, but at the same time to trust our perceptions and to make, not merely to find, meaning.

For Page Allen the paths to meaning are both outward and inward journeys. She tells of long car trips through the open expanses of the West, when she allows her imagination to rise with an ascending flock of geese, to flow over the edge of a hill with a herd of antelope. They remain, these elusive exotic creatures, in her paintings. Innocent and wise, always alert to danger, the antelope are here one moment, vanished the next. Merged with the deer or stag, they are ancient symbols of the spirit of the forest, keepers of its mysteries. Alone or in pairs they occupy Allen's paintings and monoprints, with a quiet aloofness underscored by their ambiguous degree of abstraction.

In her paintings the western landscape is often bisected by a pristine road. It disappears at the horizon, oddly delivering depth to the conscious flatness of the painting's surface. Even as the roads stretch into infinity, as in *The Forever Road* (fig. 62), they compress near and far, playing with accepted certainties of time and space. To the artist and to us, the roads offer the possibility of epic journeys. They are about choices—to go or not to go, to leave this place for that. Flights of the brush and the pen have long been the refuge of the artist seeking to transcend the known and the measurable. On the one hand such flights can be mere romantic escapism into the sensibilities of the past, descending at their worst into cloying nostalgia. But to artists like Allen, newly hungry for the richness and potency of the intensely personal, the road lies in an upward positive direction. For them, it is not merely a flight *from*

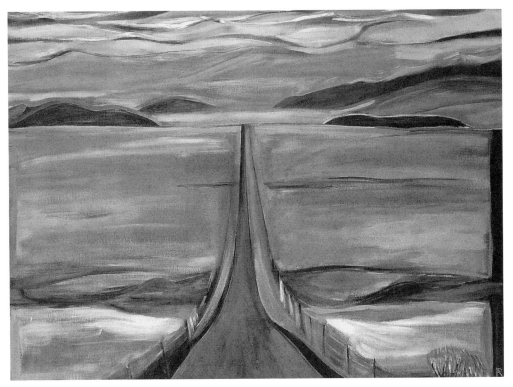

FIG. 62. Page Allen, *The Forever Road* (1990), oil on canvas, 54 x 72 in. (Private collection; photograph courtesy the artist)

something; it is, as Teilhard de Chardin explained, an ascent toward consciousness.[2] For the painter it may signal a rediscovered power of the senses, through which form finds access to our deepest emotions. Page Allen is a painter who works to intensify sensory experience, to create multisensory zones within the borders of her work.

In *A Western Path* (fig. 63), she combines the energy of intense color with powerful iconography to bring the painting alive. It echoes the oriental tradition of landscape as metaphor for life's spiritual journey, but it refuses to behave like any conventional landscape. As it rises away from us, the road widens in a kind of disconcerting reverse perspective. The pale contours of the path gain strength as they spread, flowing up and over the mountain in a powerful shape that somewhere becomes figural. This is an odd, ambiguous image, in which the eye tricks the mind. On either side of the road/figure two silhouetted antelope face each other, impinging into the space. It is reminis-

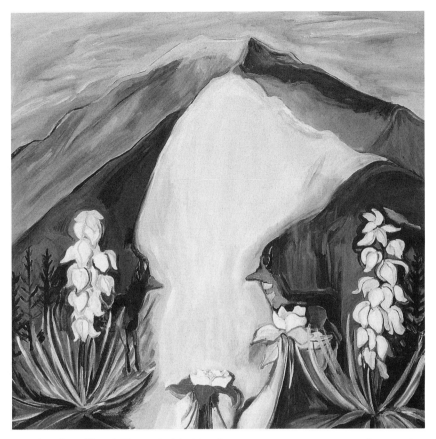

FIG. 63. Page Allen, *A Western Path* (1989), oil on canvas, 53 x 54 in. (Private collection; photograph courtesy the artist)

cent of the optical illusion known as "Rubin's figure," which can be seen either as silhouetted profiles facing each other or as a curved vase. Is Allen's path a space or a shape? No matter—it works either way, with phallic columbine and yucca flowers perpetuating the double take. *A Western Path* is a kind of summary painting, part of a series that explores old and new themes for the artist.

More recently Allen has extended the pathway theme in paintings proportioned like doors that concede a direct entrance into different kinds of spaces. Positioned carefully at the bottom of these canvases, as though at a threshold or bedside, are a pair of worn slippers. They might be modern counterparts of the late medieval shoes in Jan van Eyck's famous double portrait of *Giovanni Arnolfini and His Bride* (1434), where every object is a disguised symbol. Slip-

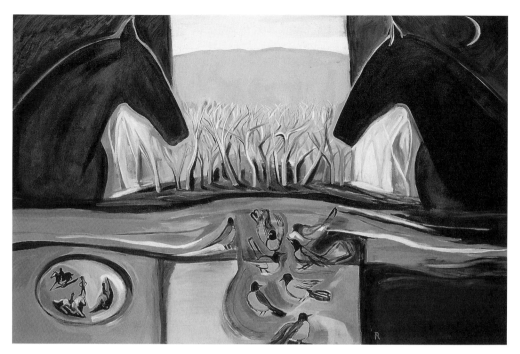

FIG. 64. Page Allen, *The Riding Lesson* (1990), oil on canvas, 54 x 80 in. (Private collection; photograph courtesy the artist)

pers have been removed as a sign that the ritual or journey of marriage has transformed ordinary interior space into sacred ground. Allen's slippers also evoke the concept of journey or pilgrimage. They point away from the viewer and into the imagined space of the canvas, delivering a literal *invitation en voyage*. Once again Allen reiterates her faith that the objects of our daily life may take their place alongside the more exotic image. With angels, doorways, or slippers, the mind's work is the same.

Sometimes she begins a canvas with a solid overlay of color, creating a space for the imagery to inhabit. From there she proceeds to explore lights and darks up and down the value scale. The canvas might be divided into quadrants or vertically into thirds, both of which serve Allen's vision formally and symbolically. In *The Riding Lesson* (fig. 64), a vertical opening through which landscape is glimpsed centers us, as if before an altar. Our visual approach is solemnized by a kind of ritual symmetry; each person and thing has its prescribed place, moving in measured, rhythmic procession into the mythic space. The artist has carefully balanced the visual weights of images:

large dark horses, their contours a blend of curves and angles, flank our visual approach into the light. The horses function like hieratic guardian figures at a temple entrance, but here the sacred is nature itself—trees, the horizontal flow of a river, a flock of birds. All are remembered elements from the artist's experience, recombined here as if in a dream. Tiny riders circling at lower left are a flashback to her daughter's riding lesson, but they retain an eerie connection to the enigmatic horses above. Fascinated with the way the active and unconscious mind interact, Allen allows them to merge in a process that is inherently and productively mysterious.

When Allen divides the canvas into glowing segments of color, the effect is not unlike that of stained glass. She has, in fact, been inspired by the richness of medieval glass and manuscripts, seeking to connect their symbolic color with a more visceral modern chromatics. Her color choices are never arbitrary or merely "colorful." Without constructing a symbolic color system (as Kandinsky did, for example), she pursues color as a powerful expressive force—energizing in its sheer beauty, resonant in its mythic association. There is a point at which kinesthetic awareness and symbolic function merge. It is a confluence found in great music, in poetry, in color and form perfectly joined. And it has been recognized for centuries: Giotto, Matisse, Dove, Rothko—all of them knew this. With them, Allen struggles to find the essential timeless harmonies that make painting last.

Allen allows room for discovery in her work. She invites the viewer to take perceptual risks, as she takes them in the process of painting. "The picture has to come into relationship with itself. I may plan certain visual correspondences, but in the end it is only by keeping my eyes open, constantly, to the unplanned connections that I will recognize completion." Sometimes it is the single intuitive gesture, the surprise of an unforeseen color juxtaposition that brings about a sudden rightness. "The piece must surprise me into being finished," she says, "which means that bit by stubborn bit, I must give up what I think I know about it."

In a large oil the artist faces the danger of overcalculating, overworking. "It is important with the oils," she explains, "to carry through the idea of a certain color or shape, and thus to simplify." Allen has learned much about simplification from her work with gouache and monoprints (plate 9). Smaller and more provisional, they are the receptacles of experiment, sometimes arenas for play. Lush opaque color floods the surface of Allen's gouaches, where she balances color-derived structure with a beguiling immediacy and freshness. In the monoprints she can explore a fluid exchange between abstraction

FIG. 65.
Page Allen, *Here Me Now*
(1990), monotype, 17 3/4 x 11
1/2 in. (Private collection;
photograph courtesy the
artist)

and realism, using one to reinforce the other. Making marks on the printing plate offers a feast of technique: they can range in rapid succession from crisp linearity to brushiness, from even washes to bold swipes of color. Space is created naturally, breaking down rigid categories of figure and background.

In her monoprints the artist's hand is very much in evidence—sometimes literally as in *Here Me Now* (fig. 65). The print of Allen's palms, superimposed one over the other, suggests a layering of meanings. On one level it is a metaphor for creativity: the touch of the artist's hand brings forth form—unique, unexpected—out of the void. Combined with the primordial toad and star-sprinkled cosmic blackness, the handprints also speak of ancient imprints on cave walls. The effect is mysterious, evoking the earliest stages of human consciousness, when art was intended not to be beautiful, but magical. Allen's is both.

First developed in the monotype process, Allen's use of layering or collaging forms one over the other allows the artist to work on multiple levels within a single painting. While she layers forms, she simultaneously collages meanings. In her *Torso* series, for example, she has built up dense layers of form and color within the template-inspired shape of a female silhouette (plate 10). The elements are familiar: hands, toads, antelopes, angels, leaves, birds, whirling suns. What is new here is the containment of the shapes within the torso—like colored X-rays of the human soul—but so dense, so significant that they screen the mundane elements of flesh and bone. They have taken over the inner space of the body, pushing against its contours, sometimes breaking through them. It is as if Allen wants to mirror the profusion of nature, the contradictory abundance of her own being, and the great visual pile-up of our cultural heritage—all at once—now! One wants to call them self-portraits of an artist whose selfhood is perfectly congruent with her work. Wasn't it William Carlos Williams who wrote, "The artist is always and forever painting only one thing: a self portrait"?

Like much of her painting, the torsos quiver with passion—awake to despair, yet alive to hope. Rhythmic, glowing with color, dense with the physicality of paint and image, the torsos stretch the eye in their technical range: delicate glazing, scumbled brushiness, refined brushwork reminiscent of a seventeenth-century sketch—all are fair game. There are passages too of almost clumsy painting—necessary to fix the power of the imagery and to negate trite, easy associations. Visually and metaphorically they resist detached observation. Raw, gestural paint quality fuels a sense of urgency and fierce sensuality in Allen's torsos. Like tightly locked pieces of a puzzle, they are wholes that are much more than the sum of parts. With their jerky movement and restless patterning, they demonstrate again that what gives life to style is a certain disequilibrium. One of Allen's favorite writers is Loren Eiseley, who reminds us, quoting Francis Bacon, that "there is no excellent beauty that hath not some strangeness in the proportion."[3] It is this eccentricity within an implied pattern, the overlay of hard-won awkwardness and sophistication, that enriches any encounter with Page Allen's painting. Brave, intelligent, still growing, she is an artist of rare depth. Her search for universal symbols and her concern with ending the fragmentation between mind and body are her own, but they are also part of a larger contemporary search to find meaning in the reality of art.

WOODY GWYN

Landscape Painting and the
Social Meaning of the Earth

Landscape, seen through human eyes, is never neutral. But it has taken a long time for people to realize that landscape and landscape painting carry cultural messages reaching to the heart of the human experience.[1] Take roads, for instance. Trails, paths, and highways are more than evidence of human activity. They are marks of social meaning impressed into the earth, inscriptions of cultures that made and used them. Stretched along their distance are assurances of direction and meaning that simultaneously reflect and reshape changing ideas about the land.

Certain ancient roads, like the Appian Way, the medieval pilgrimage routes, or the silk roads connecting Europe and Asia, have carried much of the world's known history over their lengths. Others, such as the great Anasazi network leading into and out of Chaco Canyon, remain mysterious. Long abandoned to the eroding effects of water, wind, and time, the fragile road traces at Chaco nonetheless still testify to careful sky and surface orientations. They suggest slow passages, at a walker's pace, through states of mind and ancient cycles of seasons, perhaps between realms of the living and dead. Though their cosmic secrets are mostly lost to modern observers, we know these Chaco roads were once of profound ceremonial and symbolic significance.

Not all southwestern roads have trafficked in such exalted collective meanings. Most, old or new, are paths from here to there—links between countless points of origin and destination. Glinting under wide expanses of open sky,

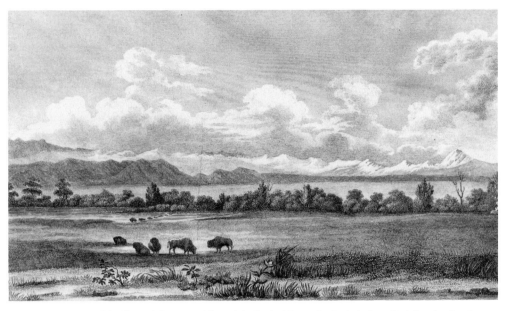

FIG. 66. Samuel Seymour, *View of the Rocky Mountains* (n.d.; before 1823), hand-colored engraving, 6 x 8 3/4 in. (Courtesy Stark Museum of Art, Orange, Texas)

these ribbons of passage testify to human visitation in the always encroaching emptiness. For in parts of the West, it is still the void that defines the landscape and defies artists to capture it. Generations have taken up the challenge. Along with writers, poets, and photographers, the landscape painter has struggled to image the changing American West—no mean task in places whose character resides in an elusive, pristine otherness. Awestruck, early beholders recorded the West's roadless sweep of earth and sky, observed but as yet unchanged by humanity (fig. 66).

But the primeval emptiness soon gave way to the axe and the wagon wheel, etching traces of relentless westward movement. Nineteenth-century American landscape paintings often became visual demonstrations: here is what progress looks like. Here are the resources of the West, ready to serve the needs of its settlers (fig. 67). Until recently, when revisionist views of nineteenth-century American landscape painting have made us question its subtly disguised political and social biases, the interaction of humanity and the landscape was seen as a salutary, inevitable "taming" of nature's chaos.[2]

Each generation learns to see landscape according to a socially constructed set of ideas. Such paradigms are, of course, the product of complex historical

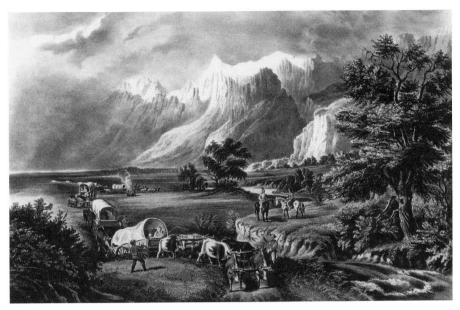

FIG. 67. Fanny Palmer, *The Rocky Mountains, Emigrants Crossing the Plains* (1866), lithograph, 17 1/2 x 25 3/4 in. (Courtesy Amon Carter Museum, Fort Worth, Texas)

forces. Renaissance humanism and the evolution of scientific method, for example, are two factors of profound importance in shaping the Euro-American view of landscape in the past five hundred years. From Van Eyck's tiny glimpses of landscape seen through open windows, to Piero's often-tyrannical one-point perspective, to Poussin's carefully orchestrated recessional planes, we can follow a single implicit assumption: that landscape is there to be seen and ordered by human will. As soon as a human gaze rests upon a patch of land, it becomes an object of which we (or specifically, the artist) become the acting subject. The power of eye and hand transforms landscape into a social product.

In American painting, these assumptions are visible in a 1915 painting by Taos artist Oscar Berninghaus, *A Showery Day, Grand Canyon* (1915; fig. 68). Both artist and patron (the railroad) were keenly aware of the tourist potential of the canyon and were eager to lure visitors to the Southwest. Even as this painting celebrates the accessibility of natural wonders, it speaks, in a subtler way, about nature as public theater. Stretched out before a group of foreground visitors, the chasm is a grand visual spectacle, a performance complete with dramatic effects of clouds and rain. Incorporated by our own act of looking, we join the other spectators behind a retaining wall that defines and

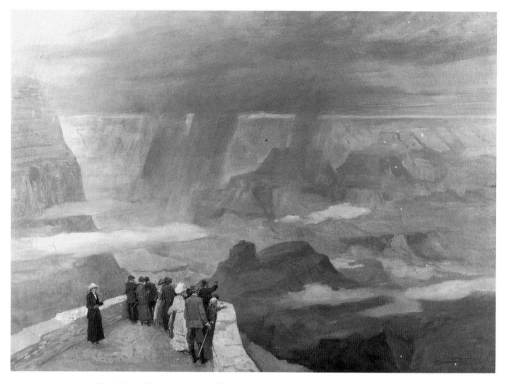

FIG. 68. Oscar Berninghaus, *A Showery Day, Grand Canyon* (1915), oil on canvas, 30 x 40 in. (Courtesy Santa Fe Railway Collection of Southwestern Art)

separates human-constructed space from the wildness of the canyon. Nature here is the sublime, ineffable, calculated *other*.

Every age finds the paintings it needs. Woody Gwyn's painting helps us to understand that the external world is always mediated through subjective human experience. When he paints an isolated stretch of highway, a stand of trees, or, for that matter, the Grand Canyon, he opens an inquiry that involves more than earth, sky and vegetation. His is a visual dialogue between acute specificities of the present moment and the cumulative weight of historical vision.

Woody Gwyn's painting of the canyon (fig. 69), rare in his oeuvre for its inclusion of figures, offers a telling contrast to that of Berninghaus. Gwyn's canyon visitors press in laterally engaging the view, merging with the experience rather than standing apart from it. For them and for us, the subject-object dichotomy breaks down; apartness gives way to interaction with nature. In a certain sense, this painting summarizes one of the major themes in

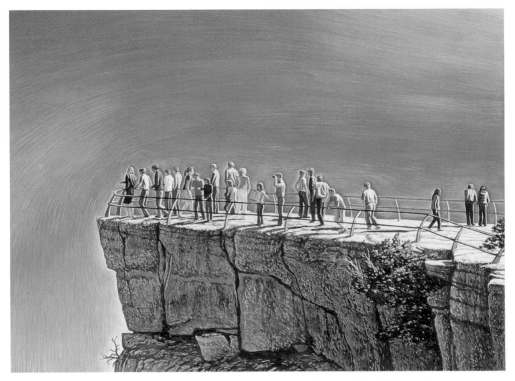

FIG. 69. Woody Gwyn, *Tourists* (1988–89), egg tempera on panel, 12 x 15 7/8 in. (Photograph courtesy the artist)

Gwyn's painting: a new kind of artistic encounter with nature. New because it dispenses with the landscapist's traditional props for evoking human associations—nostalgia, sentimentality, and the merely picturesque. In their place Gwyn has set up a model of reality born of, but not imprisoned by, the received visible world. Free to roam within his landscape of materialized essences, Gwyn plays thoughtfully with formal questions—moods of line, textures of surfaces, subtle harmonies of color—that engage him repeatedly.

When choosing the canvas size, for example, he thinks carefully about the perceptual experience his paintings will initiate. And when he returns to a subject a second or third time, it is often to establish a larger scale and therefore a new range of experience for the viewer. But even when Gwyn's paintings stretch to a length of twelve or fourteen feet, they never overwhelm the viewer with sheer size as, for example, a thundering Bierstadt or a monumental Church landscape often can.

Apart from his sensitivity to questions of scale and the power of sight,

Gwyn's painting resonates with an understanding of a second, more obvious way that landscape is socially constructed: in the twentieth century our visual surroundings are almost always the product of human transformations of nature. A road bisecting an open expanse is an obvious example of this. So are highway interchanges, bridges, and parking lots.

What are we to make of Gwyn's fragments of humanized earth? As with much good painting, the initial pleasure of looking gradually gives way to rich, unexpected complexities. These paintings are, in fact, full of tension and paradox. At once timeless and utterly contemporary, they visibly contradict the pace of the twentieth century, this era of speeded-up perception, minutes crowded with visual incident, and quickly forgotten optical layering.

We feel the inexorable tension between highways built for speed and painting that demands slow, deliberate looking; between knowing that the center of things is elsewhere and Gwyn's insistence that it is palpably here, now, on this stretch of road; between a silent space devoid of human trespass and the sure knowledge that a blur of hurtling metal will soon whine past, impatient to devour unseen distances. For these are paintings about the implications of the beyond, about arbitrary completion and deliberate incompletion. Always, Gwyn paints less than he knows.

These landscapes, studied slowly, invite us to consider anew the absences and presences within the land. Though tinged, often, with alienation, melancholy, or loss, Gwyn's subjects press quietly beyond what they describe. Like the road cuts his brush interrogates (plate 11), they slice into the western landscape with an acute visual clarity. And like some of Georgia O'Keeffe's work (which he admires), they cut swiftly to the heart of a tangle of myths flung over the West—a network as ineradicable as its web of old and new roads. We could travel endlessly within this system, whose interchanges in steel and concrete mimic (in a kind of latter-day platonic scheme) the impossibly delicate brain synapses where visual and cultural meaning connect.

Like the earth's surface, each mind has its own topography; Woody Gwyn's is open, fluid, expansive like his canvases. Disguised in the persuasive truth-telling of realism, his paintings invite us to explore realms where nature and culture, (long and perhaps falsely dichotomized,) test mysterious new affinities.

Introduction

1. Marsden Hartley, "Red Man Ceremonials: An American Plea for American Esthetics," *Art and Archaeology* 9, no. 1 (January 1920): 14.

Chapter 1

1. Some of the material in this chapter has been adapted from my catalogue essay for *The Informing Spirit: Art of the American Southwest and West Coast Canada, 1925–1945*, organized and circulated by the McMichael Canadian Art Collection and the Taylor Museum for Southwest Studies, Colorado Springs Fine Arts Center, Colorado Springs, Colorado, 1994.

2. See, for example, Barbara Novak, *American Painting of the Nineteenth Century* (New York: Harper & Row, 1969); Kynaston McShine, ed., *The Natural Paradise: Painting in America 1800–1950* (New York: Museum of Modern Art, 1976); and Ruth Appelhof, ed., *The Expressionist Landscape: North American Modernist Painting 1920–1947* (Birmingham, Ala.: Birmingham Museum of Art, 1988).

3. Mircea Eliade, quoted in J. B. Jackson, *Discovering the Vernacular Landscape* (New Haven, Conn.: Yale University Press, 1984), 41.

4. Jack Burnham, *The Structure of Art*, rev. ed. (New York: George Braziller, 1973), 15.

5. See, for example, Elsie Clews Parsons, *Pueblo Indian Religion*, 2 vols. (Chicago: University of Chicago Press, 1939); Florence Hawley, "Pueblo Social Organization as a Lead to Pueblo Prehistory," *American Anthropologist* 39 (1937): 504–22; and Edgar Hewett, *Ancient Life in the American Southwest* (Indianapolis: Bobbs-Merrill, 1930).

6. Alfonso Ortiz, *The Tewa World* (Chicago: University of Chicago Press, 1969), 24. The Pueblo share their belief in sacred mountains with the Navajo, whose landmark peaks include Blanca Peak (Sis Naajini), Mount Taylor (Tsoodzil), the San Francisco Peaks (Dook'o'ooshiid), Hesperus Peak (Dibe Nitsaa), Huerfano Mountain (Dzil Na'oodilii), and Gobernador Knob (Ch'ool'i'i). As Navajo poet George Blueeyes writes in *Between Sacred Mountains* (Tucson: Sun Tracks and University of Arizona Press, 1984),

The Sacred Mountains have always been where they are now.
They have been like that from the beginning.
They were like that in worlds before this.
They were brought up from the Underworld
And were put back in their respective places. (p. 2)

Still another reference to sacred mountains in Native American tradition comes from Black Elk, the Oglala Sioux leader, whose memoir records his vision of "standing on the highest mountain of them all, and round about beneath me was the whole hoop of the world. . . . And I saw that it was holy" (*Black Elk Speaks*, ed. John G. Neihardt [1932; reprint, Lincoln: University of Nebraska Press, 1961], 43).

7. Alfonso Ortiz, "Ritual Drama and the Pueblo World View," in *New Perspectives on the Pueblos*, ed. Alfonso Ortiz (Albuquerque: University of New Mexico Press, 1972), 144.

8. Frank Waters, "A Tribute to Brett," in *The Brett: Fifty Years of Painting in New Mexico 1924–1974* (Santa Fe: Jamison Galleries, 1974), n.p.

9. Ortiz, "Ritual Drama," 137.

10. Ibid., 144.

11. W. J. T. Mitchell, *Iconology: Image, Text, Ideology* (Chicago: University of Chicago Press, 1986), 8.

12. Vincent Scully, *Pueblo: Mountain, Village, Dance*, rev. ed. (Chicago: University of Chicago Pres, 1989), 372–73.

13. Ibid., 58.

14. Deuteronomy 12:2.

15. For a discussion of this changing view of mountains, see Marjorie Hope Nicolson, *Mountain Gloom and Mountain Glory; the Development of the Aesthetics of the Infinite* (Ithaca, N.Y.: Cornell University Press, 1959) and Henry More, "The Great Usefulness of Hills and Mountains," in *A Collection of Several Philosophical Writings of Dr. Henry More*, (London, 1712), bk. 1, chap. 3, 47.

16. Martha Doty Freeman, "New Mexico and the Nineteenth Century: The Creation of an Artistic Tradition," *New Mexico Historical Review* 49, no. 1 (1974): 11–12.

17. Susan Sontag, "The Aesthetics of Silence," in *The Discontinuous Universe: Selected Writings in Contemporary Consciousness*, ed. Sallie Sears and Georgianna W. Lord (New York: Basic Books, 1972), 60.

18. Ortiz, *The Tewa World*, 25.

19. I have written elsewhere of the influence of such ideas among artists working in New Mexico. See Sharyn R. Udall, *Modernist Painting in New Mexico 1913–1935* (Albuquerque: University of New Mexico Press, 1984) and "Beholding the Epiphanies: Mysticism and the Art of Georgia O'Keeffe," chapter 5 in this volume.

20. Wassily Kandinsky, *Concerning the Spiritual in Art*, trans. M. T. H. Sadler (1914; reprint, New York: Dover, 1977), 8, 13, 20.

21. It should be emphasized here that Theosophy was only one of a number of nineteenth-century mystically based belief systems that grew out of comparative religious studies in the Enlightenment. Other outgrowths were the revival of Rosicrucianism in France in the 1880s and, somewhat later, the Anthroposophy of Rudolf Steiner. Common bases were the writings of Charles F. Dupuis, author of *Origine de tous les cultures ou religion universelle* (1794), and Richard Payne Knight's *Symbolical Language of Ancient Art and Mythology: An Inquiry* (1818; 1876). For further discussion of this, see Robert P. Welsh, "Sacred Geometry: French Symbolism and Early Abstraction," in *The Spiritual in Art: Abstract Painting 1890–1985* (Los Angeles: Los Angeles County Museum of Art, 1986), 63–88.

22. For discussion of Hartley's mysticism, see Gail Levin, "Marsden Hartley and Mysticism," *Arts* (November 1985): 16–21.

23. Hartley, quoted in Carol Rice, "The Mountains of Marsden Hartley" (Minneapolis: University of Minnesota Gallery, 1979), n.p.

24. Kandinsky, *Concerning the Spiritual in Art*, 24.

25. Cather, quoted in Freeman, "New Mexico and the Nineteenth Century," 5.

26. D. H. Lawrence, "Men in New Mexico" (1922), quoted in Keith Sagar, ed., *D. H. Lawrence and New Mexico* (Salt Lake City: Peregrine Smith, 1982), 18.

27. Van Deren Coke, *Nordfeldt the Painter* (Albuquerque: University of New Mexico Press, 1972), 50.

28. Ortiz, *The Tewa World*, 14.

29. For a discussion of American luminism and the Transcendentalists, see Barbara Novak, *Nature and Culture: American Landscape Painting 1825–1875*, 28–33 and 266–73.

30. See chapter 6 in Udall, *Modernist Painting in New Mexico*.

31. Further discussion of Mabel Dodge Luhan's spiritual enterprises in New Mexico is contained in Lois Palken Rudnick, *Mabel Dodge Luhan: New Woman, New Worlds* (Albuquerque: University of New Mexico Press, 1984), 143–241.

32. I am grateful to Jackson Rushing for bringing this material to my attention in his paper "Feminism, Mysticism, and the Fourth World: Mabel Dodge Luhan and Pueblo Art" (unpublished paper).

33. Rudnick, *Mabel Dodge Luhan*, 165.

34. Larry Calcagno, statement in *Larry Calcagno: Works from New Mexico* (Taos, N.M.: Harwood Foundation Museum, 1987), n.p.

Chapter 2

1. This essay was co-winner of the first New Mexico Humanities Council Essay Award in 1984. In modified form it was published in *New Mexico Magazine*, July 1985.

2. This and subsequent quotations by John Fincher and Kirk Hughey are from their conversations with the author in 1982.

3. Theodore Roosevelt, *Ranch Life and the Hunting Trail* (New York, 1888).

4. Marshall Fishwick, *The Hero, American Style* (New York: David McKay, 1969), 67.

5. Philip Durham, "The Cowboy and the Mythmakers," *Journal of Popular Culture* 1, no. 1 (Summer 1967): 61.

6. Bill Peterson, "Quick-Draw Artist," *Arizona Arts & Lifestyle* (Summer 1981): 45.

Chapter 3

1. This chapter was originally published as an essay in *Drama Review* 36, no. 2 (T134): Summer 1992.

2. On Gallegos, see Don L. Roberts, "The Ethnomusicology of the Eastern Pueblos," in *New Perspectives on the Pueblos*, ed. Alfonso Ortiz (Albuquerque: University of New Mexico Press, 1972), 244. In *Relacion y Expediente*, 180, is Espejo's note of a dance at Acoma "con vivoras vivas." See J. Walter Fewkes, "The Snake Ceremonials at Walpi," *Journal of American Ethnology and Anthropology* 4 (1894): 124. Adolph F. Bandelier notes a pictograph at Abo, a possible image of the Snake Dance in earlier times. Adolph F. Bandelier, *The Delight Makers* (New York: Dodd, Mead, 1916), 277. Snake legends from Mexico and Central America, combined with sculptural representations of serpents at the temple pyramids of Teotihuacan and Tenayuca, and at Copan, encourage attempts to link the plumed serpent of Hopi religion with those from the South.

3. Elsie Clews Parsons, "A Pre-Spanish Record of Hopi Ceremonies," *American Anthropologist* 42, no. 3 (July-September 1940): 541–42.

4. Elsie Clews Parsons, *Pueblo Indian Religion*, 2 vols. (Chicago: University of Chicago Press, 1939), xi.

5. Fewkes, "Snake Ceremonials at Walpi," 124.

6. Alfonso Ortiz, "Ritual Drama and the Pueblo World View," in *New Perspectives on the Pueblos*, ed. Alfonso Ortiz (Albuquerque: University of New Mexico Press, 1972), 145.

7. Exceptions were sometimes made in the case of certain visitors, such as anthropologist J. Walter Fewkes, who with his party was allowed into the kivas in 1891 and 1893. Certain photographers, for example George Wharton James in 1896, likewise were allowed access to the kivas. Fewkes mentions the efforts of uninvited white spectators to enter kivas during the Snake Dance of 1891 ("Snake Ceremonials at Walpi," 5).

8. Fewkes, "Snake Ceremonials at Walpi," 84–85.

9. W. R. Mateer in *Masterkey* 8, no. 4 (October 10, 1879): 150–55. German art historian Aby Warburg visited New Mexico and Arizona in the winter of 1895–96, during which time he attended and photographed a three-day Hopi ceremonial at Oraibi. Though he did not witness the summer Snake Dance, he had read much about it before his trip to the United States and lectured in Germany on Hopi "Serpent Ritual" some twenty-six years later. Like other writers of his day, Warburg compared the Indians of the Southwest to the ancient Greeks (see note 18, below) and wrote of the function of symbol, causality and residual magic in their cultures. See E. H. Gombrich, *Aby Warburg: An Intellectual Biography* (London: Warburg Institute, 1970), 88–92, 216–227, and plates 10a, 10b, and 10c.

10. Most early accounts use the name Moqui or Moki. Only later did anthropologists adopt Hopi, the name the Indians called themselves.

11. Robert Taft, *Artists and Illustrators of the Old West 1850–1900* (Princeton, N.J.: Princeton Univ. Press, 1953), 216 and 366 n. 13.

12. John G. Bourke, *The Snake-Dance of the Moquis of Arizona* (1884; reprint, Glorieta, N.M.: Rio Grande Press, 1962), 156–57.

13. Taft, *Artists and Illustrators*, 348.

14. Peter Moran, "The Estufas and So-Called Sacred Fires of the Moqui Snake Dance of 1883," in *Moqui Pueblo Indians of Arizona and Pueblo Indians of New Mexico, Extra Census Bulletin, Eleventh Census of the United States*, ed. Thomas Donaldson (Washington, D.C., 1893), 69–70.

15. Mary Roberts Coolidge, "The Glamour of the Southwest," in *Santa Fe New Mexican*, June 6, 1940, Artist and Writers Edition, n.p.

16. *Hamlin Garland's Observations on the American Indian, 1895–1905*, ed. Lonnie E. Underhill and Daniel F. Littlefield Jr. (Tucson: University of Arizona Press, 1976), 103.

17. T. V. Keam, "An Indian Snake Dance," *Chambers's Journal* (1883): 14–16.

18. E. B. Tylor, "Snake Dances, Moqui and Greek," *Saturday Review*, October 18, 1884, 10–11.

19. See, for example, the bibliography in Fewkes, "Snake Ceremonials at Walpi," 124–26.

20. Luke Lyon, "History of Prohibition of Photography of Southwestern Indian Ceremonies," in *Reflections: Papers on Southwestern Culture History in Honor of Charles H. Lange*, ed. Anne van Arsdall Poore. Papers of Archaeological Society of New Mexico 14 (Santa Fe: Ancient City Press, 1988), 261 n. 2.

21. Farny had earlier made illustrations for *Century Magazine* to accompany Frank Hamilton Cushing's account of his years at Zuni. Those Zuni illustrations were likewise based on photographs, in that instance those of John K. Hillers.

22. William H. Truettner, "The Art of Pueblo Life," in Charles Eldredge, Julie Schimmel, and William H. Truettner, *Art in New Mexico 1900–1945: Paths to Taos and Santa Fe*, (New York: Abbeville Press, 1986), 89.

23. G. Wharton James, "The Snake Dance of the Hopis," *Camera Craft* 6, no. 1 (1902): 7–8.

24. Ibid.

25. Information on this and subsequent references to Snake Dance films are found in Lyon, "History of Prohibition of Photography," passim.

26. Edward S. Curtis, *The North American Indian*, 20 vols., with photograph supplements (Norwood, Mass.: Plimpton Press, 1907–1930), vol. 12, xi.

27. Couse did not originate this practice. Years earlier, for example, William Henry Jackson had photographed "Taqni, Moki Indian Snake Priest, Arizona." Others, like Curtis, would make many portraits of the individual snake priests between 1900 and 1921. See Curtis, *North American Indian*, vol. 12, passim; also see Beaumont Newhall and Diana E. Edkins, *William H. Jackson* (Fort Worth: Amon Carter Museum, 1974), 51.

28. Carl Sandburg, foreword (1921) to *William Penhallow Henderson 1877–1943*. Retrospective exhibition catalog. Santa Fe: Museum of Fine Arts, Museum of New Mexico.

29. D. H. Lawrence, "Just Back from the Snake Dance—Tired Out," *Laughing Horse* 11 (September 1924), n.p.

30. Lawrence, cited in Keith Sagar, ed., *D. H. Lawrence and New Mexico* (Salt Lake City: Peregrine Smith, 1982), 72.

31. Thomas Donaldson, ed., *Moqui Pueblo Indians of Arizona and Pueblo Indians of New Mexico, Extra Census Bulletin, Eleventh Census of the United States* (Washington, D.C., 1893), 74.

32. Alida Sims Malkus, "Those Doomed Indian Dances," The *New York Times*, reprinted in *El Palacio* 14, no. 10 (May 15, 1923): 149–52.

33. John Sloan, "The Indian Dance from an artist's Point of View," *Arts and Decoration* (January 1924): 17, 56. Sloan was one of the American artists who worked most actively to preserve and champion Indian art, encouraging its elevation from craft to fine art. He served as president of the 1931 *Exposition of Indian Tribal Arts*, a major New York showing of high-quality Native American work presented as art.

34. Lyon, "History of Prohibition of Photography," 245. Between 1924 and 1930 these Snake Dancers toured the United States, organized by M. W. Billingsley and accompanied by lectures and demonstrations.

35. Kabotie is not the only Hopi artist to make Snake Dance paintings or drawings; others include Otis Polelomena, Gilbert Naseyowma, and Lawrence J. Outah.

36. Nelson H. H. Graeburn, ed., *Ethnic and Tourist Arts: Cultural Expressions from the Fourth World* (Berkeley and Los Angeles: University of California Press, 1976), 2.

37. Robert F. Berkhofer Jr., *The White Man's Indian: Images of the American Indian from Columbus to the Present* (New York: Alfred A. Knopf, 1978), 111.

38. Lucy Lippard, *Mixed Blessings: New Art in a Multicultural America* (New York: Pantheon, 1990), 9.

39. Don Talayesva, *Sun Chief*, ed. Leo W. Simmons (New Haven, Conn.: Yale University Press, 1942), 252.

40. "Hopis Must Oust Council on Their Own," *Albuquerque Journal*, April 4, 1991, D-1.

Chapter 4

1. Marsden Hartley, quoted in Mabel Dodge Luhan, *Movers and Shakers* (1936; reprint, Albuquerque: University of New Mexico Press, 1985), 460.

2. Hartley, letter to Harriet Monroe, 23 June 23, 1918, Elizabeth McCausland Papers, Archives of American Art, Smithsonian Institution (hereafter cited as McCausland Papers, AAA). D. H. Lawrence would later give a nearly identical title, "Altitude," to a play he began at Taos in the early 1920s but never finished. The town's elevation, seven thousand feet above sea level, plays a central role in defining its character.

3. Hartley to Monroe, 20 August 20, 1918, McCausland Papers, AAA.

4. This poem was published in Alice Corbin Henderson, comp. *The Turquoise Trail: An Anthology of New Mexico Poetry* (Boston: Houghton Mifflin, 1928), 44–51.

5. Hartley to Monroe, July 3, 1919, McCausland Papers, AAA.

6. Gail Scott, who has published the most recent volume of Hartley's collected poems, says that Hartley's literary reputation reached its peak during the late teens and early 1920s. He published three volumes of poetry, one book of essays, and many individually published pieces during his lifetime. See Gail Scott, ed., *The Collected Poems of Marsden Hartley 1904–1943* (Santa Rosa: Black Sparrow Press, 1987). The occasion in Santa Fe was not the only instance when Hartley destroyed his work; in 1935 he destroyed one hundred paintings and drawings to conserve storage space.

7. These scrapbooks, including the poem and photograph reproduced here, are now in the possession of Mrs. Fenyes's granddaughter, Leonora Frances Curtin Paloheimo, who has kindly given permission for their use.

8. Remark contained in Sloan's diary, *John Sloan's New York Scene* (New York: Harper & Row, 1965), 303.

9. See, for example, his self-portrait crayon drawing from 1908 reproduced in Barbara Haskell, *Marsden Hartley* (New York: Whitney Museum of American Art, 1980), fig. 11.

10. In faint pencil on the handwritten copy are the words "Self-portrait," probably in Mrs. Fenyes's hand.

11. Gail Levin has pointed out that Hartley's probable direct sources for this painting were a Hopi Sio Hemis Kachina, Chippewa miniature canoes, and a carved wooden eagle from Vancouver. All were then in the Berlin Museum für Völkerkunde. Gail Levin, "American Art," in *Primitivism in 20th Century Art*, ed. William Rubin (New York: Museum of Modern Art, 1984), 459.

12. See, for example, Wassily Kandinsky, *Concerning the Spiritual in Art*, trans. M. T. H. Sadler (1914; reprint, New York: Dover, 1977), 6–20.

13. Hartley to Stieglitz, November 12, 1914, Beinecke Library, Yale University, New Haven, Connecticut; copy at AAA.

14. Marsden Hartley, "America as Landscape," *El Palacio* 5 (December 1918): 340–41.

15. Marsden Hartley, "Red Man Ceremonials: An American Plea for American Esthetics," *Art and Archaeology* 9 (1920): 7.

16. Marsden Hartley, "The Spangle of Existence," essay, Hartley Papers, AAA.

Chapter 5

1. See *The Spiritual in Art: Abstract Painting 1890–1985* (New York: Los Angeles County Museum of Art and Abbeville Press, 1986).

2. Maurice Tuchman, "Hidden Meanings in Abstract Art," in *The Spiritual in Art*, 19.

3. See, for example, Arthur Jerome Eddy, *Cubists and Post-Impressionism* (Chicago: A. C. McClurg and Co., 1914) and Sheldon Cheney, *A Primer of Modern Art* (New York: Boni & Liveright, 1924).

4. Clement Greenberg, review of Georgia O'Keeffe's paintings, *Nation* 162 (15 June 1946): 6.

5. A group of O'Keeffe's letters, selected and annotated by Sarah Greenough, is included in *Georgia O'Keeffe: Art and Letters* (Washington, D.C.: National Gallery of Art and New York Graphic Society, 1987) (hereafter cited as *Art and Letters*).

6. Julia Kristeva, "Women's Time," trans. Alice Jardine and Harry Blake, *Signs* 7 (1981): 13–35, passim.

7. William Innes Homer, *Alfred Stieglitz and the American Avant-Garde* (Boston: New York Graphic Society, 1977), 242.

8. See Lawrence W. Chisholm, *Fenellosa: The Far East and American Culture* (New Haven, Conn.: Yale University Press, 1963).

9. See Frederick C. Moffatt, *Arthur Wesley Dow (1857–1922)* (Washington, D. C.: National Collection of Fine Arts, 1977), 102–3.

10. O'Keeffe to Anita Pollitzer, January 17, 1917, reprinted in *Art and Letters*, no. 16, 159. The authors and texts referred to are the following: Willard Huntington Wright, *Modern Painting* (New York, 1915) and *The Creative Will: Studies in the Philosophy and the Syntax of Aesthetics* (New York, 1916); Clive Bell, *Art* (London, 1914; New York, 1915); Marius de Zayas, *African Negro Art: Its Influences on Modern Art* (New York, 1916); Arthur Jerome Eddy, *Cubists and Post-Impressionism* (Chicago, 1914); and Charles H. Caffin, *Art for Life's Sake: An Application of the Principles of Art to the Ideals and Conduct of Individual and Collective Life* (New York, 1913).

11. Eddy, *Cubists and Post-Impressionism*, 122.

12. Kandinsky, quoted in *The Spiritual in Art*, 11.

13. Sarah Greenough, "From the Faraway," in *Art and Letters*, 136.

14. Wassily Kandinsky, *Concerning the Spiritual in Art*, trans. M. T. H. Sadler (1914; reprint, New York: Dover, 1977), 32. The first English translation was under the title *The Art of Spiritual Harmony*.

15. See, for example, plates 8 and 9 in *The Spiritual in Art*. The profound influence of Theosophy on early artistic abstraction has been acknowledged by a number of writers, including Sixten Ringbom, who notes, "Whatever one might otherwise think about the claims and intellectual quality of the theosophical teachings, the crucial role of Theosophy in the emergence of nonrepresentational art is becoming increasingly clear. In a seemingly endless stream of publications Theosophy provided artists with a wealth of artistically exploitable ideas and images. Most important was its interpretations of the spiritual as being formless in a physical but not an absolute sense" (Sixten Ringbom, "Transcending the Visible: The Generation of the Abstract Pioneers," in *The Spiritual in Art: Abstract Painting 1890–1985*, 136–37).

16. See, for example, Sharyn R. Udall, *Modernist Painting in New Mexico 1913–1935* (Albuquerque: University of New Mexico Press, 1984), 6–7. Members of the Stieglitz circle adopted modernism's spiritual concerns as it suited their personal inclinations; Hartley, Dove, and Weber were vitally interested, Marin—self-professed Yankee independent—less so.

17. Sue Davidson Lowe, *Stieglitz: A Memoir/Biography* (New York: Farrar, Straus Giroux, 1983), 290.

18. O'Keeffe to Anita Pollitzer, January 4, 1916, reprinted in *Art and Letters*, no. 6, 147.

19. O'Keeffe's feminist attitudes were not often publicly stated, but in one important interview she tried to draw together her feminist concerns with aesthetic issues: "I am interested in the oppression of women of all classes . . . though not nearly so definitely and so consistently as I am in the abstractions of painting. But one has affected the other. . . . I am trying with all my skill to do painting that is all of a woman, as well as all of me" (O'Keeffe, interview with Michael Gold, editor of the *New Masses*, published in Gladys Oaks, "Radical Writer and Woman Artist Clash on Propaganda and its Uses," *New York World*, March 16, 1930, Women's Section, 1, 3).

20. See letter no. 68; 274 n. 2; and 285 n. 68 in *Art and Letters*.

21. O'Keeffe to Henry McBride, February 1923, reprinted in *Art and Letters*, no. 27, 171. In an annotation to this letter Sarah Greenough comments that O'Keeffe believed that "men were of a separate, 'different class,' but not a superior one" (*Art and Letters*, 278 n. 27).

22. See O'Keeffe to Blanche Matthias, March 1926, reprinted in *Art and Letters*, no. 36, 183, and 280–81 n. 36. See also Robert Galbreath, "A Glossary of Spiritual and Related Terms: Fourth Dimension," in *The Spiritual in Art*, 373.

23. See Gail Levin, "Marsden Hartley and Mysticism," *Arts* (November 1985): 16–21.

24. Marsden Hartley, *Adventures in the Arts* (1921; reprint, New York: Hacker Books, 1972), 116–17.

25. O'Keeffe to Donald Gallup, March 31, 1952, reprinted in *Art and Letters*, no. 110, 262.

26. Maurice Tuchman, "Hidden Meanings in Abstract Art," 43. See also Sherrye Cohn, "Arthur Dove: The Impact of Science and Occultism on his Modern American Art" (Ph.D. diss., Washington University, 1982); Maurice Tuchman, "Arthur Dove and Theosophy," *Arts* 58 (September 1983): 86–91.

27. Charles Eldredge, "Nature Symbolized: American Painting from Ryder to Hartley," in *The Spiritual in Art*, 124.

28. Dove, quoted in *Art and Letters*, 286 n. 73.

29. Edith Evans Asbury, "Silent Desert Still Captivates Georgia O'Keeffe, Nearing 81," *New York Times*, November 2, 1968, p. 39.

30. See *Art and Letters*, 277 n. 19.

31. O'Keeffe, statement in *Georgia O'Keeffe*, unpaginated. See, for example, "Portrait W, No. III" (1917), reproduced as plate 26, *Art and Letters*.

32. O'Keeffe, quoted in Jo Gibbs, "The Modern Honors First Woman: O'Keeffe," *Art Digest* 20 (1 June 1946): 6.

33. See Linda Dalyrimple Henderson, *The Fourth Dimension and Non-Euclidean Geometry in Modern Art* (Princeton, N.J.: Princeton University Press, 1983), 31–33, 34–46, 78 for a discussion of Theosophy's role as popularizer of these ideas.

34. Weber, "Fourth Dimension," 25. See also, Linda Dalrymple Henderson, "Mysticism, Romanticism and the Fourth Dimension," in *The Spiritual in Art*, 219–37.

35. O'Keeffe to Anita Pollitzer, December 13, 1915, reprinted in *Art and Letters*, no. 5, 146.

36. O'Keeffe to William Howard Schubart, July 25, 1952, reprinted in *Art and Letters*, no. 111, 262.

37. O'Keeffe to Sherwood Anderson, September [1923?], reprinted in *Art and Letters*, no. 29, 173–74.

38. O'Keeffe to Dorothy Brett, February 1932, reprinted in *Art and Letters*, no. 60, 206.

39. O'Keeffe to Caroline Fesler, February 5, 1956, reprinted in *Art and Letters*, no. 114, 265–66.

40. Weber, "Fourth Dimension," 25.

41. Roxana Robinson, *Georgia O'Keeffe* (New York: Harper Collins, 1989), 195.

42. Alfred Stieglitz, catalogue introduction, *The Third Exhibition of Photography by Alfred Stieglitz* (New York: Anderson Galleries, 1924), unpaginated.

43. Quoted in Laurie Lisle, *Portrait of an Artist* (New York: Seaview Books, 1980), 115.

44. O'Keeffe to Dorothy Brett, October 1930, reprinted in *Art and Letters*, no. 54, 201–2.

45. O'Keeffe to Aaron Copland, July 19, 1968, reprinted in *Art and Letters*, no. 120, 269.

46. Kandinsky, *Concerning the Spiritual in Art*, 37.

47. Avid reader of Kandinsky that she was, it is likely that O'Keeffe was aware in 1919 of his "Black Spot" drawings and painting from c. 1912 (illustrated in *The Spiritual in Art*, 142). By 1976 she had forgotten any extraneous influence when she wrote of her own "Black Spot" series: "I never knew where the idea came from or what it says. They are shapes that were clearly in my mind—so I put them down" (O'Keeffe, statement in *O'Keeffe*, opposite pl. 15).

48. O'Keeffe to William M. Milliken, November 1, 1930, reprinted in *Art and Letters*, no. 55, 202.

49. O'Keeffe to Ettie Stettheimer, August 24, 1929, reprinted in *Art and Letters*, no. 49, 195.

50. Often during her life O'Keeffe spoke of her nurturing by Stieglitz, whom she sometimes resented. She wrote, "I feel like a little plant that he has watered and weeded and dug." Quoted in by Greenough, *Art and Letters*, 280 n. 36.

51. Robinson, *Georgia O'Keeffe*, 139.

52. Tuchman, "Hidden Meanings in Abstract Art," 20.

53. Paul Rosenfeld, "Musical Chronicle," *Dial* 81 (1926): 530.

54. Quoted in Lois Rudnick, "Re-Naming the Land: Anglo Expatriate Women in the Southwest," in *The Desert is No Lady: Southwestern Landscapes in Women's Writing and Art*, ed. Vera Norwood and Janice Monk (New Haven, Conn.: Yale University Press, 1987), 16. Austin also viewed Taos Pueblo and its environs through a mystical lens; in 1930 she wrote of its "impenetrable timelessness of peace, as though the pueblo and all it contains were shut in a glassy fourth dimension, near and at the same time inaccessibly remote" (Mary Austin, *Taos Pueblo* [San Francisco: Grabhorn Press, 1930], 7).

55. Mary Austin, *Lost Borders* (New York: Harper and Bros., 1909), 10. See also Elizabeth Duvert, "With Stone, Star, and Earth: the Presence of the Archaic in the Landscape Visions of Georgia O'Keeffe, Nancy Holt and Michelle Stuart," in *The Desert is No Lady*, 197–222.

56. Lois Rudnick, personal communication, April 27, 1989; also see her article in *D. H. Lawrence Review* 14 (1981). Luhan gave two Buddha statues to Hartley.

57. Mabel Dodge Luhan, "Georgia O'Keeffe in Taos," *Creative Art* 8 (June 1931): 407.

58. Quoted by Greenough, *Art and Letters*, 280 n. 34, from a manuscript in the Mabel Dodge Luhan Archives, Yale Collection of American Literature, Yale University.

59. See Greenough, *Art and Letters*, 283 n. 53.

60. Lawrence, quoted in Keith Sagar, ed., *D. H. Lawrence and New Mexico* (Salt Lake City: Peregrine Smith, 1982), ix.

61. Georgia O'Keeffe, statement in *O'Keeffe*, opposite pl. 64.

62. This is also a theosophical tenet, a belief that the human "health aura" surrounding a person draws its strength from the sun. See Ringbom, "Transcending the Visible," 140.

63. O'Keeffe to Russell Vernon Hunter, October 1932, in *Art and Letters*, no. 63, 211.

64. O'Keeffe to Cady Wells, early 1940s, reprinted in *Art and Letters*, no. 93, 243.

65. O'Keeffe, statement in *O'Keeffe*, opposite pl. 3.

66. O'Keeffe, quoted in Lloyd Goodrich and Doris Bry, *Georgia O'Keeffe* (New York: Whitney Museum of American Art, 1970), 23.

67. Alan W. Watts, *Nature, Man and Woman* (New York: Mentor Books, 1958), 102.

68. Lucy Lippard, *Overlay: Contemporary Art and the Art of Prehistory* (New York: Pantheon Books, 1983), 50.

69. O'Keeffe to William Howard Schubart, July 28, 1950, reprinted in *Art and Letters*, no. 102, 253.

70. See Barbara Rose, "Georgia O'Keeffe's Universal Spiritual Vision," in *Georgia O'Keeffe* (Tokyo: Seibu Museum of Art and Gerald Peters Gallery, 1988), 98–100.

71. Carl G. Jung, commentary to *The Secret of the Golden Flower*, rev. ed. (New York: Harcourt Brace Jovanovich, 1962), 115.

72. O'Keeffe, statement in *O'Keeffe*, opposite pl. 88.

73. O'Keeffe to William Howard Schubart, January 19, 1951, reprinted in *Art and Letters*, no. 107, 258.

Chapter 6

1. See any of the basic histories of photography, such as Beaumont Newhall, *The History of Photography* (New York: Museum of Modern Art, 1964) or, more specifically, Van Deren Coke, *The Painter and the Photograph* (Albuquerque: University of New Mexico Press, 1964).

2. Robert Hughes, "A Vision of Steely Finesse: Georgia O'Keeffe 1887–1986," *Time*, March 17, 1986, 83.

3. O'Keeffe, quoted in *Art and Letters*, 277 n. 17.

4. Georgia O'Keeffe, letter to Sherwood Anderson, February 11, 1924, quoted in *Art and Letters*, 176.

5. Sarah Whitaker Peters, *Becoming O'Keeffe: The Early Years* (New York: Abbeville Press, 1991).

6. Unsigned review [Henry McBride?], *New York Sun*, December 31, 1938, clipping in Eliot Porter Papers, Amon Carter Museum, Fort Worth, Texas.

7. Eliot Porter, "An Early View of the Southwest," in *Eliot Porter's Southwest* (1985; reprint, New York: Henry Holt, 1991), 23.

8. O'Keeffe to William Howard Schubart, October 26, 1950, reprinted in *Art and Letters*, no. 105, 255. Schubart was Stieglitz's nephew and O'Keeffe's financial advisor during those years.

9. Ibid.

10. Donna Pierce, essay in *Mexican Churches: Eliot Porter and Ellen Auerbach* (Albuquerque: University of New Mexico Press, 1987), 17.

11. Ibid. These espadaña facades can be found, according to Pierce, as far north as the southwestern United States.

12. Spud Johnson, journal entry from Mexican trip dated February 15, 1951 (p. 35). Spud Johnson Papers, Harry Ransom Humanities Research Center, the University of Texas at Austin.

13. Johnson, Mexico journal entry, 89.

14. Roxana Robinson, *Georgia O'Keeffe* (New York: Harper & Row, 1989), 500; Charles Eldredge, *Georgia O'Keeffe: American and Modern* (Fort Worth: InterCultura, 1993), 207.

15. Georgia O'Keeffe to William Howard Schubart, March 27, 1951, *Art and Letters*, no. 108, 261.

16. See, for example, Hartley's *Carnelian Country* (1932; Regis Collection, Minneapolis) or *Earth Warming* (1932; Montgomery, Alabama, Museum of Art).

17. F. P. [Fairfield Porter], "Reviews and Previews: Georgia O'Keeffe," *Art News* 54, no. 3 (May 1955): 46–47.

18. O'Keeffe would make other descents of the Colorado in 1964, 1969, and 1970.

19. Eliot Porter, quoted in *Eliot Porter's Southwest* (1985; reprint, New York: Henry Holt, 1991), 5. His book *The Place No One Knew: Glen Canyon on the Colorado* (San Francisco: Sierra Club, 1963) documents his series of river trips.

20. O'Keeffe to Ansel Adams, August 6, 1961, Ansel Adams Archive, AG 31, Center for Creative Photography, University of Arizona, Tucson (hereafter cited as CCP).

21. Multiple versions of the story have been recounted: by Porter in *Eliot Porter* (Boston: New York Graphic Society and Amon Carter Museum), 38; by Robinson in *Georgia O'Keeffe*, 501; and by Calvin Tomkins in "Profile: Georgia O'Keeffe," *New Yorker*, 4 March 4, 1974. O'Keeffe's sketches from this and several other river trips would eventually inspire her *Canyon Country* series. Porter's photographs were later published in his book *The Place No One Knew*.

22. Georgia O'Keeffe, statement in *Georgia O'Keeffe* (New York: Viking, 1976), opposite pl. 61.

23. Arthur Wesley Dow, *Composition*, 5th ed. (New York: Baker and Taylor, 1903), 60.

24. Theodore Stebbins Jr., "The Memory and the Present: Romantic American Painting in the Lane Collection," in *The Lane Collection: 20th Century Paintings in the American Tradition* (Boston: Museum of Fine Arts, 1983), 21.

25. Paul Rosenfeld, *Port of New York* (1924; reprint, Urbana: University of Illinois Press, 1961), 208.

26. Susan Sontag, "Writing Itself: On Roland Barthes," in *A Susan Sontag Reader* (New York: Vintage, 1983), 437.

27. Quoted in Roland Barthes, *Camera Lucida: Reflections on Photography*, trans. Richard Howard (New York: Hill and Wang, 1981), 53.

28. O'Keeffe's paintings in the later 1940s continue to employ the V shape in insis-

tent ways as seen, for example, in works from her increasingly abstract blackbird series, such as *Black Bird Series, In the Patio IX*, 1950.

29. Georgia O'Keeffe to Eliot Porter, undated letter (contextually 1940–45). Her companion on the trip, she wrote Porter, was "Mary" (perhaps her friend Mary Callery). Eliot Porter Papers, Amon Carter Museum.

30. Porter, "An Early View," 23.

31. Susan Sontag, "The Image-World," in *A Susan Sontag Reader*, 350.

32. Barthes, *Camera Lucida*, 6.

33. Barthes, *Camera Lucida*, 49.

34. Porter, *Eliot Porter's Southwest*, 5.

35. Porter's notebooks of birds are housed with his papers at the Amon Carter Museum.

36. O'Keeffe, statement in *Georgia O'Keeffe*, opposite pl. 63.

37. This idea appears in several of Levi-Strauss's works, succinctly in *The Scope of Anthropology*, trans. Sherry Ortner Paul and Robert A. Paul (London: Jonathan Cape, 1967), 24 ff.

38. Lachaise's *Head of Georgia O'Keeffe* is now part of the Alfred Stieglitz Collection, Metropolitan Museum of Art. In a 1976 postcard to Ansel Adams, O'Keeffe remarked that the sculpture didn't look like her. O'Keeffe to Adams, December 17, 1976, Ansel Adams Correspondence, AG 31, CCP.

39. Stieglitz was, however, interested in sculpture related to his own modernist concerns. In 1921 he photographed O'Keeffe holding a small Matisse African-inspired bronze sculpture, *La Vie* (1906), which Stieglitz then owned. He also possessed several African masks, two of which remained on the walls of O'Keeffe's Abiquiu studio at the time of her death. See Peters, *Becoming O'Keeffe*, 121, fig. 53.

40. William Innes Homer, *Alfred Stieglitz and the American Avant-Garde* (Boston: New York Graphic Society, 1977), 291 n. 52. See also Peters, *Becoming O'Keeffe*, 153–55.

41. Victor Burgin, quoted in Laura Mulvey, "'Magnificent Obsession': An Introduction to the Work of Five Photographers," in *Visual and Other Pleasures* (Bloomington: Indiana University Press, 1989), 139.

42. Another striking example, and one that links O'Keeffe directly to both Steichen and Rodin, is Steichen's 1908 photograph of Rodin's famous sculpture of Balzac, the pose for which was emulated by O'Keeffe in a Stieglitz photograph of her, *Georgia O'Keeffe: A Portrait* (1920; National Gallery of Art, Washington, D.C.). See Peters, *Becoming O'Keeffe*, 108–10.

43. Ludwig Feuerbach, from *The Essence of Christianity* (1843), quoted in Sontag, "The Image-World," 349.

44. Sontag, "The Image-World," 349.

45. O'Keeffe, statement in *Georgia O'Keeffe*, opposite pl. 104.

46. Webb's study of the West resulted in, among other things, his *Gold Strikes and*

Ghost Towns (Garden City, N.Y.: Doubleday, 1961) and *Georgia O'Keeffe: The Artist's Landscape* (Pasadena, Calif.: Twelvetrees Press, 1984).

47. Todd Webb, *Looking Back: Memoirs and Photographs* (Albuquerque: University of New Mexico Press, 1991), entry dated July 24, 1964, p. 183.

48. *Todd Webb: Photographs* (Fort Worth: Amon Carter Museum, 1965).

49. Sontag, "On Style," in *A Susan Sontag Reader*, 145.

Chapter 7

1. All quotations from Page Allen are taken from her journal or from conversations with the author during July 1990.

2. Pierre Teilhard de Chardin, *The Phenomenon of Man* (New York: Harper & Row, 1959), 258.

3. Loren Eiseley, *The Night Country* (New York: Charles Scribner's Sons, 1971), 148.

Chapter 8

1. This essay was published as an introduction to *Woody Gwyn* (Lubbock: Texas Tech University Press, 1995).

2. See, for example, the essays in *The West as America: Reinterpreting Images of the Frontier, 1820–1920*, ed. William H. Truettner (Washington, D.C.: National Museum of American Art, 1991) and Jules David Prown et al., *Discovered Lands, Invented Pasts: Transforming Visions of the American West* (New Haven, Conn.: Yale University Press, 1992).

INDEX